# The Oil Painting Course You've Always Wanted

## GUIDED LESSONS FOR BEGINNERS AND EXPERIENCED ARTISTS

### Kathleen Lochen Staiger

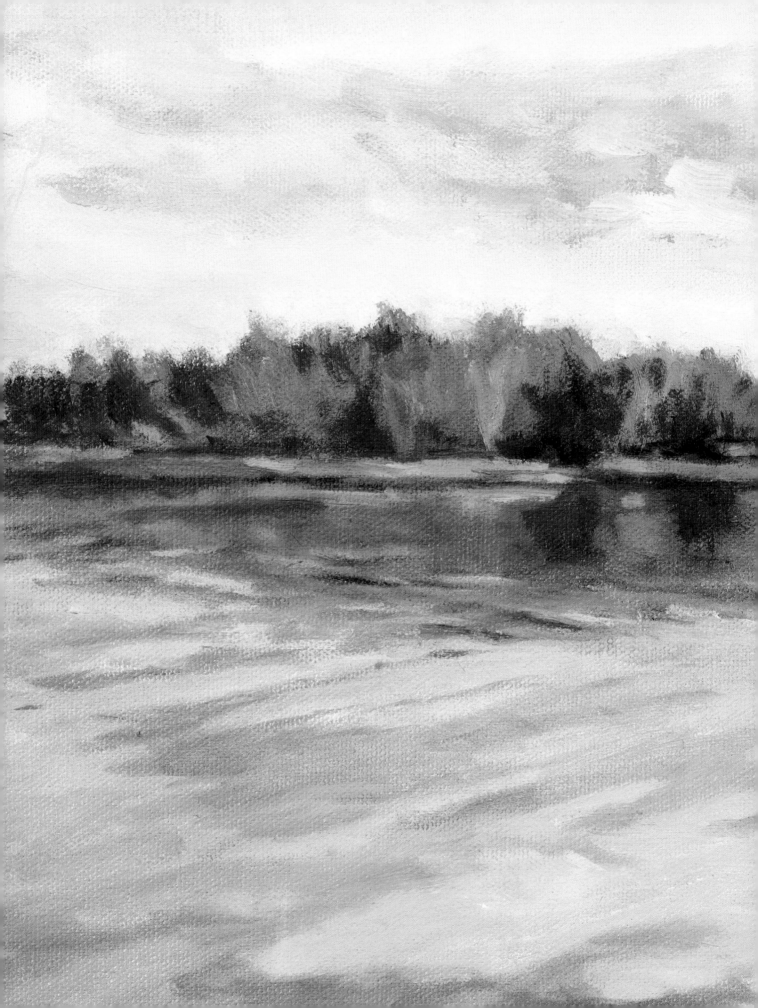

# The Oil Painting Course You've Always Wanted

## GUIDED LESSONS FOR BEGINNERS AND EXPERIENCED ARTISTS

Kathleen Lochen Staiger

WATSON-GUPTILL PUBLICATIONS/NEW YORK

*To my husband, Bill, my best friend and biggest fan,*
*who always believed I could do this.*

This book exists, in large part, because of the enthusiasm of my students who urged me to set down my teaching in more permanent form. I would like to thank them. Many of the paintings in this book are the result of their talent.

Friends Irene Marco, Joan McCarthy, and Dierdre Bugbee helped by reading and critiquing the text, and writer Ann Taylor gave me publication tips. They all shared my joy at having the book accepted for publication.

I owe a lot to my photographers: Carter Gibbons, who started the project and who will be remembered with great affection; Anne Malsbury, a photographer friend who spent hours in my studio shooting over my shoulder; and Jon Pine, who does amazing digital photography. I appreciate both their excellent work and their patience with me.

A big hug and thanks go to my daughter Shari for lending her expertise as a graphic designer to correlate and edit the illustrations.

Last, I must thank my mother for her encouragement and love, and especially for all the meals she cooked to free my time to devote to the writing of this book. I love you, Mom.

PREVIOUS PAGES: *Kathleen Lochen Staiger,* Early Morning on the Indian River, *oil on canvas*

EXECUTIVE EDITOR: Candace Raney
EDITOR: Alison Hagge
DESIGNER: Patricia Fabricant
PRODUCTION MANAGER: Hector Campbell

*Library of Congress Cataloging-in-Publication Data*
Staiger, Kathleen Lochen.
  The oil painting course you've always wanted : guided lessons for beginners and experienced artists / Kathleen Lochen Staiger.
    p.  cm.
  ISBN 0-8230-3259-0
1. Painting—Technique. I. Title.
  ND1473.S73 2006
  751.45—dc22
                                        2005030763

Printed in Malaysia

First Printing, 2006

7 8 / 13 12 11 10

# Contents

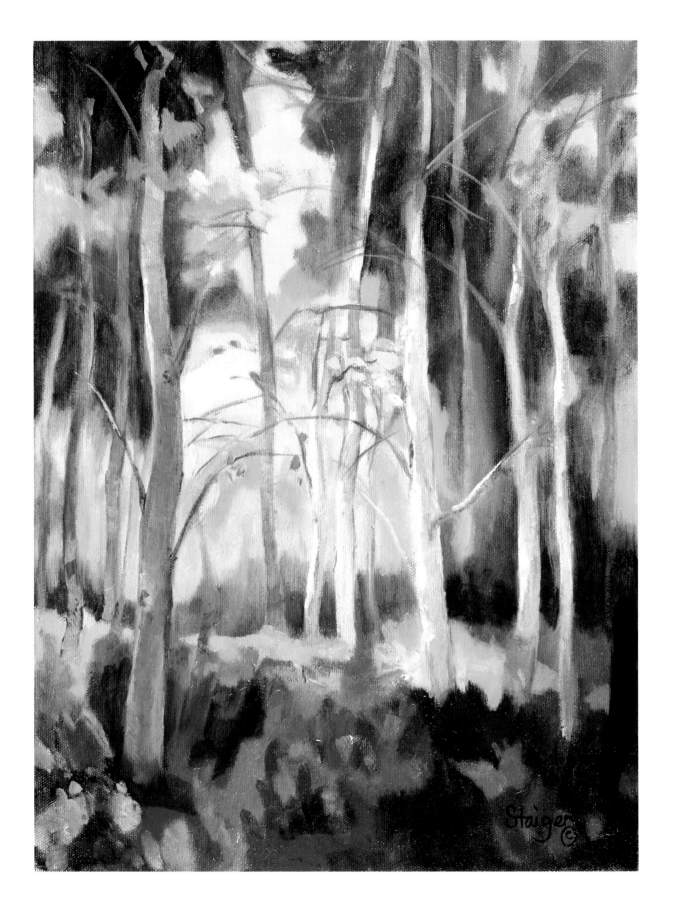

INTRODUCTION

# Introduction to the Course

FOR YEARS I have been hearing from my students, "Why haven't I ever learned this before?" This book is the result of requests that have come to me over the years to put my teaching down in permanent form. It is taken directly from the Basic Techniques of Oil Painting course I've taught successfully for more than thirty-five years. Whether you are a beginning painter or one who has painted for years but never had a really good basic course, this book will teach you how to paint—and how to paint better.

*The Oil Painting Course You've Always Wanted* is an actual painting course that you can take at home. Working at home (rather than in a classroom) gives you the advantage of being able to spend as much time as you need on each project. Using this book gives you other benefits, too, because I have been able to include a lot of additional material that I couldn't teach in the original course due to time constraints. You will find a lot of help with problem solving and mistake fixing, as well as greater depth in each subject.

The course is organized into a series of lessons. Each lesson deals with a different aspect of painting, and each lesson builds on the previous one so that you learn by *doing*, which is, of course, the very best way of learning.

To get the most out of the book, you should start at the beginning and do each exercise and project. Don't skip any chapters, even if you think you know what's in them. You may miss something new and useful. The step-by-step projects in each lesson cover such topics as shading, color mixing, color theory, brush handling, and composition. I will guide you through the creation of a still life painting, landscape painting, and portrait painting, with specific technique information on each subject.

I have devoted a large portion of the book to the important subject of color mixing. There is an entire chapter dedicated to it as well as specific color advice in each of the other lessons. So after you finish this course, you shouldn't ever have to search hit-or-miss for the right color again.

While this book is directed at oil painters, the methods of color mixing, including the important Rule for Shadows, are of benefit to any artist working with color, and many of the exercises can be adapted to other media.

Throughout the book you will see examples of students' paintings from the course, so you can compare the instructions for the projects with some finished work.

You do not need any previous experience in art or painting, and talent is not a requirement for this class. This book will not only teach you how to paint, but will also teach you a new way of seeing—and hopefully will mark the beginning of a lifelong enjoyment of painting.

*Kathleen Lochen Staiger,* Aspen Grove, *oil on canvas*

# Getting Your Supplies Together

THIS CHAPTER will give you some information and pointers about the supplies you will need. It's a good idea to always buy the very best materials you can afford, but there are acceptable substitutes to professional-grade supplies that will work just fine while you are learning. I will point out where you can substitute and where you should invest in better quality. On pages 12–13 you will find a concise list of supplies. Welcome to the class!

## PAINT

I like to work with traditional oil paint, but water-mixable oil paint will also work. If you are starting out, I recommend using student-grade oil paint because it is reasonably priced and its quality is acceptable. Winton and Academy are the student-grade lines of paint made by Winsor & Newton and Grumbacher respectively. While you can use any brand of paint, the colors I list are based on these two brands and are exactly what you will need to do the exercises.

While most colors are nearly the same from brand to brand, some of the yellows vary widely. There also may be a little confusion over the different ultramarine blues available. French Ultramarine and Ultramarine Blue are almost exactly the same in most brands. Winton and Academy both call this color French Ultramarine, so we have listed it as French Ultramarine blue throughout the book to avoid confusion. If you want to use Ultramarine Blue in another brand, or any other color in another brand, just be sure to compare the color you buy against the one on the list so that you get the right color.

NOTE: While you can mix brands, be sure you don't mix oil paint with acrylic or alkyd paint.

In addition to the thirteen essential colors, I have included two optional oxide colors on the shopping list—Oxide of Chromium (green oxide) and Indian Red (red oxide). These colors are mentioned in the text but are not necessary.

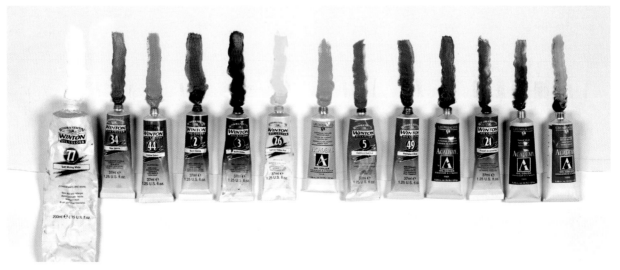

Paint selection: Soft Mixing White, Raw Sienna, Yellow Ochre, Burnt Sienna, Burnt Umber, Lemon Yellow Hue, Cadmium Yellow Medium, Cadmium Red Hue, Permanent Rose, Alizarin Crimson, French Ultramarine blue, Thalo Blue, and Thalo Green.

# BRUSHES

You will need a basic assortment of brushes. Bristle brushes are the ones you will depend on for most of your painting. There are several kinds of bristles. Get natural brushes made from hog bristle. They have split ends, giving them the ability to make soft edges. The bristles should taper to an edge when you look at the brush sideways. If the top edge spreads out like a whisk broom, you have a cheap brush that will be difficult to manage.

For your bristle brushes, buy "flats." The word "flat" means that the bristles are square at the top and long. "Bright" brushes are also square at the top, but are short and stubby. "Filbert" brushes are shaped into an oval at the top rather than a square. You will need a small, medium, and large flat bristle brush; you don't need any bright or filbert bristle brushes.

Each brush will have a number near the metal collar (called the "ferrule") that holds the bristles. Numbers vary from brand to brand, but the #10 flat used in this book was ¾ inch wide, the #6 flat was ½ inch wide, and the #2 flat was ¼ inch wide.

You will need one or more inexpensive utility brushes. These are commercial-grade brushes with hog-hair bristles and a short handle that are used for many household and craft projects. Utility brushes are available at hardware stores. Don't purchase an expensive house painting brush; they're too thick and hard to clean.

A fine-pointed brush made of softer hair (such as sable) will help you paint lines and details. Real sable can be extremely expensive, but there are many sable substitutes (I call them "sable-types"). Whatever you choose, it is important that it comes to a sharp point, and should be ½ to ⅝ inch long so that it will hold a useful amount of paint. (Like bristle brushes, sables come in a variety of tips, including flats, brights, and filberts.) We will only need one fine-pointed sable or sable-type brush. Be aware that the numbering system is different between sable and bristle brushes.

Finally there are two specialty brushes that are very useful. The first is an angled shader. It has a distinctive tip that is cut at an angle. Buy one with synthetic hairs. The other is a hake brush, which has very soft hairs and is used for blending.

Always buy the best brushes you can afford. Winton brushes are acceptable; however, I prefer Robert Simmons's Signet brushes because they are well constructed and they last a long time.

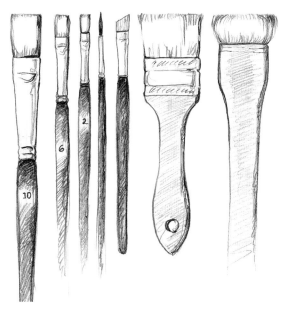

*Brush selection: #10 flat bristle, #6 flat bristle, #2 flat bristle, fine-pointed sable, angled shader, utility brush, and hake.*

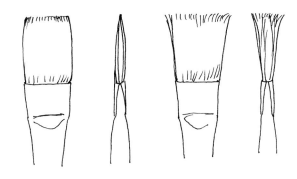

*A good-quality bristle brush (LEFT) tapers in when viewed from the side. A poor-quality bristle brush (RIGHT) spreads out like a whisk broom.*

# SUPPORTS

Supports are the surfaces upon which you paint. The usual support for oil painting is some form of canvas, although supports can also be made of wood, pressed board, or paper. Some surfaces are rough; these grab onto the paint and allow vigorous brushwork. Some surfaces are smooth; these are good for fine detail, but are more difficult to work with during the first layers because the paint doesn't have much to grab onto.

## Canvas

Most commercially available canvas comes already primed with acrylic gesso and is ready for painting. (Acrylic gesso is used for both oil and acrylic paintings.) Gesso protects the canvas and provides a pleasant, nonabsorbent surface on which to paint. It is possible to buy canvas that is "oil primed," but I prefer the acrylic priming because it doesn't crack when subjected to stress.

Canvas panel is the least expensive support. It is simply canvas that has been glued to a stiff backing. Many students like the relative cheapness of these supports and they are fine for practice work. Most artists, however, prefer stretched canvas. The canvas is stretched tightly around wooden stretcher bars and nailed or stapled in back or on the edge. Some canvases have two inches or more of selvage in back, which makes them easy to restretch if necessary. I recommend buying a name brand, such as Fredrix.

Fredrix also makes a "pad" of real canvas that is available in a variety of sizes and is handy for practice work. Beware of similar pads made of plastic textured to mimic canvas; they do not accept paint well. If you can't get a real canvas pad, use canvas panels.

## Wood and Pressed Board

Artists have painted on prepared wood panels for hundreds of years. You can buy wood panels and prime them yourself using acrylic gesso, or buy pressed board (Masonite) panels that are primed with gesso and ready to use. Gessobord is one such brand.

## Paper

Paper makes an acceptable support for oil painting—provided that it is heavy enough (300-lb watercolor paper works fine) and properly primed. (Oil paint will destroy unprimed paper.) To prime your paper, brush a layer of acrylic gesso on each side of the paper and let it dry thoroughly. For added permanence mount the paper on a stiff backing.

# EASELS

Many different kinds of commercially made easels are available. The two most common are standing easels and tabletop easels. If you're handy, you could even make your own easel. The most important factor when choosing or making an easel is that it will accommodate the largest canvas you will ever use. (Canvas size is a very personal matter; some artists never paint larger than 16 x 20 inches and others prefer 36 x 48 inches or larger.)

Standing easels are easy to adjust to the right height to suit your chair and come in a great range of prices. Some of the tripod types can be wobbly but have the advantage of folding up. Easels with an H shape tend to be more stable. Tabletop easels are more portable. They have a device at the top that secures your painting, and a handle to make it easy to carry a wet painting. The disadvantage to these is that if you are sitting at a table you may have to use a pillow so that you are at a comfortable height to paint. Think about how you plan to use your easel (where you will be painting, whether portability is important, et cetera) before you make your purchase.

# MEDIUMS AND CLEANERS

The word "medium" means two things in art. Medium refers to the material you use to create your art. Paint, collage, and pen and ink are examples of mediums. Medium also refers to what you use to *thin* your paint. The medium for watercolor paint is water, for example. For oil painting, you can use a simple paint thinner, such as odorless mineral spirits or odorless Turpenoid, as a medium. However, this is not very satisfactory, as it thins out the binding agents in the paint and tends to make your paint layer look flat and dull. Thinner alone is useful to thin paint, which is helpful when you want to sketch your subject on the canvas.

Traditionally, the medium for oil painters has been a mixture of artists' oil, turpentine, and varnish. Because we are now aware of the toxicity of turpentine fumes, many artists no longer use gum turpentine either to thin their paints or to clean their brushes. Since turpentine is the only paint thinner or solvent that completely dissolves varnish, many artists have also stopped using varnish in their painting medium.

Today's mediums usually consist of some form of linseed oil and a turpentine substitute such as odorless mineral spirits, odorless Turpenoid, or similar paint thinner made by various art manufacturers (such as Grumbacher's Grumtine). Odorless Turpenoid has very low toxicity, and as we use very little, there are no health concerns.

The easiest and best medium for oil painters, in my opinion, is a simple combination of plain or refined artists' (not hardware store) linseed oil and odorless Turpenoid or odorless mineral spirits. With this medium the paint will flow easily off your brush and not get sticky. Don't be confused by the many forms of painting oils on the shelf. Stick to linseed oil. If you can't find it in one brand, look in another. Both Gamblin and Grumbacher make plain or refined linseed oil.

Be wary of prepared mediums. Many are fast-drying or contain stand oil. Fast-drying mediums can make your paintings susceptible to cracking if they are not used with care, and in a long painting session they can get tacky and drag on your brush. Mediums that contain stand oil tend to be thick and gummy, and if you use them I recommend that you dilute them with paint thinner until they work comfortably. Both types of mediums are thick, don't flow easily from the brush, and dry with a high gloss that will stand out in contrast to areas in which no medium was used.

If you use water-mixable oil paint (such as Winsor & Newton's Artisan line and Grumbacher's MAX line), you will need a medium especially made for the brand you choose.

I recommend using Turpenoid Natural to clean your brushes. (Turpenoid Natural, which comes in a can or bottle with a green label, is different from odorless Turpenoid, which comes in a can with a blue label and which we use as a thinner and for our medium.) Turpenoid Natural is completely nontoxic and rinses with water. It is an excellent cleaner, and will remove 95 percent of the paint from your brushes or your clothes. (Plain soap and water will remove the rest.) I don't recommend using it in your painting medium, though, as it is yellow, thick, and extremely slow drying.

## PALETTES AND ACCESSORIES

No matter what kind of palette you use, the most important thing is that it is large enough. Your palette should be at least 12 x 16 inches. You need room to mix paint, and you will want to be able to space the daubs of paint far enough apart so that the corner of your brush doesn't pick up red when you're dipping into yellow.

Personally, I like paper palettes because you never have to clean your palette; you just throw the paper away when you're done. These can be purchased, but that's an unnecessary expense. You can easily make one by covering a piece of cardboard or any stiff board with freezer (butcher's) paper (positioned shiny side up), available in grocery stores. Unless you intend to hold the palette while you paint, it is not necessary to have a hole in the palette.

You'll need something to hold your medium and your brush cleaner. I avoid small, attached palette cups—because large brushes don't fit in them and they can't be emptied separately. Instead, I use two cleaned tuna cans. Any wide, shallow cans will do, but you'll be cleaning these out for reuse so be careful to check the inside to make sure there isn't a knife-sharp interior rim.

And finally, you'll want a palette knife. Don't confuse this with a *painting* knife, which is thin and flexible. Palette knives are fairly stiff metal or plastic knives. They are not intended for painting, but rather to be mixing tools for the paint on your palette. The most useful of these are trowel-shaped—this helps to keep your knuckles out of the paint.

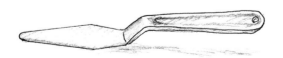

*Palette knife with trowel shape*

## Going Shopping

Now that you have learned something about all the materials you will be using, it's time to go shopping. If you already have some supplies, be sure to check them over and add what you need—especially the paint, as it's important to have the right colors for the exercises.

You might find it helpful to make a photocopy of this shopping list and take it with you to the art supply store. Or, if you have access to the Internet, you can purchase your supplies online from a discount catalog company, or go to your local art supply store. Reputable catalog companies and their Web sites are easily found by looking at the ads in any issue of *American Artist* or *The Artist's Magazine*.

### Paint

Both Winsor & Newton and Grumbacher make good student-grade paints—with the Winton and Academy lines, respectively. I recommend choosing your colors between them as indicated. It is important that you get the correct brand as the colors may vary—particularly with the ultramarine blue. Winton paints have numbers; Academy paints do not. I would suggest that you buy 37 ml tubes of paint of the colors, and a 200 ml tube of the white.

You will need one tube of each of the following colors:

- LEMON YELLOW HUE (Winton #26)
- CADMIUM YELLOW MEDIUM (Winton #65 or Academy)
- PERMANENT ROSE (Winton #49)
- CADMIUM RED HUE (Winton #5)
- ALIZARIN CRIMSON (Academy)
- FRENCH ULTRAMARINE BLUE (Winton #21 or Academy)

- THALO BLUE (Academy)
- THALO GREEN (Academy's Thalo Green, blue shade is the equivalent)
- YELLOW OCHRE (Winton #44 or Academy)
- BURNT SIENNA (Winton #2 or Academy)
- BURNT UMBER (Winton #3 or Academy)
- RAW SIENNA (Winton #34)
- WHITE This should be a Titanium or Titanium-Zinc combination; Winton's Soft Mixing White (#77) works well.
- OXIDE OF CHROMIUM (Winton #31) (optional)
- INDIAN RED (Winton #23) (optional)

## Brushes

- #2 FLAT BRISTLE BRUSH (¼ inch)
- #6 FLAT BRISTLE BRUSH (½ inch)
- #10 FLAT BRISTLE BRUSH (¾ inch)
- FINE-POINTED SABLE OR SABLE-TYPE BRUSH The hairs should be at least ½ inch in length.
- 1½-INCH UTILITY BRUSH
- 1½-INCH HAKE BRUSH
- ANGLED SHADER

## Mediums and Cleaners

If you're using traditional oil paint, you'll need to purchase the items listed below. In addition, you'll want to procure two wide, flat cans (such as tuna-fish cans) that you can use to hold your medium and cleaner. Be sure these cans do not have a sharp interior edge.

- LINSEED OIL (2.5 ounces) This should be artists' linseed oil (plain or refined).
- ODORLESS TURPENOID (473 ml) You can also use Grumtine or odorless mineral spirits.
- TURPENOID NATURAL (946 ml)

If you're using water-mixable oil paint, you'll need to purchase the items listed below. In addition, you'll want to procure one wide, flat can (such as a tuna-fish can) that you can use to hold your medium as well as a large container to hold your water.

- MEDIUM This should be the same brand as the majority of the paint you are using. It will probably be labeled "Linseed Oil H2/0" or something similar.
- TURPENOID NATURAL (236 ml)

## Other Supplies

- CANVAS PANELS One 8 x 10-inch panel and two 12 x 16-inch panels.
- CANVAS PADS Two 12 x 16-inch real canvas pads, such as the one made by Fredrix. Each pad should contain ten sheets. If you don't want to work on canvas pads, you can buy other practice canvas as long as it's real canvas.
- PALETTE It should be at least 12 x 16 inches. If you don't want to use a commercially made palette, you can make your own out of sturdy cardboard or hardboard.
- ROLL OF FREEZER (BUTCHER'S) PAPER OR A DISPOSABLE PAPER PALETTE
- MASKING TAPE
- EASEL
- PALETTE KNIFE
- PAPER TOWELS Paper towels that tear in half-sheets are cleaner and less wasteful than standard paper towels.
- BAR OF HAND SOAP
- #2 PENCIL
- KNEADED ERASER

# LESSON ONE
# Capturing the Illusion of Three Dimensions

HOW DO YOU MAKE SOMETHING that is created on a flat surface look as though it has a solid form? In this lesson you will learn how to use light and shadow to make your shapes pop off the canvas.

To make our drawings and paintings look real, we have to give up outlines. There are no outlines in real life, just lights and darks—and colors, of course, but that comes later. In this lesson we will be making tonal studies.

Tonal studies are drawings that have no outlines; the form is created solely by lights and darks (the tones) both on and around the form. You only see the edges of the forms if they are either lighter or darker than the background tone. That means that if there is a place on your object that is the same tone as the area behind it, you will not be able to see the edge of the object in that particular spot. We call that "losing the edge" and it is a useful artistic tool.

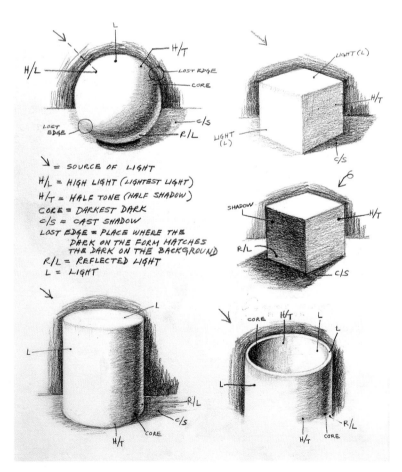

= SOURCE OF LIGHT
H/L = HIGH LIGHT (LIGHTEST LIGHT)
H/T = HALF TONE (HALF SHADOW)
CORE = DARKEST DARK
C/S = CAST SHADOW
LOST EDGE = PLACE WHERE THE DARK ON THE FORM MATCHES THE DARK ON THE BACKGROUND
R/L = REFLECTED LIGHT
L = LIGHT

*The completed tonal studies project*

# Making Tonal Studies of Geometric Forms

You will need the following:
SUPPLIES: A #2 pencil, some white paper (any kind), and a good eraser.
TIME: About 2–2 ½ hours

These five tonal studies will help you to understand how lights and shadows define forms. We will draw a sphere, two different cubes, and two different cylinders.

## DRAWING A SPHERE

Using a *very* light line (remember you won't want to see the outline when you are finished), draw a small circle approximately two to three inches in diameter. Then add a line indicating the table upon which the circle is resting.

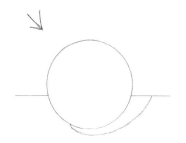

*Draw the sphere and table and identify the light source and cast shadow.*

### Identifying the Light Source and Cast Shadow

To understand how light and shadow fall on an object, we must first determine where the light is coming from. The lighting most frequently used by artists comes from above and to the left. This angle of light provides a good pattern of shadows on your subject. Draw an arrow above and to the left of your circle to indicate the light source.

The shadow that the sphere casts on the table travels directly away from the source of light. The shape of the cast shadow is determined by the shape of the object and the angle of the light, and it always follows the ups and downs of the surface on which it is lying.

In rounded objects that bulge out and block an overhead light, there will always be some cast shadow directly under the object, even on the side nearest the source of light. Draw the cast shadow for your sphere.

### Defining the Background and Surface

Now start using tone to define the elements in your drawing. In order to see the sphere against the wall, we need to darken the wall. Shade the area behind the sphere down to the edge of the table with a medium gray. You are putting in a

background tone in order create the shape of the sphere, so make sure that the sphere is clearly defined with a nice sharp edge. (This tone can be faded out as it goes away from the sphere.) The light drawing that you made at the beginning of this exercise should now disappear so that no outline is visible.

Sketch in the table with a light gray tone, and fill in the cast shadow with a darker tone. Notice how the cast shadow gets very dark, almost black, under the sphere where it touches the table. Darken your cast shadow in that area and label the shadow "C/S."

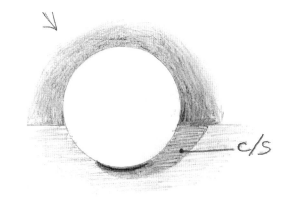

*Add tone to the wall and table and to the cast shadow under your sphere.*

## Adding Body Lights

Body lights are lights that appear on an object. When doing tonal studies, we identify three areas of light appearing on an object: general light, highlight, and reflected light.

### GENERAL LIGHT

The part of the object that is turned toward the source of light will, of course, be light. Label the light side of the sphere "L."

### HIGHLIGHT

If the object is shiny, the closest point of the object to the source of light will have a highlight (a spot of slightly grayish white). Because we are working in black and white, we can't see the highlight against the general white of the sphere, so simply make a dotted line from the arrow (showing the source of light) to a spot just inside the sphere and label it "H/L."

### REFLECTED LIGHT

Reflected light is the only light that appears on the *shadow* side of an object. It is light that reflects into a shadow from surrounding lights. In the image on the facing page you can see that the shadow on the sphere is not solid, but gets lighter near the bottom edge. That is because light is bouncing off the tabletop and reflecting into the sphere. Reflected light may come from many sources—another wall or ceiling, or perhaps (in an outdoor setting) the sky. These lights bounce into the shadow side of the object most

*Too many reflected lights can break up the shadow patterns that give strength to a design, so sometimes they should be ignored or downplayed.*

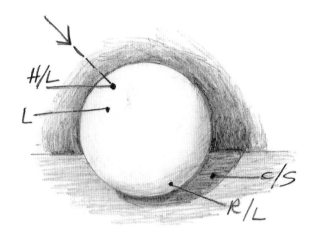

*Add and label the light areas.*

strongly in places where the reflecting surface is either very close, as in the tabletop in our drawing, or very strong, as from a bright sky. The only time you will not see reflected light is if the object is completely surrounded with black.

When the background is light, don't put the reflected light on your object right at the edge or you won't be able to see that edge. Instead, bring it slightly inside and darken the edge enough so that it shows up against the background. As the reflected light continues around the sphere and the background becomes darker, bring the reflected light back to the very edge so that you again have contrast and can see the form. Remember that reflected light is never as bright as the light on the lighted side of the sphere. Sketch in the reflected light on your sphere with a light gray and then label it "R/L."

## Distinguishing Body Shadows

The shaded part of the *object* is called its "body shadow." This is distinct from the cast shadow, which is the shadow created by the object. Body shadows are subtle and typically include three parts: halftone, shadow, and (on a rounded object) the core of the shadow. In this instance, the shadows follow the curve of the sphere at right angles to the source of the light.

### HALFTONE

As the sphere's surface starts to turn away from the light, it will begin to darken. This area of part light, part shadow is called the "halftone." Sketch a very light tone where you think the form is starting to turn away from the light. The halftone will follow the shape of the sphere and go from light into shadow very softly, with no perceptible edge. You may need to smudge your pencil marks with your finger to achieve this effect. Refer to the image below to see how to make your halftones and shadows follow the curve of the sphere. Label the halftone "H/T."

### SHADOW AND THE CORE OF THE SHADOW

Your sphere now has general light, reflected light, and halftone. It is time to put in the rest of the body shadow. Because this is a rounded object, the shadows will gradually get darker the farther the curve travels from the source of light. The darkest part of the shadow is directly opposite the lightest light (except for the reflected light at the edge). Make your pencil tone gradually darker until it bumps into the reflected light. Try to keep the transition between these two areas soft. Next to the reflected light there should be one area that is clearly the darkest.

This area is called the "core of the shadow" and it only occurs on rounded objects. Make a blurred edge between the core and the reflected light, and label it "core."

## Refining the Drawing

Take a look at your drawing. You may find that your cast shadow and the tone you have on the wall are similar. If that is the case with your drawing, you should either darken or lighten the wall where it meets the cast shadow so that you can see the edge of the table. This is called "increasing the contrast." Finally, make sure that your sphere doesn't resemble a fuzzy tennis ball. Keep all of your edges sharp and clean.

## Identifying Lost Edges

As you look at the drawing, you will probably see one or two places where the tone on the sphere and the tone of the background are the same and you have "lost" an edge. Artistically, this is a good thing because it helps the eye move from the shape of the sphere into the surrounding areas. Connecting the shapes in this way knits the composition together and makes it stronger. If you find such places, circle them and label each "lost edge."

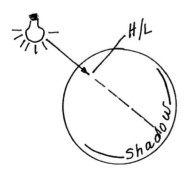

*Shadows follow the curve of the form at right angles to the source of light.*

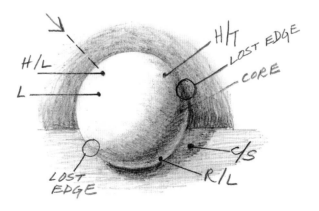

*Add shadows to the sphere and find the lost edges.*

# DRAWING A CUBE, PART ONE

Draw a cube and a tabletop, following the directions that accompany the three images below. Add an arrow indicating the light source. All of your lines should be very light. Fill in a background tone on the wall portion of the drawing. Make sure the edges of the cube are clearly and sharply defined.

Now define the table surface and cast shadow. Make the tabletop pale gray and the cast shadow a darker gray. Notice that since the cube is sitting flat on the table, we can't see under it and there is no area of very dark shadow, as there was in the sphere.

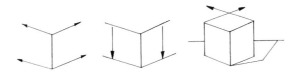

*To make a cube, draw a "Y" and repeat the upper angles at the bottom of the "Y" (LEFT). Decide how wide the sides should be and draw them with vertical lines (MIDDLE). Draw the top of the cube, repeating the angles going in the same direction. Add the tabletop and cast shadow (RIGHT).*

## Adding the Body Lights

Building upon the lessons you learned while drawing the sphere, add the body lights to your cube. The highlight and reflected light are not visible on the cube, so we will leave them out and simply concentrate on the subtleties of the general light.

### GENERAL LIGHT

The top surface of the cube faces up, toward the light, so it will be light. Label it "L" for light. The left side of the cube is also facing the light, so it, too, will be light. Label it "L" as well.

You now have a situation where two light sides are coming together. If your drawing is as light as it should be, you will not be able to see the edge. This is not a good place to lose an edge;

you need to see it for the drawing to make sense. In order to make the edge more visible, you must either lighten or darken one side. Put a smudge of tone along either side of the edge (down the side *or* across the top). This tone should be very light—just enough to make the edge visible. Use your eraser and a paper shield to make the edge very sharp. (The cheated tone is indicated by an asterisk in the image below.)

## Distinguishing the Body Shadows

Unlike a sphere, a cube has flat sides, so shadows are even rather than gradually darker tones. The shadow side of the cube is around the back and not visible and there is no core of shadow on a flat surface, so we only need to concentrate on the halftone.

### HALFTONE

The right side of the cube is turned partially away from the light and so is halftone. Make it an even light gray and label it "H/T."

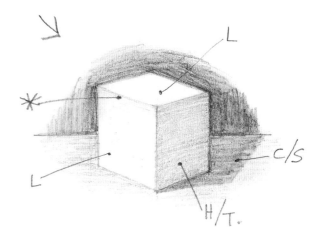

*Add tone to your cube and label it. The asterisk indicates the spot where you need to create tone in order to avoid losing an edge.*

# DRAWING A CUBE, PART TWO

For our second cube we are going to change the light source to a position still above the object but coming toward us from the back and to the right. This is called "backlighting." Add the arrow as shown below to indicate the source of light. Draw the cube, tabletop, and cast shadow. Notice again that the shadow extends directly away from the source of light.

Add tone to your drawing and define the wall and table. Shade in the wall with a medium gray and add a light gray tone to the table. Shade in the cast shadow and label it.

## Adding Body Lights

First, let's focus on the general light. Since the top of the cube is still facing the light source coming from above, it will remain light. Label it "L." As with the other cube, there is no highlight, so we don't need to worry about adding one.

Next, let's look at the reflected light. The bottom portion of the shadow side will be a little lighter, showing the influence of reflected light from the table. Label the reflected light "R/L."

## Distinguishing Body Shadows

First, let's focus on the halftone. The right side of the cube is turning away from the light so it will be halftone. Fill it in light gray and label it "H/T."

Next, let's look at the shadows. As with the first cube, there is no core of shadow, so we only need to focus on the shadow. The left side of the cube is opposite the source of light, so it will be in full shadow. Fill it in with a darker gray, blending into the reflected light at the bottom.

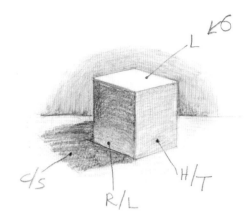

*The same cube with backlighting*

# DRAWING A CYLINDER

A cylinder combines a rounded side with a flat top. To make your cylinder, follow the instructions that accompany the illustrations below and then add a line for the tabletop. Put an arrow for the source of light above and to the left, and make the cast shadow extend away from the light to the edge of the table.

Add tone to your drawing and define the background and table. Fill in the wall area with a middle gray tone, and the tabletop with a lighter gray.

## Adding the Body Lights

Because a cylinder has a flat plane on its top like a cube and is rounded on its sides like a sphere, the light will fall differently on these two areas.

### GENERAL LIGHT

Since the top flat part and the left curved side both face the light, you will have the same situation you had in the first cube where two light planes are coming together. Add a smudge of tone down the side of the edge to define it (indicated by the asterisk on the next page).

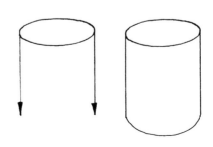

*To make a cylinder, draw an ellipse and then two lines (FAR LEFT). Connect the sides with a rounded line (LEFT).*

### HIGHLIGHT

If the cylinder was shiny, you would find a high-light on the top edge going down the side. (We will paint this highlight in Lesson Four.)

### REFLECTED LIGHT

The outer right edge of the cylinder's shadow will be slightly lighter to show reflected light. Put the reflected light in with a light gray tone. Make sure the tone of the wall is dark enough so that the reflected light is visible.

## Distinguishing Body Shadows

Start the halftone where you judge the cylinder is beginning to turn away from the light, and then continue getting darker to the core. Label all of the parts of light and shadow.

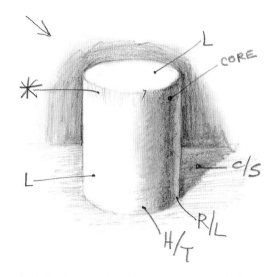

*The shaded cylinder with table, cast shadow, and labels. The asterisk indicates the spot where you need to create tone in order to avoid losing an edge.*

# DRAWING A HOLLOW CYLINDER

It won't be necessary to include a tabletop or cast shadow for this exercise, so draw an enlargement of the top portion of the cylinder only. Add a smaller ellipse inside the first one so that the walls of the cylinder appear to have some thickness. Shade the exterior of this cylinder exactly as you shaded the first cylinder. Leave the center of the top empty.

## Identifying the Light Source

Put in the same source of light as you did for the first cylinder. Now imagine the light coming from above left and hitting the inside of the cylinder. What part of the inside of the cylinder do you think would receive the most light? The light strikes the inside *right* part of the cylinder, making that the lightest area. The shadows on the inside, in other words, are directly opposite what they are on the outside.

## Defining the Interior Shading

Inside the cylinder, going from *right to left*, put in halftone and then gradually increase the shadows toward the left (no reflected light). Now your cylinder should look convincingly hollow.

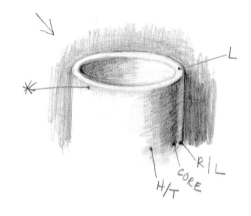

*A hollow cylinder. Notice the reverse lighting on the inside.*

## TAKING IT FURTHER

An optional but fun exercise is to do a tonal study of two white eggs on a white napkin. This is called a white-on-white exercise and will challenge you to let go of outlines. Place two eggs on a napkin. Arrange some folds. Use a constant source of light such as a table lamp. Remember to do your initial drawing *very* lightly. This is an exercise in close observation, so draw and sketch only what you actually see—not what you expect to be there. There will be several places where you will lose edges; if you don't see the edge at any point, don't put it in. You will see many reflected lights and changes of tone on the eggs; don't think that because eggs are supposed to be white, they always look white.

## LOOKING AHEAD

This lesson has shown you how lights and shadows follow and define forms. The simple geometric shapes that you have been drawing are the basic ingredients for more complicated shapes. For instance, trees, vases, arms, and legs are cylinders; houses and other buildings are cubes; and many fruits and certain shapes on people (such as the skull and eyeball) are basically spheres. We will be building upon these important skills in all of the other lessons in the book, as you can see from Alvina Balog's painting below.

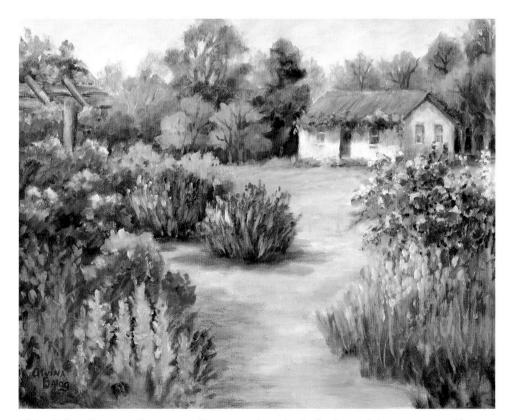

*Alvina Balog,* Cottage, *oil on canvas. You can see how closely the shape of the cottage resembles a cube; the front is in the light (except for the cast shadow from the eaves) and the side is in halftone. Alvina has also successfully dealt with the color changes that occur as objects recede into the distance.*

# LESSON TWO
# Making Your Brush Behave

THE FIRST THING you need to learn in painting is how to control your materials so that they do what you want them to do. This lesson will show you how to manipulate your brushes and paint to get a variety of different effects. The project for the lesson will be a series of exercises in brushstroke technique—ranging from basic advice on how to load your brush to methods of blending color and creating a variety of textures. You will also learn the trick to getting a fine line (some artists find the hardest part of making a painting is signing their name), and how to set up your painting area, mix your medium, care for your brushes, save your paint, and clean up when you're done.

---

## BEFORE YOU START

### When do I use medium and the palette knife?

Before you get out your supplies and prepare to paint, let's discuss how to use medium and the palette knife—because you will be using both in the following exercises.

When do you use medium? The answer is: whenever the paint doesn't come off your paintbrush easily. Most of the time, the paint will come out of the tube in the perfect consistency to paint. Occasionally it will be too stiff, and you will need to dip your brush into medium so that the paint will spread easily. Add medium whenever you feel that the paint needs to be moistened, but remember that you are not using watercolor. Don't thin the paint so much it becomes pale and watery-looking unless you specifically want that effect. In general usage, oil paint should look solid and cover the canvas. There are times when you want to apply the paint in a thin, transparent film. Paint thinned with enough medium so that it is transparent is called a "glaze." (Glazing is discussed more on pages 35 and 96.)

Painters use palette knives to spread paint the same way bricklayers use trowels to spread mortar, or cake decorators use spatulas to spread frosting. In other words, the paint is always picked up on the *bottom* of the blade, and is applied the same way. Keep your knife clean so that it spreads the paint smoothly.

*Always apply paint with the bottom of the palette knife, never the top.*

# GETTING YOUR SUPPLIES READY

Take a few minutes before each painting session to prepare your materials so that they are ready to go, in good condition, and efficiently arranged. Taking the time to get everything organized will pay off in a more productive session—and will allow you to more fully experience the *pleasure* of painting.

## Painting Mediums and Cleaners

Get out the ingredients for mixing your medium (linseed oil and odorless mineral spirits or turpentine substitute such as odorless Turpenoid) and a small glass jar with a lid (such as a jam jar). Use a piece of masking tape to make a mark halfway up the jar. Fill the jar halfway with linseed oil and the rest of the way with the mineral spirits or turpentine substitute. Tip the jar back and forth without shaking to mix. Label the jar "medium." If you are using water-mixable oil paints, you can skip this step.

Get out the two small, wide-mouthed containers from your supplies. Mark one "M" for medium, the other "C" for cleaner. Pour about two tablespoons of medium into the container marked "M." If you are using water-mixable oils, put about two tablespoons of water-mixable linseed oil medium into the container. Pour about ½

*If paint comes out of the tube with extra oil, use your palette knife to place it on a paper towel. The towel will absorb the excess oil and then you can transfer the paint to your palette.*

inch of Turpenoid Natural into the container marked "C." If you're using water-mixable oils, fill a large container with water.

## Paint

Get out the colors listed for the project you will be doing. Put the paint at the edges of your palette, leaving some space between each color and maximum space in the middle for mixing. Immediately replace the caps on your paint so they don't get lost.

## Palette and Canvas

You can either use a purchased paper palette or you can cover your 12 x 16-inch cardboard with freezer paper, shiny side up, and secure it with masking tape. Place your canvas on your easel.

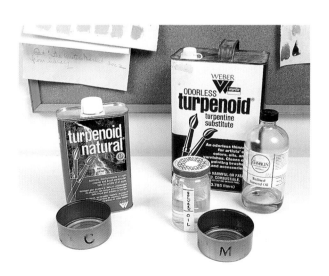

*Supplies for medium and brush cleaning (LEFT) and a good arrangement for your painting area (ABOVE)*

# ARRANGING YOUR PAINTING AREA

Over the years I have noticed that beginning artists often struggle with how to set up their working space, so I have put together some suggestions for how to efficiently organize your painting area. They will help you avoid putting strain on your arms and back, and will help prevent unwanted paint from getting on you and your painting.

It would be ideal to have a designated area for painting, but space is at a premium for many artists and art students. A tabletop easel is easy to put away when you are finished painting, and Turpenoid Natural has none of the strong fumes associated with traditional solvents, so you should be able to set up your painting area almost anywhere—a garage, patio, or even a corner of the kitchen table.

If you are working with a tabletop easel, place it right in front of you with nothing in front of it. The area immediately in front of your easel is for resting your arm, which will give you precise control while painting. Don't put anything—even temporarily—that involves wet paint in this space. Many students put their palettes right in front of their easel, making it necessary to reach over the palette to get to the painting. This is not a good idea—and often leads to unintentionally decorated stomachs.

Select a chair, or adjust the chair you have, so that you can reach your painting without strain. You may want to use a cushion. Place your palette either to the left or right of the easel, nearest to your painting hand, and keep the medium and cleaner nearby (perhaps behind the palette). Put the large containers of your medium ingredients and brush cleaner out of the way.

Paper towels or rags can be kept near your nonpainting hand. Some artists like to tear off many sheets of paper towels and make a time-saving stack, and then keep one in their nonpainting hand for quick wipes. A garbage bag or receptacle should be nearby. It is also a good idea to keep a small coffee can or jar nearby to hold brushes (handles down, of course), when they're not in use.

*Never lay your brushes on your palette. They will always roll into the paint and you will end up getting paint on everything.*

---

## GETTING IT RIGHT

### How thick should the paint be?

Paint can be applied in numerous ways, from very thin to impasto. Here are a few of the more common techniques.

**VERY THIN:** The paint is thinned with medium. This type of paint layer is used for underpainting, glazing, and making fine lines.

**SOLID BUT SMOOTH COVERAGE:** The paint covers the canvas solidly, but does not rise above the surface of the canvas. This is a good method to use when you are going to paint over the layer while it is still wet. It is also used in superrealistic styles where no brushwork is visible.

**VISIBLE BRUSHSTROKES:** A perceptible layer of paint rises above the surface of the canvas. This style of application features visible brushstrokes and is favored by many artists.

**IMPASTO:** The paint layer is built up in thick ridges. Care must be taken in using this kind of application because of the danger of cracking.

# Exploring Different Methods of Applying Paint

You will need the following:

**PAINT**: Burnt Umber, Yellow Ochre, white, and any yellow, red, and blue

**OTHER SUPPLIES**: Two sheets of practice canvas. For all of the painting exercises in this book you will need your brushes, medium, cleaner, paper towels, palette knife, and palette; in the future we will simply refer to these items as "all basic painting supplies."

**TIME**: About 2½–3 hours

## LOADING THE BRUSH

Before you start to use any brush,* you should season it by dipping it in medium. This coats the bristles of the brush and makes it easier to clean. Be sure to wipe the brush dry (and never pull on the bristles when you are drying them, as they may come out). This only needs to be done once at the beginning of every painting session.

Throughout this lesson you should paint with the width of the brush rather than the edge, unless directed otherwise. Load your brush with paint by pulling it from the *edge* of a daub of paint on your palette. Although it may be tempting, resist the urge to load your brush by dipping it directly into the middle of your paint daub. (It may seem as if I am going into needless detail, but countless times I've witnessed students take a brush full of blue, dip it into the center of their white paint, and then wonder later why they can't get clean color, so now I always mention this tip.) After you have dipped your brush in the paint, rub it gently from side to side on the palette to evenly distribute the paint across the edge of the brush.

*Except the hake brush and any other brushes that you want to use for blending; these should be used dry.

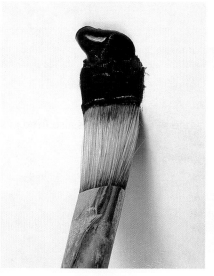

To load a brush, pull the paint from the edge of the daub on your palette.

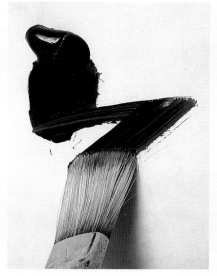

Swish the brush back and forth on the palette to evenly distribute the paint.

# MASTERING THE BASIC BRUSHSTROKES

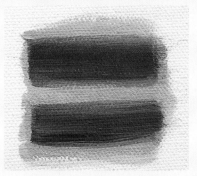

*A practice canvas with the finished brushstrokes* (FAR LEFT). *The flat stroke is used for realistic styles. The surface of the paint is smooth, without obvious brushstrokes* (LEFT).

Each of these exercises should be about two inches square unless otherwise specified. Start at the upper left of your canvas and go in a row to the right. If you keep the exercises in the same order as the instructions, it will be easy to refer back to them.

## Flat Stroke

The flat stroke is intended to create a very smooth surface, free of obvious brushstrokes. Artists who make ultrarealistic paintings favor this technique.

*1.* Season and load your #6 flat bristle brush with a color of your choice.

*2.* Use the wide side of the brush to cover a two-inch square of the canvas with a solid, smooth layer of paint.

*3.* Add stripes of other colors as desired, keeping the paint application flat and blending the strokes together. (Soft brushes, such as sable flats and filberts, which are not in our supplies, are ideal for this technique.)

## Edge-of-the-brush Stroke

Now turn the #6 brush so that you are painting with the edge of the brush. If your brush is constructed well, you will notice that it tapers to an edge when you view it from the side. See what kind of lines you get with the edge of your brush. Newer brushes, of course, will create sharper edges than older brushes, and sables or synthetic sables will give sharper edges than bristle brushes. Try this exercise with your angled shader brush, too.

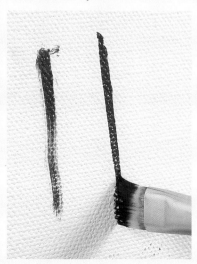

*The edge of your brush can be used to create lines. The first example shows a line made with a #6 flat bristle brush; the second was done with an angled shader.*

## Impasto

A thick application of paint is called "impasto." The thickness of the paint makes it almost sculptural. Vincent van Gogh used an impasto technique to great effect.

1. Put a lot of paint on a seasoned #2 flat bristle brush and paint in thick, short strokes. The paint should stand up in ridges.

2. Add other colors as desired, placing the strokes side by side without blending. The strokes should look sharp and distinct.

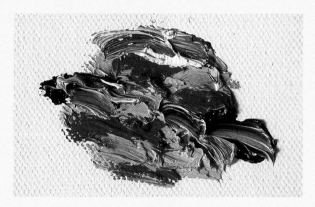

*Impasto is thick paint that stands out from the surface of your canvas.*

## Flip-flop Stroke

To create a flip-flop stroke, load paint on both sides of the brush.

1. Season and dip both sides of a #10 flat bristle brush in a light color of your choice.

2. Paint a short and straight diagonal stroke about ¾ inch long.

3. Turn your hand thumb up and draw a stroke at a right angle to the first stroke.

Continue doing this until you have a three-inch square filled with diagonal strokes going in both directions. This stroke is widely used for backgrounds and to suggest woven surfaces. It can also be used in sweeping horizontal or vertical strokes when you want to rapidly fill a large area with color.

Clean your brush and load both sides with a darker color. Choose one section of your exercise and, using the same stroke, paint the darker color into the lighter one. You can then wipe your brush and go back to the first color and overlap the second if you wish. If you just make a few strokes, you will have very obvious chips of light and dark color; the more you go over it, the more blended it will get. Neither effect is better than the other; they're just different.

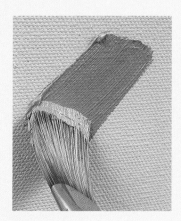

*To make a flip-flop stroke, paint a straight diagonal stroke about ¾ inch long.*

*Turn your hand and stroke your brush in the opposite direction.*

*The finished flip-flop stroke*

## Stipple or "Pounce" Technique

This stroke is useful for distant grasses and for textures in wood or shells. For this exercise, you can use any large, stiff brush, such as your #10 flat bristle or utility brush. Try the bristle brush first, then the utility brush.

1. Plunge the brush head down directly into the center of a daub of dark paint and pull it straight up without disturbing the thick paint on the brush. Tap it a few times on the palette to remove excess paint.

2. To apply the paint, tap the head of the brush straight down onto the canvas and pick it straight up without stroking. Continue doing this until the brush runs out of paint.

You are actually printing with the top of the brush, and each brush will give you a different imprint. Notice that you get different effects as your brush runs out of paint.

*To load the brush for stippling or pouncing, plunge the brush into a daub of paint and pull it back.*

*Then tap the head of the brush onto the canvas. Continue tapping until the paint is gone.*

## Dry Brush

Most color blending is done while both colors are wet, but when you want to change or add a color after the paint on your canvas has dried, you can use the dry brush technique. New color can be rubbed over older, dried paint to create a number of interesting effects. When done lightly, dry brush has a scratchy appearance that works well to suggest the texture of weathered wood. It can also be used to blend one color over another, to add more light, to add a subtle overlay of contrasting color for added interest in a painting, or to soften an edge.

When you use the dry brush technique in your paintings, you will work on a dry, painted surface, and use a dry (not seasoned) brush. For this exercise, we will practice this technique directly on the bare canvas, and use a brush that was seasoned during a previous exercise.

1. Instead of holding your #10 flat bristle brush as you would a pencil, pick it up using four fingers on one side of the brush and your thumb on the other. This is called an "overhand grip." It is often used when you want to gently lay a color on the surface, or to lay one color on top of another without digging into a layer of wet paint.

2. Pull out a small amount of Burnt Umber, loading the whole side of the brush.

3. Rub the side of the brush on the palette to remove most of the paint. When the brush is almost dry, lightly rub the side of the brush on the canvas. The paint will catch on the surface weave of the canvas, allowing the color of the canvas to show through.

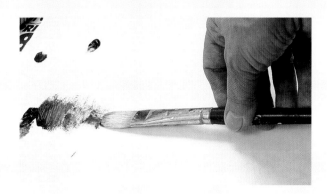

*When employing the dry brush technique, make sure to use an overhand grip and drag the paint out of the daub.*

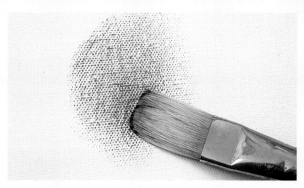

*When applying the paint, hold the brush so that the broad side is level with the canvas.*

## Scumbling

Scumbling is similar to dry brush in that it involves dragging a fresh color on top of a dry layer of paint in such a way that part of the dry under layer shows through. The difference is that when scumbling you use more paint on the brush. Either a regular or an overhand grip can be used. This technique is useful in highlighting heavy impasto and textured surfaces and also in making a color more interesting.

As with the dry brush exercise, we will practice this technique directly on the bare canvas. Of course, when you use scumbling on your paintings after this exercise, you will work on a dry, painted surface.

1. Load the side of your #10 flat bristle brush with thick paint.

2. Using an overhand grip, very lightly drag the brush over the surface of the canvas. The paint should skip parts of the canvas, allowing irregular sections of bare canvas to show through.

To try scumbling over another color, paint an area of Burnt Umber on your canvas. Burnt Umber dries very quickly, and you can come back in a day or so and scumble a lighter color on top of this base.

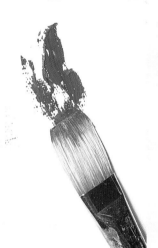

*When scumbling, drag the paint over the surface, but allow the under layer to show through.*

*Scumbling is frequently done over a textured underpainting. Here we see a light color dragged over a prepared underpainting. The thick scumble catches on the ridges of the paint and highlights the texture. See also the example on page 39.*

# Lines

Many students have difficulty making fine lines because they get accustomed to the thickness of paint that you ordinarily use to paint everything else; this thickness will not work to create a fine line. Making a line is really very easy if you can learn these three tricks: First use a brush that comes to a fine point. Second dilute the paint so that it resembles ink in consistency. Third paint with just the tip of the brush. Let's start by painting a continuous fine line.

1. Put a puddle of medium next to the Burnt Umber on your palette.

2. Using your pointed brush, pull out a little umber and mix it into the medium until it resembles ink in consistency.

3. Load the brush fully with the diluted paint and stroke the brush tip on the palette to reshape the tip.

4. Instead of holding the brush as you would a pencil, hold it so that it is at a right angle to the canvas and only the tip touches the surface.

5. Using only the very tip of the brush, make one continuous, curling line (like an explosion in a spaghetti factory). In order to keep the line very fine, you must keep the pressure light and even. Rest your arm on the table, or otherwise support it to help keep a controlled pressure on the brush. You may find it easier to lay your canvas flat rather than keep it on your easel.

6. Write your name in script.

Remember that fine, *straight* lines can also be made with the edge of an angled shader or other sharp-edged flat brush. Now let's try making two different kinds of varied lines, going from thin to thick (or vice versa).

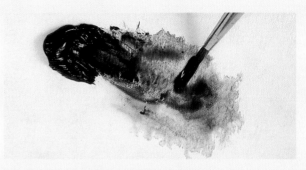

To make a fine line, first thin the paint with medium to the consistency of ink.

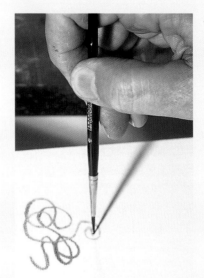

Allowing just the tip of the brush to touch the canvas, apply a light, even pressure and paint a fine, continuous line.

1. Reload your brush and paint a long, continuous line (like a shoelace), changing the pressure from light to hard to light, and so on, without lifting the brush from the canvas. Notice that more pressure increases the width of the line.

2. Now hold your brush midway on the handle. Make a series of vertical strokes, applying more pressure to your brush at the bottom of the stroke and then releasing the pressure as the stroke goes up. Make a row of these strokes, working quickly so that the spacing looks natural. Lean some of the strokes one way, some another, and overlap the strokes so that the row looks like grass.

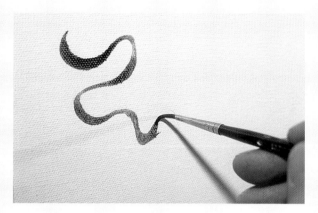

*To make a line that varies in thickness from thin to thick, vary the pressure on your brush.*

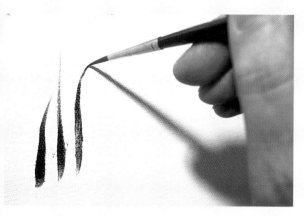

*Here the thick-to-thin line is used to paint grass.*

Now let's try making a thin, light line. This is a bit trickier than the other lines. The color can't be thinned too much or it won't show up, but if it is painted heavily, it will be thick and uneven. The solution is to paint the line thickly (on wet or dry paint), and then use a clean brush with a sharp edge (like an angled shader) to cut it down to size. If the underlying paint is dry, dampen the clean brush *slightly* with medium.

1. Paint a patch of dark color solidly, but not too thickly.

2. Load your pointed brush with white paint mixed with a little medium so that the paint comes off the brush. (Do *not* thin the paint to the consistency of ink as in the previous exercises.) Paint a white line on the darker color. Do not be concerned with the thickness or unevenness of the line.

3. Using the angled shader, cut down your line so that it is thin and even.

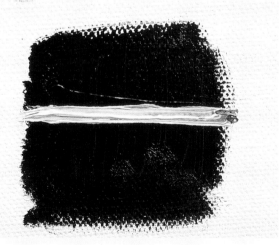

*Painting a fine line in a light color can be a challenge. Here is how it's done: First paint the line any way you are able. In this example the line is painted into wet paint.*

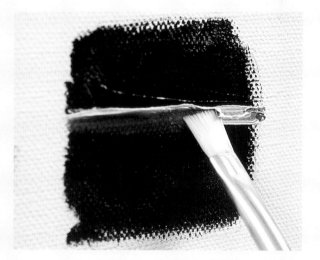

*Next cut the line down with a sharp-edged brush, such as the angled shader shown here.*

# Hake Brush Technique

The hake brush is a very soft brush made for blending. Its special value lies in the fact that it melts colors together without smearing them (unless the colors are painted very thickly). It is never seasoned, because blending is best done with a dry brush.

Hake brushes can be used in many different situations. They can soften leaves in background trees, throwing them slightly out of focus and increasing the sense of depth; they can make spots on an apple or a fish melt into and become part of the surface rather than looking as though they're standing out from the surface; and they are good for making reflections in the water look slightly blurred. Because most hake brushes are wide, use just the corner if you're working on a small area.

1. Using any brush, paint a yellow square on your canvas.

2. Clean the brush and then use it to add red spots to the yellow square.

3. Hold the hake brush with four fingers on one side of the brush (near the bristles), and your thumb on the other, with the handle angled up between the thumb and forefinger.

4. Keeping your arm stationary, use wrist action to whisk the brush very gently back and forth over your colors until they melt together. If the brush starts to pick up too much paint, wipe it on a paper towel.

# Sgraffito

Sgraffito means, roughly, "scratched in." It refers to the process of scratching through one layer of paint to expose the layer underneath. Fine lines can be added in this manner, sometimes more easily than by painting them.

1. Use a #10 flat bristle brush to apply a thin but solid layer of Burnt Umber paint in a 1½-inch square. Push the paint into the weave of the canvas so that there is no perceptible thickness of paint on the surface.

2. Use a palette knife to gently place a smooth "frosting" of Yellow Ochre paint over the wet Burnt Umber square.

3. Using the most pointed brush handle you have, scratch a design through the Yellow Ochre, exposing the Burnt Umber.

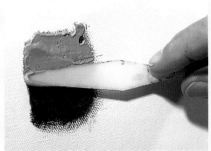

*The sgraffito (scratching) technique involves applying two layers of paint, one on top of another.*

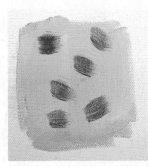

*The hake brush is a useful tool for throwing things out of focus and for blending. Here is the unblended paint.*

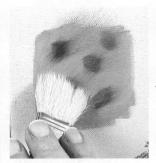

*The hake brush is gently whisked back and forth over the paint so that the colors get slightly blurred.*

*Then a pointed object (such as this brush handle) is used to scratch through the top layer, exposing the layer underneath.*

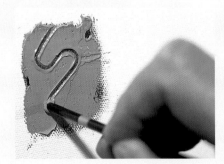

# CREATING TRANSITIONS BETWEEN COLORS

There are many times when you need to blend one color into another. If the surface texture of the object you're painting is smooth, the colors should blend imperceptibly, with no edges to the tones. If the surface texture is bumpy, the color change needs to reflect the bumpy texture.

## Making a Smooth Blend

Let's practice making a gradual transition from one color into another on a smooth surface.

**1.** Use the full width of a #10 flat bristle brush to paint a two-inch-long stripe of any color. Clean the brush.

**2.** Next to the first color and touching it, paint a stripe in another color.

**3.** Wipe your brush dry and place it at the top of the double stripe, half on one color, and half on the other. Stroke down several times until the colors blend together.

 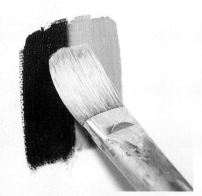 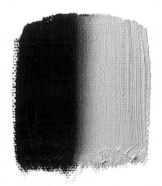

*To blend one color into another on a smooth surface, first paint two stripes touching each other.*

*Then place your brush across the two colors and stroke down. Repeat as necessary.*

*The smoothly blended transition*

## Creating a Bumpy Texture

In the exercise for the flip-flop stroke, you practiced changing the color on a woven texture. Now let's practice making bumpy textures.

**1.** Using just the corner of your #2 flat bristle brush, paint small daubs of any color solidly in a 2 x 1-inch column.

**2.** Clean your brush. Leave a ¼-inch space and make a second column in a different color.

**3.** Fill the middle ¼ inch with dabs of each color. Keep the colors separate as much as possible.

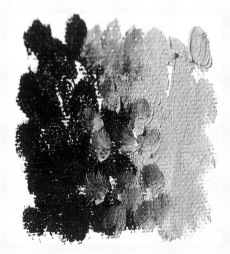

*To blend one color into another with a bumpy texture, use small, dabbing strokes that interlace in the middle.*

# EXPERIMENTING WITH PRINTING TECHNIQUES

Sometimes it is helpful to use something other than a brush to paint a texture. Anything that has a rough surface can be used to transfer paint to canvas. Before you begin this experiment, gather some materials such as paper doilies, burlap, corrugated cardboard (with the corrugation exposed), paper towels (the cheaper and harder the better), or anything else you can think of that has an interesting surface.

1. Use an overhand grip to load a smooth layer of paint on the side of your #10 brush.

2. Rub the paint over the surface of the material, trying to get paint only on the bumps of the surface texture.

3. Place the painted surface face down on the canvas, hold it securely in place (if it moves, your texture will smear), and rub the back of your thumbnail over it to transfer the color. (If you are using a doily, put a piece of paper over the doily and then rub.)

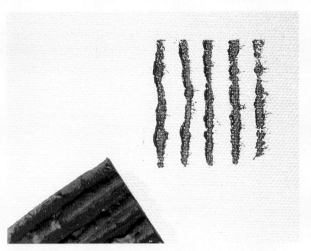

Many objects can be used to print a texture on your canvas. Here corrugated cardboard was peeled to expose the ridges. Then paint was applied to the ridges and they were pressed onto the canvas. Lots of other objects can be used as well. Here are the imprints made with a natural sponge (BELOW, LEFT), a crumpled newspaper (BELOW, CENTER), and the textured surface of a paper towel (BELOW, RIGHT).

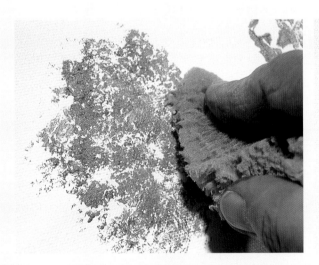

# USING WET TECHNIQUES

Wet techniques involve using paint that has been thinned with medium so that it resembles watercolor. The paint will run, so use a fresh canvas and lay it flat for the following exercises. Two of the most common wet techniques are glazing and spattering.

## Glazing

A glaze is a transparent layer of oil paint. It is created by mixing paint with lots of medium to the point where the paint becomes transparent. If the desired color is light, the color is thinned with more medium instead of adding white paint. (White paint would make the glaze cloudy.) Glazes are used to create the following visual effects:

- to tone down a color that is too garish
- to darken a color
- to enhance a color (make it brighter)
- to add depth and interest to areas of a painting that look "chalky"
- to add transparency and depth to water
- to enhance the texture of an underpainting

There are three things to remember when using a glaze. First, glazes must be painted over dry areas of color (solidly dry to the touch, not sticky). Second, always glaze darker colors over lighter ones or you will get a haze. Third, use a soft brush and a light touch when applying the glaze; don't rub back and forth over the surface or the under layer might start to dissolve.

The medium you choose for your glaze is very important. Avoid prepared fast-drying glazing mediums unless you fully understand how to use them. Many of these mediums require that a painting has been drying at least six months before they are used. (A standing rule in oil painting is never to put something fast drying over something slow drying because of the danger of cracking.) Most artists will want to proceed with the painting long before then. I recommend that you use your regular medium so that the drying time of all the layers of your painting is uniform. Glazing is discussed further on page 95 and 96.

## Spattering

Spattering is often used by landscape painters to give the impression of seed heads in wild grasses. It also gives spotted texture to a piece of fruit, to a beach, or even to a macadam parking lot. (See painting on page 37.)

1. Using paper towels, mask the areas of your painting that you do not want to be affected by the spattering.

2. Pour a small puddle of medium near your Burnt Umber.

3. Use a large brush with stiff bristles to mix a little paint into the medium; your #10 flat bristle brush (or even an old toothbrush) would work.

4. Load the brush with a lot of the paint/medium mixture.

5. Point the brush to the place on the canvas that you want to spatter and run a finger or a palette knife across the bristles.

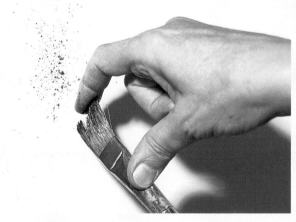

*When spattering, make sure to point the brush precisely where you want the spatter.*

You can also use directional spatter to wonderful effect. A directional spatter is more gestural and bold than a regular spatter and is best done with big mop of a brush—something that will hold a lot of thinned-down paint. The brush is snapped in the direction you want the spatter to travel. This causes a spatter with a directional movement, which is useful in painting the spray of crashing waves. Obviously, care must be taken to keep the spatter confined to the canvas—and to the right place on the canvas. Confine the action to a snap of the wrist, rather than flinging with your whole arm. Make sure to practice this technique until you are confident that you can control the spatter before trying it on a painting. And once you're ready, block off areas of the painting that you don't want spattered with newspaper to protect them.

Another variation is to spatter paint thinner (either odorless Turpenoid or mineral spirits) instead of paint into a glaze and then lift out individual elements or areas. This technique gives very interesting effects when the glaze is done over a contrasting color, which is then revealed when the liquid makes holes in the glaze. Generally glazes are applied on top of painted surfaces; however, for this exercise you will glaze directly on the canvas.

1. Paint a three-inch square with a blue glaze. The surface should be damp, but not runny.

2. Load a large brush with paint thinner.

3. Spatter the liquid into the blue glaze. If this is done correctly, you will have a starry sky.

4. To lift out, simply dampen your pointed brush with medium and erase lines to make a tree against the starry sky.

This concludes your experiments in brush technique. Clean up instructions follow on page 38.

*Here a layer of wet paint has been spattered into with paint thinner. This technique can also be used over a thoroughly dry underpainted color.*

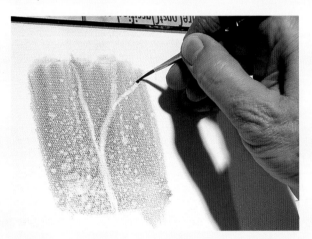

*A clean brush dampened with medium is used to lift out the paint.*

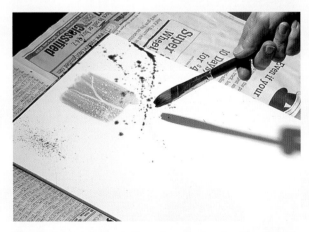

*The directional spatter is flung from the brush with a flick of the wrist. It is perfect for representing the spindrift of a wave, but be careful not to get paint all over.*

*Lynne Hutchison,* Time Out, *oil on canvas. Lynne effectively used the spattering technique to show the spotted texture of this macadam parking lot.*

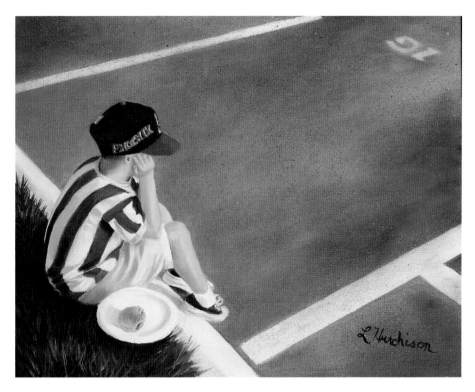

*Kathleen Lochen Staiger,* Autumn, *oil on canvas. I created this painting by applying multiple glazes over an abstract underpainting. Then I spattered and dripped paint thinner to create certain effects; some of the leaves were glazed on and some were lifted out to reveal the underlying color.*

# CLEANING UP

At the end of each of our lessons, follow these simple instructions for cleaning up:

1. If your medium looks clean, pour it back into the medium bottle. Wipe out the can and save it for next time. If your medium looks dirty, pour it in the garbage.

2. Wipe the paint from all your brushes and rinse them thoroughly in the brush cleaner (Turpenoid Natural). Press the bristles *gently* against the bottom of the can and then stroke back and forth to let the cleaner reach the inside of each brush. Set them aside to be washed.

3. Remove the palette paper from your palette and throw it in the garbage. (If you have paint that could be reused, see Saving Paint on the following page.)

4. Pour your dirty brush cleaner in the garbage and rinse the can in water. Wipe it dry and save it for next time.

5. Clean your brushes in mild soap and lukewarm water. Work up suds in each brush by moving it in a circular motion in the palm of your hand. Use your thumbnail or a stiff brush to spread the bristles apart to reach into the center and to scrape any remaining paint from the brush. Rinse, squeeze out excess water, and reshape the brush.

6. Store your brushes handles-down in a coffee can, or lay them flat to dry. Your brushes are vulnerable when wet. Do not store them in a box where they might shift, allowing the bristles to press against the inside of the box and get bent. Avoid devices that roll the brushes inside a carrier; these will also bend the edges of the bristles. Take care of your brushes and they will last you a lifetime.

7. Wash your hands with ordinary soap and water to clean them. If you have paint under your nails that won't come off with soap and water, use brush cleaner.

8. Paint on your clothes can easily be removed with a prompt application of brush cleaner and, if necessary, a shot of fabric stain remover before they are put in the wash. Remember that Turpenoid Natural is nontoxic and water soluble; you can put stained clothes in the washing machine with a regular load.

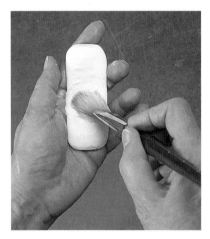

*To clean your brush, first swish it in Turpenoid Natural to get most of the paint out; then gently rub it on a bar of hand soap.*

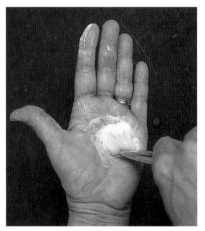

*Swirl the brush on the palm of your hand to get the suds up into the bristles.*

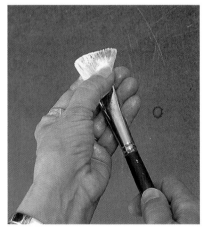

*Use your thumbnail to gently spread the bristles and force the paint out of the interior of the brush.*

# SAVING PAINT

It's good to be frugal—within reason. You can try to save moist paint by covering the palette with a very dense plastic wrap, such as Saran Wrap, but it doesn't work very well. If you must save the paint, transfer the usable paint onto a smaller piece of palette paper, put that into a covered container, and freeze it. Alternatively, you could put it in a plastic tray (such as those that small frozen foods come in), slide that into a plastic freezer bag, and put it in the freezer. Special mixtures can be frozen in plastic film canisters.

If you decide to try to save the whole palette, cover it with plastic wrap (but *don't* freeze it). When you are ready to paint again take a *fresh* piece of palette paper and transfer any usable paint. You will be surprised at how little paint remains usable. It is best not to use paint that has started to harden because the bonding action between the paint and the canvas occurs during the drying process, and if that process has started, you are losing some of the strength of your paint layer.

Please don't ever start a painting session with a palette filled with dried and drying paint. It is frustrating to jab at a dried-up daub of paint when you are in the middle of an inspiration.

You can get unsoiled paint back into tubes that are not full. Use your palette knife to pile a little paint in the tube opening, and then rap the bottom of the tube on a table. (Don't pound it or the paint will end up on your ceiling.) You can also create a vacuum that will suck the paint back into the tube by holding the tube near the metal collar with one hand, and at the bottom with the other hand, and then pulling apart with a twisting motion. Personally, I would only go through this for the more expensive colors.

Now that you have learned how to handle the tools and materials of painting, let's move on to the very important lesson on color mixing.

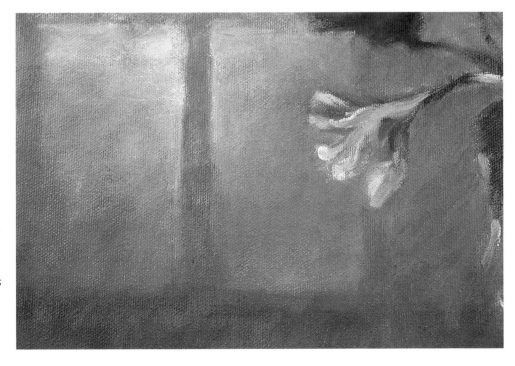

*Kathleen Lochen Staiger,* Still Life with Peaches *(detail), oil on canvas. I used dry brush and scumbling techniques to bring out the light coming through the windows and to add interest on the wall. The full painting appears on page 101.*

# Getting the Colors You Want

Wouldn't it be great if you could pick up your brush and mix any color you wanted, knowing exactly what colors to use instead of trying one after the other and ending up with mud? This chapter will make the whole process a lot easier by presenting a foolproof system of color mixing. You will learn how to create bright colors and learn how to make these colors soft and grayed. You will find out which colors of paint are used to darken light colors, and how to change colors to make shadows. Once you have learned this easy method, you will never again be stumped for the right color.

We will start by going over the basics of color, and yes, we will be talking about the color wheel. But before you decide that this is all "old news," take a look at the expanded color wheel on page 44 and see how it differs from what you may have learned about color wheels. (Notice the extra circles of color at each of the three primaries, for instance.) Even if you are an experienced painter, you will probably find some fresh answers to your painting problems in this chapter. The projects in this lesson consist of exercises in color mixing. Actually doing these exercises will reward you with a thorough knowledge of how color works.

## THE ELEMENTS OF COLOR

Color can be described in terms of three basic characteristics: hue, value, and chroma. Hue refers to the basic nature of the color—whether it is red or blue or green. The word "hue" is sometimes used interchangeably with "color." All of the varieties of a hue—dark and light, warm and cool, dull and bright—make up a color "family." For example, all reds—from pink to maroon, from fiery red to wine red—are part of the color family of red. Value refers to the quality of being dark or light. Chroma refers to the comparative brightness or dullness (grayness) of the color. Both value and chroma will be discussed in detail later in this chapter. For the time being let's focus on hue.

*This little abstract shows the many variations in the color family of red.*

## Primary Colors and the Split-Primary System

There are three primary hues: red, yellow, and blue. These hues are called primaries because they (along with black and white) are the basis for mixing all the rest of the colors, and because they cannot themselves be mixed from any other colors.

Have you ever seen a color wheel in which the purple was dull and muddy-looking? That happens when an artist uses the same red to make purple as she does to make orange. A better way is to have two variations of each of the primaries, one tending more to the cool side and the other a little warmer; the two combined make a neutral color. By having two versions each of red, yellow, and blue, you can choose the primary that will work better to create the color you want—a cool rose red to make purple and a warm orangey red to make orange, for example. This is called the "split-primary system" and it enables artists to achieve brilliant mixtures of every color on the color wheel.

Take out and organize the warm and cool versions of your three primary hues:

| | WARM SPLIT PRIMARY | COOL SPLIT PRIMARY |
|---|---|---|
| YELLOW: | CADMIUM YELLOW MEDIUM | LEMON YELLOW HUE |
| RED: | CADMIUM RED HUE | PERMANENT ROSE |
| BLUE: | THALO BLUE | FRENCH ULTRAMARINE BLUE* |

*There is divided opinion among artists and teachers whether French Ultramarine blue (or Ultramarine Blue, if you're using a brand other than Winton or Academy) is warm or cool. I consider it to be cool.

## Neutral Primaries

While split primaries are warm or cool variations of a primary, a neutral primary is one that is balanced between warm and cool. These are the colors we think of as "true" red, yellow, and blue, or the "color-wheel colors." Color-wheel or neutral primaries are not necessarily created by mixing equal parts of each split primary. To mix neutral blue, for instance, you will find that French Ultramarine blue is very close to the color you want, and only needs a small amount of the powerful Thalo Blue to neutralize it.

I have found that a lot of students have trouble getting the proportions right in mixing the color-wheel colors, so I use children's crayons to help judge the colors. Buy a small box and take out red, yellow, blue, orange, green, and violet. Making color swatches with these crayons will help you get the correct mixtures for the exercises in this lesson. As soon as you finish these exercises it won't be important to create the color-wheel colors.

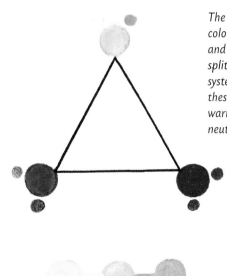

*The three primary colors (yellow, red, and blue). In the split-primary system each of these colors has a warm, cool, and neutral variation.*

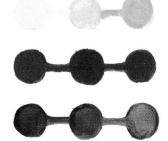

# SETTING UP YOUR PALETTE

Follow the palette diagram to set out your paint. Keep all paint daubs near the edge so that maximum space is left in the center for mixing. Leave spaces as indicated for mixing other colors. (When setting up your palette after the exercises in this lesson and Lesson Four, you won't need to mix the neutral colors on your palette or leave spaces between the split primaries for these mixtures.)

## Mixing the Neutral Primary Colors

To make your neutral primaries, it's best to start with a daub of the version of the primary that is closest to the color that you are trying to mix and then add the other split-primary color a little at a time. If you use up all of one of the palette colors while you're mixing your neutral primaries, squeeze out a little more so you still have all of the original colors.

## NEUTRAL YELLOW

In the space between the two yellows on your palette, place another daub of Lemon Yellow Hue. Add Cadmium Yellow Medium to it, a little at a time, until you have neutral yellow.

## NEUTRAL RED

Put an extra blob of Cadmium Red Hue in the space between the two reds and add Permanent Rose to get neutral red.

## NEUTRAL BLUE

Put an extra daub of French Ultramarine blue in the space between the two blues and add just a touch of the very strong Thalo Blue. Since the blues are quite dark, you will need to either brush them out thinly, or add just a bit of white to a small daub of the mixture to see what it looks like. (This method can be used to check any dark color.)

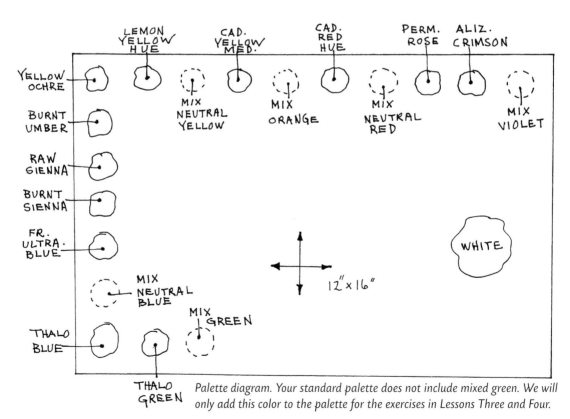

Palette diagram. Your standard palette does not include mixed green. We will only add this color to the palette for the exercises in Lessons Three and Four.

## Mixing the Secondary Colors

There are three secondary hues: orange, green, and violet. These hues are mixed from two primary hues. Look at the color wheel to the right to find the right split-primary partners to mix for maximum brilliance in your secondary colors.

Mix these secondary colors in the reserved spaces on your palette. Start with the lighter of the two colors in the mixture and gradually add the darker—*not* the other way around. Mix enough of each color to do all of the exercises. The three primaries (red, yellow, and blue) and the three secondary colors (orange, green, and violet) make up the six major color families.

### ORANGE

Use Cadmium Yellow Medium and Cadmium Red Hue to make orange. Start with Cadmium Yellow Medium and then add Cadmium Red Hue a little at a time.

### GREEN

Use Lemon Yellow Hue and Thalo Blue to make green. Put a blob of Lemon Yellow Hue next to Thalo Green at the bottom of your palette and gradually add Thalo Blue in very tiny amounts. Mixed green is shown on the palette to the left; however, on the standard palette setup it is mixed as needed in a variety of different combinations. See Mastering Greens on pages 113–115.

### VIOLET

Use French Ultramarine blue and Permanent Rose to make violet. Start with Permanent Rose and add French Ultramarine blue in the upper right corner of your palette. After thoroughly mixing the two colors, use your palette knife to scrape the mixture out thinly so that you can check the color.

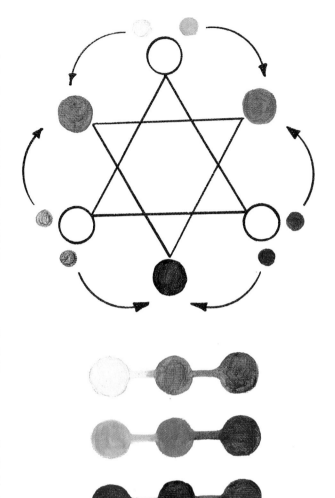

*Each of the three secondary colors is created by mixing the adjacent split-primary partners.*

*If you make a mistake in a color mixture and get too much of one of the colors, start fresh. It takes a lot of paint to make a difference in a wrong color.*

## The Tertiary Hues

The tertiary hues are simply colors formed by mixing a primary with the secondary nearest to it on the color wheel. For example, yellow and green make yellow-green. The tertiary hues are yellow-green, blue-green, blue-violet, red-violet, red-orange, and yellow-orange. When creating tertiary colors, use the split-primary closest to the secondary color instead of the neutral primary; this will give you brighter colors.

## Warm and Cool Color Families

When you look at the complete color wheel, you will notice that you can divide the wheel in half from yellow-green to red-violet, and that half of the wheel's colors look warm, reminding you of fire, while the other half of the colors on the wheel looks cool, reminding you of water. While we perceive warm and cool varieties within each color family, in the general sense we think of all reds, yellows, and oranges as warm and all blues, greens, and violets as cool. So while red is a warm color, within that general category there can be warmer and cooler variations of the general color red.

## Value and the Color Families

Value is the second element of color. It refers to the quality of being light or dark. Light colors are described as "high value" and dark colors as "low value." All colors have a full range of val-ues, going from almost white to almost black. The light values of a color are called "tints," and the dark values are called "shades."

In the case of the darker colors, such as blue and violet, it is easy to create a full range of values simply by adding gradually increasing amounts of white. However, it may be harder to understand that lighter colors, such as orange and yellow, also have a full range of values, from almost white to almost black. So how do you make a light color darker? You may think that it would be simply a matter of adding black, but this doesn't work out well. Black is a useful tool, but it is not a universal darkener. It will always dull a color as well as darkening it. In addition, black is not truly neutral but rather acts like a blue in color mixing. (Try mixing black with yellow and you will see that it makes green.) It is much better to learn how to darken colors with colors in the same family.

At the beginning of this lesson we talked about all the versions of a color that make up a color family. Let's meet the dark members of each color family, because these are what we are going to use to darken the lighter colors.

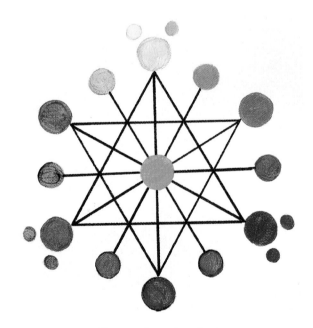

*The complete color wheel*

# The Dark Value Colors

Look at the colors on the palette on page 42. At the upper left side you will find the earth tones. These colors are actually combinations of red, yellow, and blue, but they can be used to darken some of the light colors. Three of the earth tones, Yellow Ochre, Burnt Umber, and Raw Sienna, are used as dark yellows. The fourth earth tone, Burnt Sienna, is used as a dark orange. Thalo Green and Alizarin Crimson are used to darken greens and reds respectively. The rest of the colors on your palette, such as blue and violet, are naturally dark and don't need further darkening.

### YELLOW OCHRE
As the name suggests, Yellow Ochre is mostly yellow, and it is the first color we use to make yellow a little darker.

### BURNT UMBER
If we want to make a yellow even darker, we can use Burnt Umber. However, Burnt Umber has a lot of color other than yellow in it, so when it is being used to darken yellow it is best to combine it with Yellow Ochre. You will notice that all the yellows are grouped together on the palette; this should help you remember that they are in the same family.

### RAW SIENNA
Raw Sienna is used as a dark, warm yellow. It is useful for darkening yellows that tend toward orange hues.

*Don't confuse Burnt Umber with Burnt Sienna. One of the first things you should do is memorize the names of your paint colors and be able to distinguish among them.*

### BURNT SIENNA
Burnt Sienna is used as a dark orange. Add it to bright colors in landscape paintings to soften them.

### ALIZARIN CRIMSON
This deep red is used to darken lighter reds. It should come out of the tube almost black.

### THALO GREEN
Thalo Green can be used to darken lighter greens, but is most often used as a base green and is mixed with a variety of different light colors. Because of its versatility, Thalo Green can be the only green on your palette. (More about this in Taming Thalo Green on page 114.)

*These are the paints we use to darken lighter colors. The darkening colors for yellows are Yellow Ochre and Burnt Umber; for warm yellows, Raw Sienna; for oranges, Burnt Sienna; for reds, Alizarin Crimson; and for greens, Thalo Green.*

# Exploring the Value Range of the Six Basic Colors

You will need the following:

**PAINT**: All thirteen colors that make up your standard palette

**OTHER SUPPLIES**: One 12 x 16-inch practice canvas and all basic painting supplies

**TIME**: About 1½–2 hours

In preparation for this project, mix generous daubs of each of the primary and secondary colors. This project will acquaint you with the pigments that serve as dark versions of our primary and secondary colors, and help you to remember them. You will create six bars of color, one for each of the basic color families. The left side of each bar will be almost white and then will gradually get darker, becoming almost black at the right side.

At some point in each bar, the pure color will appear as it is on the color wheel. If the color is naturally light (such as yellow), the pure color will appear closer to the "white" end of the color bar; if it is naturally dark (such as blue), it will appear closer to the "black" end of the bar. On the left the pure color will be mixed with white, and on the right the pure color will be mixed with darkening colors in its family.

## MAKING PRIMARY- AND SECONDARY-COLOR VALUE PROGRESSIONS

For each of these six exercises, use the neutral mixtures for the primary colors and hold the canvas vertically. Season your brushes and start near the top left corner. Make horizontal bars, one under the other, down the left side of the canvas. The rest of the canvas will be used for the next two exercises.

These exercises are simply to familiarize you with the tints each color makes when white is added, the shades that are made when darker colors are added, and which colors are used to darken the color-wheel hues. Don't make yourself crazy trying to get perfectly blended and even transitions. You will find it easier to add light and dark color to your bar if you use a vertical overlapping stroke, moving from left to right for the addition of white, and from right to left for the addition of the darker-value colors. If you find that you have gone too far with either light or dark, just load your brush with more of the main color and overlap back in the opposite direction.

### Yellow Value Progression

1. Using a #6 flat bristle brush, paint a bar of neutral yellow approximately ¾ inch wide and about four inches long. The paint should be thick enough so that you can see the grooves made by the bristles of your brush.

2. Add white to the left edge, blending it into the yellow. Since pure yellow is very close to white, only blend the white paint a little way into the yellow bar.

3. Now you are ready to add the darker yellows. Yellow Ochre is a slightly darker yellow. Add Yellow Ochre to the right edge and blend it into the yellow, working from right to left. Don't go all the way to the whitened yellow; you'll want to reserve a small area of pure yellow.

4. Since the ochre has only darkened the yellow slightly, we have to proceed to the darkest "yellow," Burnt Umber. (Raw Sienna is too warm to use with neutral yellow.) This will work for us as a dark yellow because there is already a layer of yellow and Yellow Ochre. Start at the right again and paint to the left, working the umber into the ochre mixture. Stop before you cover all of the Yellow Ochre, and make sure that the right edge of the bar is very dark.

## Orange Value Progression

1. Paint a bar of orange under the yellow bar.

2. Add white to the left edge and blend into the pure color.

3. Use Burnt Sienna for a darkener. Start at the far right with pure Burnt Sienna, then blend to the left, leaving a portion of pure orange. Burnt Sienna is a very transparent color and you may have to repeat this step several times.

## Red Value Progression

1. Paint a bar of neutral red under the orange bar.

2. Add white to the left edge and blend toward the middle. Since red is a darker color than the previous two colors, the pure color will be somewhere near or just to the right of the center of the bar.

3. Use Alizarin Crimson for a darkener, blending from right to left and stopping short of the pure red. The crimson is very transparent, so it may require several applications of paint to change the powerful cadmium pigment.

## Violet Value Progression

1. Paint a bar of violet under the red bar.

2. Add white to the left side, blending it to the right almost to the very end of the bar.

3. Go back over the white as necessary for a good transition of values.

## Blue Value Progression

1. Paint a bar of neutral blue under the violet bar.

2. Add white to the left side, blending it to the right almost to the very end of the bar.

3. Go back over the white as necessary for a good transition of values.

## Green Value Progression

1. Paint a bar of mixed green under the blue bar.

2. Add white to the left side, blending it to the right just a bit.

3. Use Thalo Green for a darkener, blending from right to left and reserving a section of pure green to the right of the center of the bar.

*Value progressions of the six basic color families*

# FINDING DARKER VALUES FOR THE TERTIARY COLORS

To find dark values of the tertiary colors, first mentally separate each of the hyphenated parts of the color. Ask yourself, "What is the darkest paint I have for each of these two colors?" Once you have identified the darkest values of each of the colors, combine and mix them in with the tertiary color.

For instance, to darken the tertiary color red-orange, mentally separate the color into red and orange. Then think of the darkest red (Alizarin Crimson) and the darkest orange (Burnt Sienna). Combine these two colors and mix them with the red-orange. (In fact, Alizarin Crimson and Burnt Sienna could be used to darken any warm red.)

Refer to the illustration to the right for the darker values of the tertiary colors. Yellow-green is darkened with Thalo Green (dark green) and Yellow Ochre or Burnt Umber (dark yellows); blue-green is darkened with Thalo Blue (dark blue) and Thalo Green (dark green); blue-violet is darkened with a dark blue (French Ultramarine blue) and violet; red-violet is darkened with Alizarin Crimson (dark red) and a dark violet; red-orange is darkened with Alizarin Crimson (dark red) and Burnt Sienna (dark orange); and yellow-orange is darkened with Raw Sienna (dark warm yellow) and Burnt Sienna (dark orange).

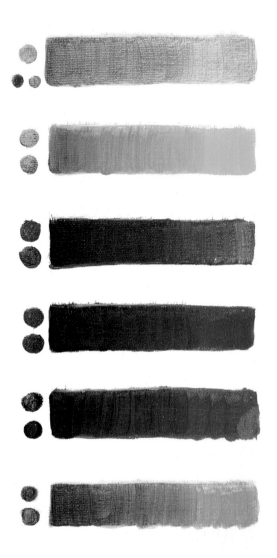

*To darken the tertiary colors, simply combine the darkening color of each of the component parts of the color.*

# ADJUSTING THE BRIGHTNESS/CHROMA OF YOUR COLORS

Chroma is the third element of color and has to do with the comparative brightness or dullness (grayness) of the color. For instance, you could have two reds of the same value, yet one might be bright and the other dull. Bright colors are described as "high chroma," and dull or grayed colors are described as "low chroma." The ability to change the chroma of a color is very important to an artist for a number of reasons.

You should change the chroma of your color when you want:

**TO MAKE SHADOWS.** Any time you want to make a shadow you need to know how to change chroma, because shadows are not bright; they are grayed.

**TO PUSH THINGS INTO THE DISTANCE.** When you want to make things look as though they are in the distance, you need to change chroma because color gets grayer as it gets farther away.

**TO MAKE COLORS LOOK NATURAL.** Most colors you see in nature are not bright; they are low-chroma versions of a color rather than full intensity (high chroma).

**TO CREATE COLOR HARMONY.** Using grayer, more subdued color in some areas of the painting creates a pleasing contrast to the brighter colors.

## Methods of Lowering Chroma

There are two methods of graying colors. One method is to mix black and white to get gray, and then add the gray as needed. This works fairly well with cool colors, less well with warm colors. Another way to change chroma is to know about the complementary colors. Complementary colors are colors opposite each other on the color wheel. They are called "complementary" in the sense that they "complete" each other. These are the complementary pairs:

- orange and blue
- red and green
- yellow and violet

When properly balanced, each complementary pair will make gray, and the darkest values of each complementary pair make black. By *not* balancing the colors evenly, you can get many lovely, subtle colors. The illustration below shows how many interesting and subtle color mixtures can be made by combining the color families of two complements—orange and blue.

*Both of these reds are the same value, but the one on the left has high chroma and the one on the right has low chroma.*

*This abstract shows how two families of complementary colors (plus white) combine to make a wide range of subtle, low-chroma colors. This is the orange and blue combination.*

# Learning How to Control Chroma

You will need the following:
**PAINT**: All thirteen colors that make up your standard palette
**OTHER SUPPLIES**: The same 12 x 16-inch practice canvas that you used for the previous project, and all basic painting supplies
**TIME**: About 45 minutes

This project shows how to change the chroma of neutral red without changing its value. First mix small amounts of each of the primary and secondary colors. Then lighten the red with some white. Paint two swatches of this lightened red side by side. We will lower the chroma of the one on the right.

## CHANGING CHROMA WITHOUT CHANGING VALUE

Mastering the skill of using chroma is easy if you remember these three simple steps: find the complement, match the value, and add the complement. Refer to the top illustration on the facing page as you follow along; we will be changing the chroma of a lightened neutral red.

**STEP 1: FIND THE COMPLEMENT.** Look at the color wheel to find the complement of the color you want to make less bright. The color wheel shows that green is the complement of red.

**STEP 2: MATCH THE VALUE.** Either darken or lighten the complement so that it matches the value of the color you are making grayer. The green mixed on your palette is much darker than the light red in the swatch, so the green needs to be lightened with white. Remember that your ultimate goal is to change the brightness of the second swatch of red without changing its value. Make the green the same value as the red by adding white to it.

Whenever possible, compare colors by placing them side by side. Put some of the color mixture on a palette knife or brush and hold it close to the color you are trying to match. This makes it easy to compare the two colors and decide what changes need to be made. What appears to be a perfect match on your palette often looks way off when held up to the original.

**STEP 3: ADD THE COMPLEMENT.** Add a small amount of the complement to the color you are making grayer. In our example, mix a *small* amount of the value-matched green into the second swatch of red. The second red now looks grayer than the first. Remember that the goal here is not to make gray; it is to make a grayer red. Only a small amount of the complementary mixture (think 10 percent) needs to be added.

Remember: find, match, and add. This is your key to mastering chroma. If you wish, you can try out the method with other colors of your choice. Use different values of colors for your experiments. Add white to the darker colors so that you can more easily see the way the color changes. If you use darker colors, go to your value progression exercise to find the right value of the complement.

Burnt Sienna is commonly used to make a neutral blue or French Ultramarine blue grayer, even if the blue is light enough to use orange as the complement. This is because it is so easy to get a little too much yellow or red when you mix orange, either of which will prevent it from being truly complementary to the blue. If the Burnt Sienna is too dark, just add white to lighten it to the value desired. It will always be a good complement to these blues.

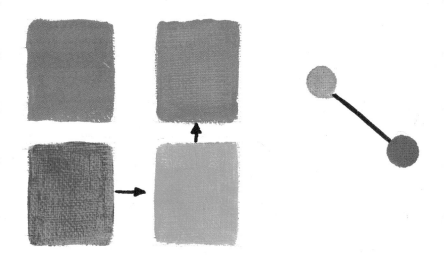

*To change the chroma of a color without changing its value, find the complement, match the value, and then add a small amount of this mixture to the color. The top left and top right squares were both a middle-value red. The challenge was to make the one on the right grayer without changing the value. I found the complement, green (BOTTOM LEFT); added white to the green to match the value of the original red (BOTTOM RIGHT); and then added some of this lightened green to the red to change its chroma (TOP RIGHT).*

TOP ROW: *I painted two squares of high-value green, found the value-matched complementary (red), and added this mixture to the second square to lower its chroma.* MIDDLE AND BOTTOM ROWS: *I followed the same steps using the complements orange and blue.*

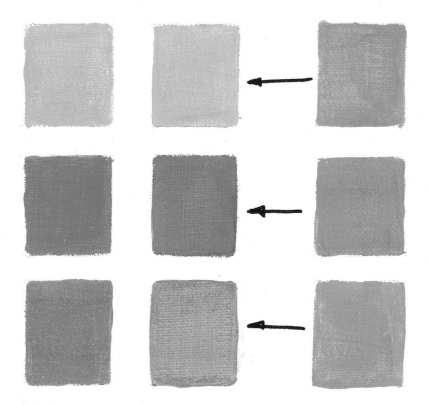

## An Exception to the Rule

While yellow is a perfect complement to a light violet, darker yellows that have Yellow Ochre and Burnt Umber in them do not work as well for darker violets because earth tones also contain blue and red—Yellow Ochre a little, Burnt Umber more. These earth tones may make violet look too brown (or warm) rather than making it grayer. To correct the balance you need to add a cool color such as French Ultramarine blue (mixed with the appropriate amount of white to bring it to the same value).

In the first pair of yellows in the example below you can see that the color-wheel violet works to make the yellow grayer because these colors are true complements. In the next pair of yellows, the yellow has been darkened with Yellow Ochre. Because the color is still almost all yellow, the violet still works.

The third pair of swatches is pure Yellow Ochre and the violet still works. However, you will often find that at this point in darkening yellow, you will get a warm color instead of graying the yellow. This is due to a little too much red in

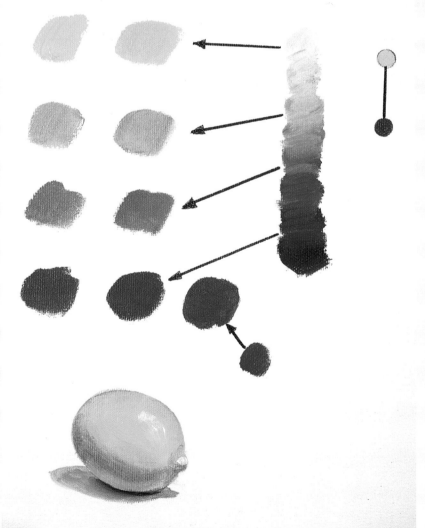

*Here are two vertical columns of yellow, progressing from light to dark. The lightest yellow is grayed in a convincing manner by an equal value violet, but as the yellow is darkened with progressively more Yellow Ochre and Burnt Umber, the violet becomes less able to successfully gray the yellow. At the darkest level, a French Ultramarine blue (of like value) has to be added to compensate for the warmth of the earth tones.*

the violet. When this happens, just add a value-matched French Ultramarine blue to counter the warm tone. This will give you the grayed yellow you're looking for.

In the last pair of yellows on the facing page, Yellow Ochre has been mixed with Burnt Umber to make a very dark yellow. With two earth tones in the mixture, violet is not a true complement any longer because there is too much orange in the earth tones. To counter that, again add a value-matched French Ultramarine blue to the violet. The blue can either be added into the violet to make blue-violet, or it can be added after the violet is mixed with the yellow. The lemon at the bottom of the image was darkened with Yellow Ochre and Burnt Umber grayed with blue-violet.

Graying violet with yellows works the same way, but unless you are graying a very light violet and can use yellow as the complement, you will always have to add extra value-matched French Ultramarine blue. The easiest way to gray violet is simply to add gray. In the example to the right you see three columns of light to dark violets. Each horizontal row started out the same, but a value-matched gray was added to the second violet and a value-matched yellow to the third. I recommend mixing the gray by combining French Ultramarine blue with either Burnt Umber or Burnt Sienna. (See Using Complementaries to Make Blacks and Grays on pages 54–55.) Both make good neutral grays and either will work. You could also use Ivory Black and white.

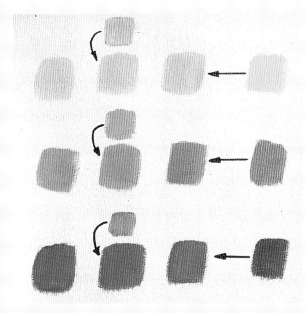

*There are two ways to change the chroma of violet without changing its value. Here we see three different values of violet. In the horizontal rows, each violet was originally the same. In the first column, the color is left unchanged. In the second column the violet has been grayed with the same value of gray. And in the third column the violet has been grayed with the same value of yellow. You can see that the gray works better.*

# Using Complementary Colors to Make Blacks and Grays

You will need the following:

**PAINT:** An abbreviated palette that includes Lemon Yellow Hue, Alizarin Crimson, Permanent Rose, Cadmium Red Hue, Thalo Green, Burnt Sienna, Burnt Umber, French Ultramarine blue, Thalo Blue, and white

**OTHER SUPPLIES:** The same 12 x 16-inch practice canvas that you used for the two previous projects and all basic painting supplies

**TIME:** About 30–45 minutes

One of the disadvantages of using black straight out of the tube is that it will look like a dead spot in your painting. If you decide to use Ivory Black (which is the recommended black pigment) to make something in your painting black, be aware that you will likely need to add some other color to it to give it some life. In general, it's better to use the variety of beautiful blacks and grays that can be made from complementary combinations.

## CREATING INTERESTING BLACKS AND GRAYS

To make black you simply locate two complementary colors of the color wheel and combine the darkest values of those two complements. Adding a bit of white to this mixture creates gray. Each combination is slightly different, and each has its special uses. Learning how to create subtle grays will greatly enhance your painting.

### Orange/Blue Combination

For this exercise, use Burnt Sienna and French Ultramarine blue. This is the fastest and easiest of the complementary combinations, and the one most artists use. Neutral gray (a gray perfectly balanced between warm and cool) is rarely used; grays that lean in one direction or the other are more interesting.

1. On your palette, mix Burnt Sienna and French Ultramarine blue. It will immediately look black, but to make a neutral gray there must be a balance between the warm color (Burnt Sienna) and the cool color (French Ultramarine blue). You won't know if it is balanced until you add white.

2. Add white and look at the color. If it looks brown, add more blue; if it looks blue, add more Burnt Sienna.

3. When you have it right, put both the black and gray in swatches on your canvas, and make a note of the color combination.

### Red/Green Combination

For this exercise, we will try two different combinations: Thalo Green with Alizarin Crimson, and neutral red (Cadmium Red Hue plus Permanent Rose) with a color-wheel green. The first combination makes a gray that is not completely neutral, but there are many uses for its slightly lavender tint. It is commonly used to paint metal (such as silver), pearls, and is perfect for Spanish moss. The second gray is much more neutral.

1. On your palette, mix Alizarin Crimson and Thalo Green. As before, you will immediately get an extremely intense black.

2. Add white. This combination of red and green won't make neutral gray because Thalo Green is not a neutral green, but a very cool green that tends toward blue.

**3.** To get a more neutral gray (not shown in the illustration below), mix neutral red with your mixed green (which, as you recall from page 43, is a combination of Lemon Yellow Hue and Thalo Blue), and then add white.

**4.** Add these mixtures and notes to your canvas.

## Yellow/Violet Combination

For this exercise, use Burnt Umber and violet (which is a combination of French Ultramarine blue and Permanent Rose). You will rarely, if ever, need to make gray out of this complementary combination, but it is useful to know how these two colors react to one another.

**1.** On your palette, mix Burnt Umber and violet. As with the first two exercises, you will get an intense black.

**2.** Add white. As you learned on pages 52–53, it is very difficult to make this gray look neutral, and the proportion of red to blue in your violet mixture may complicate the problem. You will find that the combination looks too warm no matter how you try to balance it. This happens (as you know) because the Burnt Umber is not directly complementary to violet, and the way to correct the too-warm look is to add a little French Ultramarine blue.

**3.** Add value-matched French Ultramarine blue.

**4.** Add these mixtures and notes to your canvas.

## Other Combinations

A number of other color combinations make interesting blacks and grays as well. You might try the following:

**BURNT UMBER AND FRENCH ULTRAMARINE BLUE**: These two colors work well together because there is a lot of yellow and red (orange) in the Burnt Umber.

**BURNT UMBER AND THALO BLUE**: This combination makes beautiful gray-greens that are wonderful for rocks and tree trunks.

**TERTIARY COMPLEMENTS**: Any of the colors on the color wheel in their darkest values will make blacks and grays when mixed with their complements. In fact, if all of the complements on your wheel were exactly balanced, each complementary combination would make an identical neutral gray. Remember that any black and gray that you mix will look better in your painting than black out of the tube.

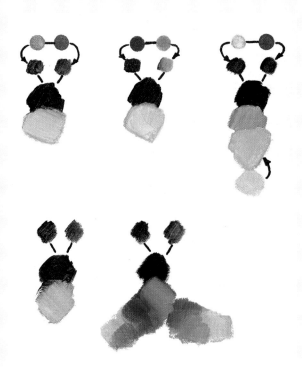

*A wide range of rich blacks and grays can be mixed by combining the darkest value of two complements. The orange/blue combination in the form of Burnt Sienna and French Ultramarine blue makes a fast black and a very neutral gray (TOP LEFT).*

*The red/green combination in the form of Alizarin Crimson and Thalo Green makes an intense black and a lavender-tinged gray (TOP MIDDLE).*

*The yellow/violet combination is less successful in making a neutral gray, and is rarely used (TOP RIGHT). Adding French Ultramarine blue helps neutralize this combination.*

*Burnt Umber combined with French Ultramarine blue also makes a fast black and a neutral gray (BOTTOM LEFT). Burnt Umber and Thalo Blue make a greenish-gray that is very useful for rocks and tree trunks (BOTTOM RIGHT).*

# Exploring Subtle Secondary Colors

You will need the following:

**PAINT**: All of the colors that make up your standard palette, except you don't need Burnt Umber and Thalo Green

**OTHER SUPPLIES**: Three small canvases (or divide a 12 x 16-inch practice canvas in thirds) and all basic painting supplies

**TIME**: About 1½–2 hours

## CREATING SUBTLE MIXTURES

The secondary colors that were mixed for the color wheel were as bright as possible. However, you often need secondary colors that are softer and more subtle. This project will give you a chance to explore some of the less brilliant (and perhaps more usable) secondary color combinations. Do as many or as few as you wish.

### Creating Subtle Greens

You have already mixed Thalo Blue and Lemon Yellow Hue to make a bright green. Now experiment with mixtures of Thalo Blue and other warm colors. Try mixtures of Thalo Blue with Cadmium Yellow Medium, yellow-orange, orange, Yellow Ochre, and Raw Sienna. Try French Ultramarine blue with the same colors.

### Creating Subtle Oranges

Try making oranges by combining first Alizarin Crimson and then Permanent Rose with all the

*Dark colors will overwhelm light ones. When mixing colors, start with the lighter color and add the darker color a little at a time.*

yellows (except Burnt Umber). Then try mixing Cadmium Red Hue with Yellow Ochre, Raw Sienna, Lemon Yellow Hue, and even Burnt Sienna. These more subtle oranges are better in autumn colors than the brighter Cadmium Red Hue/Cadmium Yellow Medium combination.

### Creating Subtle Violets

Make violet with Thalo Blue and Permanent Rose. Then try making violets with both Thalo Blue and French Ultramarine blue, mixing each of them with Alizarin Crimson and Cadmium Red Hue.

## MIXING SHADOW COLORS

You now have a good working knowledge of the three elements of color (hue, value, and chroma). Let's learn how to use them to create shadow colors. In Lesson One we discussed two kinds of shadows—cast shadows and body shadows. You will remember that body shadows are the shadows on an object that are caused by the object turning away from the

light. When you paint a body shadow, the color of the shadow is a darker, grayer version of the object's color.

A cast shadow is a shadow on a surface that is caused by another object blocking out the light. As with body shadows, the surface that the cast shadow is on determines its color. The object *casting* the shadow has nothing to do with the

color of the shadow. If a blue mug is casting a shadow on a pink cloth, the shadow on the cloth will be a darker, grayer pink. If the cloth is yellow, it will be a darker, grayer yellow.

What color is a shadow on white? A shadow on white is gray, usually painted as a blue-gray or lavender-gray. In these cases, mix your easy gray with French Ultramarine blue and Burnt Sienna, emphasizing the blue.

## Two Exceptions to the Rule

There are two exceptions to this rule. The first deals with transparency and translucency. In a transparent or translucent object, both the body shadow and the cast shadow are affected by the fact that light passes *through* the object rather than being blocked. There is no shadow side on an object when light passes through it; a translucent object, such as a flower petal, will actually be brighter on that side. Light passing through transparent color will also throw both color and light into the cast shadow. (See *Still Life with Peaches*, page 101.)

The second exception has to do with the tendency of nearby colors to reflect into each other in very strong light. In the study of the blue mug below you will notice that some of the pink of the cloth is reflected into the mug. In the painting of the orange below, the shiny orange is picking up a strong reflected light from the napkin underneath it and bouncing it back down into the cast shadow.

## An Addition to the Rule

The sun imparts a hint of yellow to every sunlit color because our sun is yellow. Indoor incandescent lights produce the same effect. Some artists like to emphasize the appearance of sunshine by adding a bit of yellow to every color in bright sunlight. You can decide whether this is something you want to try. It is a good idea, however, to add the merest *touch* of yellow to sunlit whites, or whites in a warm light.

By the same token, you should *subtract* some yellow in outdoor shadows. For example, if you are painting a fair-skinned child at the beach, her skin color may be a combination of Cadmium Red Hue, Yellow Ochre, and white. Following the concept of warm lights and cool shadows in the sun, you might use a little more yellow in the sunlit skin, and a little less (or a cooler) red for the shadows, and then proceed to find, match, and add the complement. (See *Day at the Beach*, page 59.)

*Study the shadows of a blue mug on a pink cloth. Notice how the pink cloth reflects back into the mug.*

*Notice how the intense orange reflects down into the cast shadow on the white cloth.*

# Finding the Right Shadow Color

You will need the following:

**PAINT:** All thirteen colors that make up your standard palette

**OTHER SUPPLIES:** Small canvas (half of a practice canvas) and all basic painting supplies

**TIME:** About 1 hour

Learning how to make believable shadows is very important to the success of any realistic painting. Adding black won't work because black will change the hue of warm colors and dominate both warm and cool colors. This simple method will work.

## MASTERING THE RULE FOR SHADOWS

As you can see, the process below is very similar to the process in Changing Chroma without Changing Value on pages 50–51. Remember that the key words for that process were: find, match, and add. In the Rule for Shadows, you *darken*, find, match, and add. Follow these simple steps and shadows will be easy: darken the color, find the complement, match the value, and add the complement.

**STEP 1: DARKEN THE COLOR.** Using a darker color from the same family, darken the color on which the shadow falls. This color should be the same value that you want the shadow to be. This prevents the shadow color from becoming too gray. Take a fresh piece of canvas. Make a swatch of French Ultramarine blue lightened with white. Mix a darker blue to the desired value of the shadow and add it to one side of the swatch.

**STEP 2: FIND THE COMPLEMENT.** Using the color wheel on page 44, find the complement of the shadow color. For this exercise, you check the color wheel or remember that the complement of blue is orange. You can use either orange or Burnt Sienna as the complement of French Ultramarine blue; I recommend using Burnt Sienna.

**STEP 3: MATCH THE VALUE.** Lighten or darken the complement until you have matched the value of the complement with the value of your shadow color. So add a touch of white (if necessary) to the Burnt Sienna to match the value of the dark blue.

**STEP 4: ADD THE COMPLEMENT.** To make the shadow less bright, add a small amount of the value-matched complementary color. So add the value-matched Burnt Sienna into the shadow. I suggest wiping as much of the complementary paint as you can off the brush, and then using the tiny amount left on the brush.

Now that you have the method, try other colors. Just remember: darken, find, match, and add. If you don't remember how to darken any of the colors, go back to your value progression exercise for that color on pages 46–47 and see how you changed its value. If you choose a tertiary color, just remember that the same rules hold true. Check back to Learning How to Control Chroma on pages 50–53. When you are using dark yellows and violets in complementary mixtures, remember to add more French Ultramarine blue to compensate for the earth tones.

*Ann Weibel,* Day at the Beach, *oil on canvas. Ann is an accomplished professional artist who has taken my studio course. She likes to paint her subjects in bright sunshine. Notice how her sunlit whites are warmed with a touch of yellow and even the blues of ocean and sky are warm. By contrast, the shadows on cloth and skin are cooler.*

# LESSON FOUR
# Putting It All Together

I N  T H I S  L E S S O N  you will use everything you have learned in the first three lessons—making shapes look three-dimensional, handling the brush, and mixing color—to paint a cylinder and a sphere. We will start with a cylin-der painted in the primary colors, and then move to a sphere painted in the secondary colors. Both of these forms will have body shadows and cast shadows so that you can practice mixing shadow colors for each of the six basic colors.

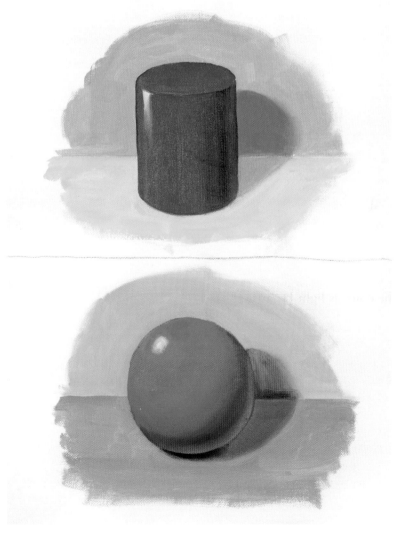

*The finished
cylinder and sphere*

# Painting a Cylinder and a Sphere

You will need the following:

PAINT: All thirteen colors that make up your standard palette

OTHER SUPPLIES: One 12 x 16-inch practice canvas and all basic painting supplies

TIME: About 3 hours

Set out all your paint according to the palette diagram on page 42. Mix neutral red, yellow, and blue as well as all three of the secondary colors. Check all of your colors against crayons to make sure of your mixtures, and remember to place the paint near the edges of the palette.

## CREATING A CYLINDER IN PRIMARY COLORS

We will now paint two of the geometric forms from Lesson One, so we will be making shadow colors for each of the six primary and secondary colors. In the earlier lesson we didn't bother drawing a shadow on the wall, but in this one we will. Refer to your value progressions, and be sure to clean your brushes thoroughly when changing colors.

### Drawing the Cylinder

Unless you are painting a very detailed subject that requires precise measuring or perspective, it is best to place your subject on the canvas with paint rather than pencil or charcoal. Burnt Sienna is generally a good color for "drawing"; if you're making a cool-colored painting, use French Ultramarine blue. The paint must be diluted with *a lot* of medium so that your drawing is very light and easily changed if necessary. (Remember that the color is light because it has been diluted with medium, not because white paint has been added.)

1. Holding the canvas vertically, divide it roughly in half with a line made with either paint or pencil.

2. Place a small puddle of medium next to the Burnt Sienna on your palette. Use a #2 flat bristle brush to pull a small amount of paint into the puddle of medium, mix it, and then test the color on your palette. Remember to keep the color very light.

*Draw the cylinder and cast shadow*

3. Draw a cylinder in the top half of your canvas, adding a tabletop and cast shadow as shown above. If you make a mistake, simply erase it with either a finger wrapped in paper towel or a clean brush and start again.

### Painting the Wall

Before you begin to paint the wall, you might find it helpful to review the Rule for Shadows on page 58.

1. On your palette, mix neutral blue with white to create a light to medium value of blue.

2. Using a #6 flat bristle brush loaded with the blue mixture, paint the wall carefully along the edges of the cylinder, shadow, and table, and then fill in the rest of the wall. Your paint layer should fill the canvas solidly, but not thickly. Don't bother to paint out to the edge of the canvas.

*Mix the shadow color for the wall*

*Paint that gets into areas where it isn't wanted can be removed with a brush dampened with a little medium.*

*Add the shadow on the wall.*

3. On your palette, mix a darker version of your neutral blue for the cast shadow. (It should have less white than the mixture you created in Step 1.) Test your color in the cast shadow to see if it looks appropriately darker than the value of the rest of the wall. You will notice that this darker blue is too bright for a shadow.

4. To make the cast shadow less bright, we need to find, match, and add the complement. First, identify the complement. Orange is the complement of blue, and Burnt Sienna, as a dark orange, is the right color to use to make this blue less bright. (Use Burnt Sienna instead of orange as a complement to blue, because Burnt Sienna is always the same and orange can vary widely according to how much yellow is in it.)

5. Add white to the Burnt Sienna if necessary to match the value of the cast shadow, and then add a *very small* amount of this mixture into the shadow color on your palette. Remember, your goal is not to make gray, but to make the blue shadow grayer.

6. When the color looks right on your palette, use a smaller bristle brush (such as a #2 or #6) and horizontal strokes to paint in the cast shadow. The farther away the cast shadow gets from the cylinder, the more blurred the edges should be. Overlap the shadow color onto the wall color to create soft edges.

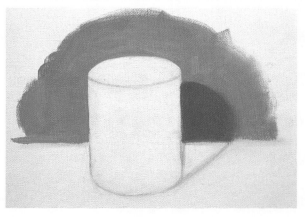

*The finished wall*

7. Step back and look at your wall, then adjust as needed.

8. Clean your brushes *thoroughly* before proceeding to the next section. (Even a trace of blue will ruin the yellow, which we use for the table.)

## Painting the Table

1. Dip the #6 flat bristle brush in neutral yellow and paint the table surface. Use horizontal strokes that follow the flat surface of the table. Leave an ⅛-inch gap between the table and the wall, and paint around the cast shadow.

2. To paint the table edge, load your brush with yellow and then use one corner of your brush to slightly overlap the blue as you fill in the gap. Be aware of which corner of the brush is hitting the blue, and use the same corner all the way across.

3. To create the color for the cast shadow, start by darkening the yellow with Yellow Ochre.

4. Now find, match, and add the complement. Violet is the complement of yellow. Lighten it with white to match the value of the cast shadow and add a small amount to the Yellow Ochre mixture. If the shadow color looks too warm, add a little French Ultramarine blue that has been lightened with white, but don't let the violet or blue overpower the dark yellow.

5. Use a #2 or #6 flat bristle brush to paint the cast shadow on your canvas. Overlap the shadow edges onto the yellow of the table so that they are soft.

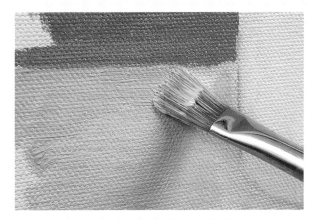

*Paint the table edge into the wall color.*

*When painting edges, turn the canvas so that the edge is always above your brush.*

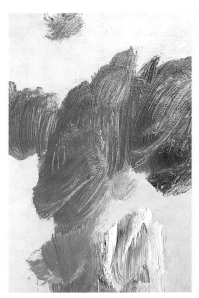

*Mix the color for the cast shadow on the table.*

## PAINTING WET AGAINST WET

*I want to make a clean edge. Can I paint wet against wet—or should I wait for one layer to dry?*

Many beginners worry about painting two wet colors against each another, because they are concerned that they will not be able to get a neat edge. In many painting styles, edges are purposely blurred to make them recede or to direct focus to the subject. In most cases, you don't want knife-sharp edges in your paintings, because they attract attention. You can get nearly knife-sharp edges by slightly overlapping the first color with the second. As shown in the image above, use one corner of the brush and just *touch* the other color as you make your edge. Wipe the brush occasionally as necessary and reload with clean color, being careful that you use the same part of the brush to continue the edge.

# Painting the Cylinder

Our procedure for painting the cylinder will be to start with the "local color," or "body color," of the cylinder. We will start by painting the sides completely, including the shadows, reflected lights, and highlights. Then we will finish with the top ellipse. That way we can easily clean up the top edges. You can either make your brushstrokes in horizontal curves, following the curves of the ellipses on the top and bottom, or you can make your brushstrokes vertical, following the straight lines of the sides. It is easier to paint straight lines than curved ones, so I suggest stroking up and down when painting the sides of the cylinder.

### BODY COLOR

1. Starting in the middle of the cylinder, use a #6 flat bristle brush and a vertical stroke to paint the sides neutral red. Leave a slight space at the edges to avoid your background colors. Cover the surface solidly but thinly.

2. Turn your canvas so that you have a clear view of what your brush is doing and paint all of the edges of the cylinder, going right up to the background color. Wipe your brush occasionally to clean off any background color.

### BODY SHADOW

1. On your palette, mix together Alizarin Crimson (dark red) and a touch of the mixed green (the complement). This color needs to be as dark as you can make it, so there is no need to adjust the value by adding white.

2. Use a #6 flat bristle brush to add the body shadow. The first stroke you put down will be the darkest, because as your brush lays the paint down, it also picks up the neutral red. For that reason, start at the core of the shadow, which is a little in from the right-hand edge. Stroke downward, pushing the shadow color into the

red. You may have to reload the brush with paint and repeat the stroke several times to get it dark enough.

3. Without wiping or reloading, lay the brush half on the left edge of the core of the shadow and half on the body color and brush down again, overlapping the first stroke with the second.

4. Again without changing the paint on the brush, overlap a third stroke over the second and slightly to the left.

5. Continue adding strokes as necessary, but remember that the shadow should stop before the center of the cylinder. The overlapping strokes should create a blended transition of shadow color, from the core to the halftone.

If the paint needs to be blended more, wipe the brush dry and lightly go over the strokes. You may have to add more shadow color and repeat these steps.

If you get too much shadow in the halftone area, or if the halftone extends too far to the left, clean your brush, load it with neutral red, place it in the clean body color, and paint overlapping strokes from left to right as necessary to correct the color.

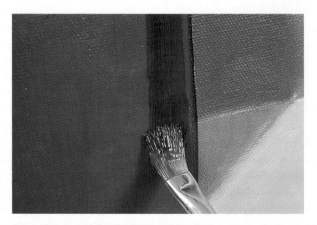

*Paint the core of the shadow on the cylinder.*

## REFLECTED LIGHT

At the right edge of the cylinder, between the core of the shadow and the background, is the reflected light.

1. Add a little white to the shadow color and lightly overlap the core of the shadow using your #2 flat bristle brush.

2. Before bringing the reflected light to the edge of the cylinder, take a look at the background color. Think: *If I lighten the edge of the cylinder, will I have enough contrast with the background?* Where the cylinder is against a cast shadow, you can safely bring the reflected light right to the edge, but if your wall is light above the shadow, you may want to leave the cylinder edge dark to contrast with the background. In that case, keep the reflected light slightly *inside* the edge. (At this point we aren't interested in lost edges.)

3. Paint to the edge, overlapping the wall color just slightly.

## HIGHLIGHT

1. The highlight for the cylinder is a slightly grayed white. Add a hint of either Thalo Green or mixed green (the complementary color) to some white paint on your palette and mix.

2. Pick up this white mixture with a #2 flat bristle brush. Lay the top of the brush at the top left edge of the cylinder, about ¼ inch from the side.

3. Pull the brush down and away to feather out the end of the stroke. If you can't get a feathered end on the first stroke, take a clean brush and, with a very light touch, pull some of the red up into the white. A dry brush can also be used to blur and soften the edges of the highlight.

*Paint the highlight on the cylinder.*

*Clean the edges.*

## THE TOP ELLIPSE

1. Using a #2 flat bristle brush or your angled shader, paint the top of the ellipse with neutral red. Use whatever strokes give you clean edges. Turn the canvas so that the edge is *above* your brush, and as always, start in the middle of the form and save the edges that overlap another color for last.

2. Use your brush to create a nice crisp edge where the ellipse of the top of the cylinder touches the sides and the wall.

3. Clean up any ragged brushstrokes and white paint from the highlight that encroaches on the edge of the ellipse.

4. Lighten the lower part of the ellipse by stroking in some white paint. This will help the top of the cylinder contrast with the sides.

5. Smooth the top with horizontal strokes that describe the flat surface.

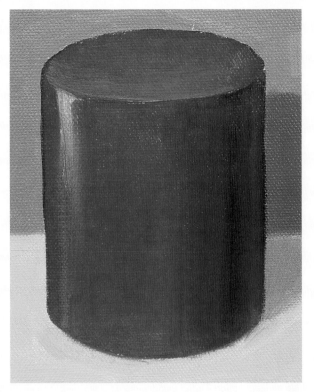

*The finished cylinder*

# CREATING A SPHERE IN SECONDARY COLORS

We're going to practice our rendering and color-mixing skills again—this time with secondary colors. Using the #2 flat bristle brush and the same mixture of medium and Burnt Sienna that you used to "sketch" the cylinder, draw the sphere in the bottom half of your canvas. Add the table edge and all of the cast shadows as shown to the right. As before, erase any mistakes with a finger wrapped in a paper towel or a clean brush.

## Painting the Wall

1. On your palette, add some white to most of your mixed green and combine the two colors.

2. Using a #10 flat bristle brush, paint the wall light green.

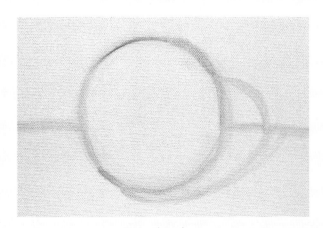

*Draw the sphere.*

3. On your palette, mix a darker green for the cast shadow. You may need to add Thalo Green to your mixed green to accomplish this.

4. Identify the complement to the shadow color (neutral red). If the value of the neutral red is close to that of the dark green, you can use it as it is. If not, then add white to lighten it or Alizarin Crimson to darken it.

5. Add a touch of the dark red to your dark green.

6. Use a #6 flat bristle brush to paint in the cast shadow, remembering to blur the edges. Turn the canvas as needed while you're painting, but finish with horizontal strokes.

## Painting the Table

1. On your palette, mix purple and white to make lavender.

2. Using a #6 flat bristle brush, paint the table lavender. Turn the canvas as needed to get clean edges, but finish with horizontal strokes that describe the table surface.

3. Mix a darker purple for the cast shadow.

4. Dark yellow is the complement of dark purple. Instead of darkening the yellow with Burnt Umber and then cooling it with French Ultramarine blue, take a shortcut and mix Burnt Umber with the French Ultramarine blue to make black, and then add white as needed to match the value of the cast shadow.

5. Add just a *touch* of this gray mixture to your dark purple.

6. Paint the cast shadow using a #2 or #6 flat bristle brush, finishing with horizontal strokes.

7. Because this is a rounded form that bulges out, the cast shadow right underneath the sphere (where it touches the table) will be almost black. Load your pointed sable brush with dark

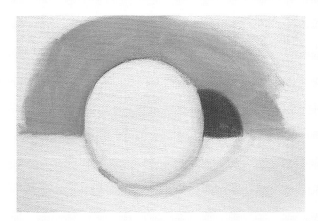

*The finished wall*

purple and the black that you made with French Ultramarine blue and Burnt Umber in Step 4, and paint this dark shadow, blending it into the rest of the cast shadow. Remember that when adding a complement to a shadow, you only need about 10 percent of the complement to make the shadow color more gray.

## Painting the Sphere

Clean up the inside of the sphere with a brush slightly dampened with medium, turning the canvas as you paint as necessary. Now you are ready to paint the body color, body shadow, reflected light, and highlight.

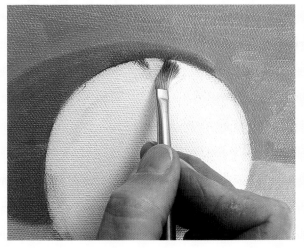

*Clean the sphere.*

## BODY COLOR

Paint the sphere orange using a #6 flat bristle brush. Start in the center and paint out almost to the edge, and then overlap the edges. Be sure to turn the canvas as needed so that you can see what you're doing, and always keep the same edge of your brush against the outside color.

## BODY SHADOW

The shape of the shadow will follow the curvature of the sphere at right angles to where the highlight will be. Hold your brush as illustrated at right and you will be able to taper the stroke at each end.

*1.* On your palette, mix a small amount of French Ultramarine blue into Burnt Sienna.

*2.* Using a #6 flat bristle brush and the same procedure that you used to paint the shadow on the cylinder, begin painting the body shadow. Start at the darkest point, the core, which should be a little in from the right edge. Your brushstrokes should follow the curve of the sphere. Because Burnt Sienna is a very weak color, expect that you will have to go over this core stroke several times.

*3.* Overlap each succeeding stroke, blending into the halftone. If you carry the shading too far, use a clean brush to remove some paint and reapply orange, blending it back over the shadow.

## REFLECTED LIGHT

Add a little white to the shadow color and use a #2 flat bristle brush to paint the reflected light to the edge of the sphere. Blend the reflected light into the core of the shadow so you have a soft transition. Notice that the reflected light is only at the edge of the sphere when there is a darker color behind the edge.

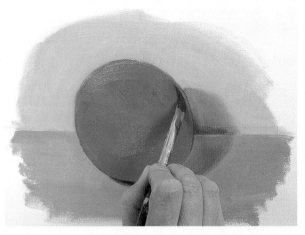

*To make the core of the shadow on the sphere, hold the brush in this position as you sweep it around to make the curve. In this way the ends of the stroke will be tapered.*

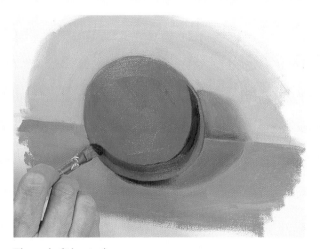

*The end of the stroke*

## HIGHLIGHT

*1.* Add a *touch* of the complement of orange (French Ultramarine blue) to white to make a very light blue.

*2.* Load the #6 flat bristle brush thickly with the highlight color and lay a single stroke onto the sphere. Do not continue to stroke over the highlight or it will disappear.

3. Clean the brush and gently blend the edges of the highlight, but don't let it grow too big. It isn't possible or necessary to completely smooth out your brushstrokes; let them show. (Softer flat sable brushes will give a smoother finish, if desired.)

4. Your brushstrokes help to convey the sense of form and should always be applied following the contours of the form. All of your brushstrokes should circle around the highlight. To achieve this effect, take a clean #6 flat bristle brush and stroke over the rest of your first paint layer so that all of the brushstrokes circle the highlight and follow the form.

When you have finished making the highlight, stop, step back, and evaluate your painting. At this point I increased the contrast between the cast shadow on the wall and the cast shadow on the table by darkening one and lightening the other where they came together. I also increased the overall darkness of the cast shadow on the table because it seemed too light.

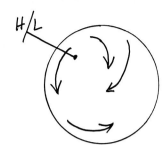

*Make sure all the brushstrokes follow the form of the sphere.*

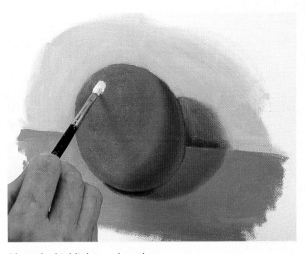

*Place the highlight on the sphere.*

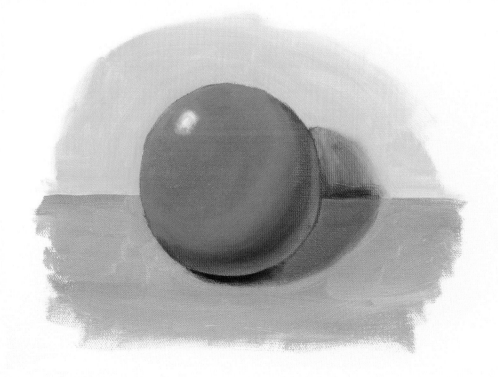

*The finished sphere*

# CORRECTING MISTAKES

## My brush slipped and I colored an area by mistake. How can I fix it?

Dampen a small stiff brush (a #2 flat bristle brush works well) with medium, wipe it dry, and use it to pick up the paint. Repeat this process, cleaning the brush between strokes, until you have completely removed the paint.

## I don't like the color I used. How can I change it?

If there is nothing under the wrong color, follow the steps above. If there is other color under the mistake, possibly something that you want to keep, use a clean, dry brush to lightly erase the wrong color. In this case you are going to repaint with the right color, so you don't need to completely remove the mistake.

*Do not rub the surface with a rag or paper towel;* this can cause a disaster, as you might remove paint from the surface of the weave of the canvas, turning it white and leaving darker paint in the crevices. You will then have to repaint in a color dark and opaque enough to cover the spotty texture you have created, which is not an easy thing to do. Having a trace of the wrong color remain is frequently beneficial to the final effect, making the color more interesting.

## I want to paint over an old painting, but the brushstrokes show through. What should I do?

Before painting over anything, use a painting knife (*not* a palette knife) to scrape down the impasto of the subject. You don't want the shape of an orange showing through a tree. If the painting is on stretched canvas, be sure to put your hand in back of the area you're working on to prevent the knife from slicing through the canvas.

## I need to paint over a dark area with lighter paint and it won't cover. What should I do?

Oil paint is slightly transparent, and becomes more transparent as it ages. It is difficult to paint light colors over dark in such a way that the light color will completely cover the dark, especially if the top layer is entirely different from the under layer, but it can be done if the area being painted over is an even color.

The problem arises when there are darker or lighter contrasting areas to be covered. The best solution is to first paint over the mistake with a color only slightly lighter than the darkest part of the area to be covered and blend the edges out softly. After that dries, paint over the area any way you wish.

If, however, you are trying to remove something dark from a light area, you should first try to remove as much of the dark paint as possible. This is the time to use a brush and a rag to first remove as much paint as you can. Then scrub the surface with medium or a solvent such as odorless mineral spirits or odorless Turpenoid. Use Turpenoid Natural as a last resort, but wipe it all off when you're through because it will impede the drying time of future paint layers. Scrape off any remaining paint with a painting knife with a metal blade (again taking care to put your hand in back of the canvas so you don't puncture it). If some paint remains, paint over it in a color dark enough to cover the remaining traces, blending the paint out to the edges of the patch. After this is dry and painted over, it should be undetectable.

## I painted a dark hard edge and now I can't make it look soft. What should I do?

This can happen when you paint hard edges with dark colors in the beginning stages of a painting, and then when you want to come back and make them soft and blurred they're dry and hard to change. The best answer for this problem lies in preventing it. In the beginning stages of a painting keep your edges soft. If you need to leave the painting for a while, smudge and blur all dark edges. The earth tones that are commonly used in the beginning stages of a painting dry very quickly. The remedy for this situation is to try to add more dark color over the hard edge and blur the new color. It may take several applications.

## I want to clean part of the first wet layer off and start again. Is this possible?

This is the place to use a rag or a paper towel dipped in medium. Always start with medium to avoid getting Turpenoid Natural on your canvas. Turpenoid Natural will slow the drying time of any paint that it is mixed with and the paint may take a month to dry. If medium doesn't work, go to the Turpenoid Natural, but be sure to wipe all of it off the canvas before painting over the area.

*When cleaning off parts of your painting, tuck the excess paper towel into the palm of your hand so that it doesn't smear your painting.*

*Kathleen Lochen Staiger,* Virginia Morning, *oil on canvas. Notice the difference between the reflection and the cast shadow of the boat.*

# LESSON FIVE
## Creating a Still Life Painting

OW DOES AN ARTIST translate what she or he sees into a painting? It isn't as simple as plunking down two apples or looking out the window and then copying what you see.

This lesson is all about what goes into making an interesting painting. It will show you how to effectively arrange your subject, how to accurately sketch the subject onto the canvas, and how to successfully develop and finish the painting. Our subject will be a simple still life.

This lesson is divided into four parts. In the first part you will learn how to make your painting interesting and then apply what you learn to the arrangement of your chosen fruit or vegeta-

bles. In the second part you will learn how to draw your objects accurately onto the canvas. In the third part you will be guided in the painting of your still life; we will use what you have learned about color and shading in the previous lessons to paint fruit that looks as if you could pick it off the canvas. In the final part I will demonstrate standard painting procedures and paint a still life.

This will be your first complete painting, and while I have some suggestions for the subject of your still life, you will choose what to paint and make your own composition. When it is finished you will have an original painting that you can frame and hang.

LEFT: *Betsey Domis,* Autumn Gourds, *oil on canvas. Betsey did a particularly good job of painting the patterns on the gourds.*

OPPOSITE: *Mirjam Borovsky,* Still Life with Striped Silk, *oil on canvas. This was only Mirjam's second painting (not counting the paint-alongs), done after she completed the beginning course. She has handled a number of surfaces beautifully—from the fabric to the glass and its effects on the cloth.*

# MASTERING THE TECHNIQUES FOR MAKING AN INTERESTING PAINTING

What is the difference between a ho-hum painting and a painting that really catches the eye and interest? During your life you have probably seen hundreds of paintings. Why do you find one painting exciting and the other boring? The answer lies in *how* the subject is painted—including what shapes and colors are used, how the light is arranged, and whether or not there are contrasts in value.

Composition is the arrangement of shapes, lines, colors, values, patterns, and textures within the shape formed by the edges of the picture. All of these are elements of composition, and when they are properly organized they transform a painting into a unified, expressive whole. Composition has two goals: the formal goal of capturing the attention of the viewer, and the expressive goal of helping the artist communicate a feeling or idea and elicit an emotional response from the viewer. Before beginning a painting, you need to become aware of the compositional techniques artists use to make their paintings exciting.

## The Elements of Composition

If all of the shapes and colors in a painting are the same, it will, of course, be boring. Therefore, the first rule of composition is *variety*. Most of the discussion related to the four elements that follow deals with different ways of creating variety.

### FORMAT

All composition takes place within the particular shape of the canvas or other surface that the artist has chosen. This shape is called the "format." It is usually rectangular, but ovals, squares, circles, and even free-form shapes can be used.

The goal of good composition is to arrange all the pictorial elements in an interesting manner within the format. The format shape is the first important part of the composition because all of the other elements (shapes, lines, colors, etc.) are placed in relationship to it. That is why it is always important to plan your painting inside a frame similar to the shape of the canvas you will be using. (Never plan your picture without putting in the edges of the format.) If you are planning a rectangular format (and most canvases are rectangles), you must first decide on whether you want it to be horizontal or vertical.

### INTERVAL

In order to make your arrangement more interesting, you need to train your eye to look at your subject not only as a vase of flowers or a tree, but as a shape (or series of shapes). You should consider how that shape relates to all the rest of the lines and shapes, and to the edges of the format. You also need to look at the spaces between your objects. These spaces, called "intervals," should all be as different as you can make them.

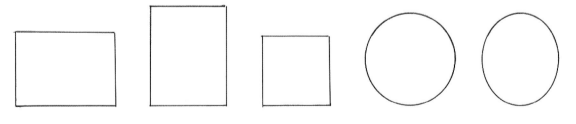

*Formats*

This is surprisingly hard to do because there seems to be something in the human mind that strives for order and regularity. If I were to ask you to make a bunch of random marks on a piece of paper, chances are that all of the marks, though scattered, would be evenly spaced.

Here is an exercise to help you become aware of interval: Draw a horizontal rectangle for a format on a piece of paper. Inside the format, draw six trees in a row. In good composition the interval between each tree will be different, including the space between the first and last tree and the edges of the format.

*Interval*

*Mirjam Borovsky,* Still Life *with Apples, oil on canvas. This was Mirjam's first painting and shows good observation of the shapes of the apples and an interesting arrangement of those shapes on the napkin. Compare this painting with the diagrams of positive and negative shapes on the following page.*

*The area in back of the napkins and apples is background (or negative) space, so we refer to this as a "negative shape."*

*The objects that the artist places on the canvas make up the positive shapes. In this view, the apples and napkin are the positive shapes.*

*"Positive" and "negative" are relative terms. If we focus on the apples alone as being the positive shapes, the napkin is the background or negative shape in relation to the apples.*

## SHAPE

There are two kinds of shapes—positive shapes and negative shapes. The apple that you paint on your canvas is a positive shape; it is the shape of an object. The minute you paint it on your canvas, however, you are creating not only the positive shape of the apple, you are also creating a background (or negative shape) around it. Each shape is important to the composition, and you need to be aware of both kinds. That is why you should never put something exactly in the middle of a painting; the negative shapes on either side of the object will be the same, and sameness is not interesting.

When composing a painting, try to use shapes that are varied. Pears or pineapples are more interesting in shape than oranges because their edges go in and out, creating interesting positive and negative shapes simultaneously. If you must paint oranges, consider incorporating a branch or leaf to add interest to the circular forms.

Strong compositions include a variety of shapes. When planning your still life, select objects that might naturally appear together on a table, and then make sure you have an assortment of different sizes and shapes. Although successful paintings have been made of just pears or just apples—where the artist has achieved variety by enhancing differences in color, lighting, and placement of the fruit—it is easier to start with variety of the fruit itself.

*Uninteresting negative shape*

*Interesting negative shape*

*No variety in the shapes*

*Good variety in the shapes*

## SPACE

Most realistic painting styles strive to depict the illusion of three-dimensional space. The bottom of a picture represents the closest point to the viewer. The higher in the picture you place something, the farther away it seems to be. A pear at the bottom of your painting looks nearer to you than one higher up in the composition, for instance.

When arranging the elements in your composition, use this sense of depth wisely. Just as a good painting has a variety of differently sized positive and negative shapes that are positioned at irregular intervals, it also has a variety of depth. In other words, it is more interesting to be able to visually travel back and forth into the space of your painting than to have everything lined up in a row. To get variety in your spatial depth, consider the distance of each object from the bottom edge of your format and try to vary these spaces. Overlapping creates the feeling of one thing being in front of another, so make sure to overlap some of the fruit as well.

*Good variety of interval and shape, but everything is lined up in a row*

*Good variety of space. Now the objects are placed at different distances from the bottom, giving the impression that some are near and some are farther away.*

# Leading the Eye

Artists use the arrangement of shapes and colors to lead the viewer's eyes around the painting. The longer the artist manages to keep the viewer's attention, the better the opportunity will be for the viewer to absorb the impact of the work.

Most viewers of art are not aware that the artist has planned a path for their eyes to travel. How does the artist do this? First, she or he plans for the most important part of the painting to be spotlighted by attention-getting contrasts of light and dark, or perhaps the brightest color. This spotlighted area is called the "focal point" or "center of interest." It will generally be located somewhere in the central area of the painting (but almost never in the exact center). The surrounding shapes will be arranged so that they subtly lead the eye around the painting and back to the focal point. The artist tries not to create any shapes that point out of the canvas, or to put very bright colors right at the edge of the canvas. In Mary Cassatt's painting *The Boating Party,* every element of the composition leads so strongly to the baby that it doesn't make any difference that this area does not have the most contrast or the brightest color. Follow the shapes from anywhere on the canvas and you will see how they all lead to this focal point.

*The arrows show how all of the forms move toward the focal point of the baby. Even the negative shapes of the water make triangles that point toward him.*

*Mary Cassatt,* The Boating Party, *Chester Dale Collection, Image © Board of Trustees, National Gallery of Art (Chester Dale Collection), Washington, D.C. This is a wonderful example of how an artist can lead the eye of her viewer.*

# Things to Avoid

As you compose your painting, you will naturally want to avoid anything that leads the viewer's eyes out of the picture. Here are some common mistakes to watch out for.

**KISSING EDGES**: Edges that don't overlap or separate, but just touch. This is spatially confusing. To fix this mistake, simply overlap or separate the two objects.

**POINTS OF TENSION**: Two objects that come very close to each other without touching. This causes a visual tension that is distracting. As with kissing edges, fix this by definitely overlapping or separating the two objects.

**TANGENTIAL LINES**: Lines from separate objects that run into each other to form a single edge. This confuses the eye. Shift the objects so it doesn't happen.

**STARS**: Elements in the painting that come together at a single point, drawing the eye. Break up the star or downplay some of the elements.

**PULLING APART**: Shapes that cling to the edges of the format like children at a sixth-grade dance—closer to the edges than they are to each other and leaving a big space in the middle. If you get the feeling you could cut the design in half and have two workable pictures, you need to get your shapes closer together.

**LUMPING**: Shapes that are all stuck together. Is there space between some of the fruit, or is it all in a lump? Some things should be overlapped, but not everything; some separation creates a more interesting negative shape.

**STACKING**: An object that is centered directly under another shape. This stops the movement in a composition. Move one of the shapes.

**ARROWS POINTING OUT**: Objects that taper to a point and are close to an edge, pointing out. Turn them around so that they point toward the center of your design and/or move them away from the edges.

**OBJECTS THAT RUN OFF THE PAINTING**: Roads and rivers can easily lead the eye right out of the canvas (not shown below). Interrupt the outward flow with a vertical shape, such as a bush or tree, that redirects the eye and keeps it inside the frame.

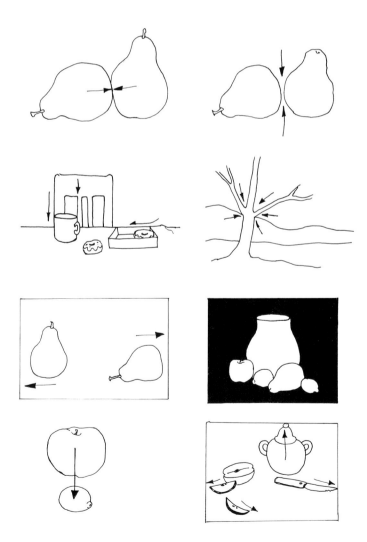

*Things to avoid in composing your painting: (FROM TOP TO BOTTOM, LEFT TO RIGHT): kissing edges, points of tension, tangential lines, stars, pulling apart, lumping, stacking, and arrows pointing out*

# UNDERPAINTING

*I haven't started my painting yet, but I know that I'd like to add a bit of texture and color contrast. What can I do to help achieve this?*

Occasionally you may want to paint on something other than a smooth, white canvas. If you want to build up *textural* effects, use fast-drying products such as underpainting white, modeling paste, or oil gel medium and follow the directions on the tube. (See page 29 for an example of this effect.)

Many artists also underpaint their canvases because they prefer to paint on a neutral color (such as gray or tan). That way, light colors show up and don't need to be corrected for value later. Artists also sometimes experiment with underpainting in a "countercolor," which adds subtlety and interest to the top colors. The landscape on page 117 was underpainted in Alizarin Crimson to add interest to the mainly cool colors that were added on top. The image below shows how underpainted color can influence the color on top.

If you would like to paint on a tinted canvas, thin your paint with odorless mineral spirits or Turpenoid and paint a transparent glaze (called an "imprimatura") over the canvas. This will dry rapidly and can then be painted over.

## Can I underpaint an oil painting with acrylic paint?

*Never* underpaint an oil painting using opaque acrylic or acrylic medium. I know that many respected artists have used this technique. However, the latest scientific findings advise against this practice, because solid acrylic forms a closed surface that prevents a good bond with oil paint. You can thin acrylic with water to the consistency of watercolor paint to put a *transparent* veil of color on the canvas so that the white of the canvas shows through. This technique can also be used to seal a sketch on the canvas.

*Underpainting in countercolors*

# Creating a Still Life Painting

You will need the following:

**PAINT**: All thirteen colors that make up your standard palette

**OTHER SUPPLIES**: One 8 x 10-inch canvas panel, all basic painting supplies, and three vegetables or pieces of fruit

**TIME**: About 9 hours total (three sessions, each roughly 3 hours)

Standard painting procedure is to work on the whole painting at once. The canvas is first covered with general areas of color and shadow, the painting is then gradually developed, and the details are added last. I have found that this method leaves students fearful and frustrated because they can't see their way past the "mess" of their first layer of paint. I find it easier to present each element separately; that way you can see progress from the beginning and your canvas will never look hopeless. This method also gives me the opportunity to break down the process into manageable steps and teach one thing at a time. Standard painting procedure will be demonstrated at the end of this lesson.

## CHOOSING YOUR SUBJECT

It is much better to paint something simple well, than it is to paint something complex poorly. Pineapples, grapes, and peppers are extremely difficult to paint and I don't recommend them for beginners. On the other hand, some fruit, such as oranges and grapefruit, are so simple in shape that it is hard to make them look like fruit and not beach balls. Things that are long, such as bananas, celery, and some kinds of squash, involve perspective drawing and also present problems for the beginner. Here are some tips.

**GOOD CHOICES**: Round (rather than long) squash, radishes, eggplants, mushrooms, tomatoes, pears, apples, peaches, plums, strawberries, nectarines, cherries, limes, and lemons are all good choices; you can find others. Objects that have several colors or are speckled will add interest to your composition, too.

**BAD CHOICES**: Red Delicious apples (too dark); oranges and grapefruit (too geometric); grapes, onions, garlic, pineapple, peppers, and lettuce (too complicated); celery, carrots, bananas, and long squash (too hard to make it look like they are lying flat on the table). All of these choices present difficulties; I suggest bypassing them for the time being.

Choose vegetables or fruit that have a variety of sizes, shapes, and colors. Don't get such an extreme variation in size that one dwarfs the rest, however; a cherry paired with a watermelon won't work. I would choose all fruit or all vegetables so that the objects have something in common. For convenience, though, I will refer to your subject as "fruit" from now on.

Look around the produce section of your market and see what you can find. Look for things that have interesting shapes and colors without being too complicated. A leaf and stem can make an interesting addition to a piece of fruit, but avoid masses of green leaves.

Although you may have to replace your fruit if it gets past its prime, it's best to work from real fruit so that you can really study your subject. Don't use artificial fruit and don't make it up out of your head. One of the goals of this exercise is to closely observe what you are painting. If you make it up, your painting will not be believable.

You will need three objects in total. If you choose to include more, it's best to get an odd number. This will help in maintaining variety. Buy more so that you have choices when you're organizing your composition.

# COMPOSING THE SUBJECT

Use what you have learned about composition to arrange your three objects in an interesting way on the paper towel. You'll notice that I didn't have you use a regular cloth napkin; this is because I want you to focus on the fruit—and not get distracted by the intricacies involved with depicting folds.

1. Set up your painting area, but don't put your paint on the palette yet.

2. Place a white paper towel or napkin where you can easily see it (more about this in Step 5) and arrange the three objects on top, keeping in mind what you have learned about composition. Place the largest piece of fruit in the rear and the other two further forward, at different depths. Consider laying one of the objects down. Overlap two and leave one separate. If there are stems, have them point inward, rather than out. (If you really want to paint the fruit in a certain position, but the stem is pointing the wrong way, simply paint the stem the way you want it to go, turning the fruit as necessary when you are ready.) A piece of fruit that won't stand up can be propped up with an eraser or stabilized by having a small bite or slice taken off the bottom where it doesn't show.

3. Light the subject. It is amazing what light can do to add drama to a few pieces of fruit. The light should come from the front and to one side. A table lamp is a better idea than an overhead light or a window, because the light will be strong and constant. To see how shadows can play an important part in a composition, look at the painting on page 101.

4. The background will be a color of your choice and can be entirely made up. Please don't try to make a real-looking table, and don't worry about it now. It will be painted after your sketch is complete.

5. The napkin that you used in Step 2 is for positioning purposes only, so keep it flat. For this exercise, I plan to have you design your own napkin according to what will look interesting with the shapes of your fruit. If you want to paint a real napkin, keep it *simple* and arrange your fruit so that the tallest piece is higher than the back edge of the napkin.

## Troubleshooting Your Composition

Take a long look at your arrangement, referring back to the common mistakes list. Consider whether you might want to make a piece of fruit larger or smaller when it comes to the sketch. Although you should paint the fruit as close to life as possible, remember that you have the power to alter the size of any individual piece to make it look better in the composition.

# SKETCHING THE SUBJECT ON THE CANVAS

Now you are ready to sketch your subject onto the canvas. When choosing a medium for the sketch, the most important criterion is that it be easily removable; you may change your mind several times before deciding on the final arrangement. The other important consideration is that the sketching material should be compatible with your paint.

As mentioned in Lesson Four, the best medium for sketching on canvas is paint. Thinned with paint thinner or medium (*not* Turpenoid Natural), paint can be as light as you want it to be for the first tentative placement of shapes, and then darker as you become more certain of your choice of composition. The painted lines will prevent you from getting too

detailed too soon, and mistakes can easily be removed with a rag or paper towel.

I strongly advise against using pencil to sketch your composition. Pencil lines encourage finely detailed drawings that you may be reluctant to bury under paint, thus creating a coloring-book approach to painting. Painting is a matter of applying one layer of color over another. The first layer is simple and without much detail, and then other colors and details are added on top. If you draw all your details with pencil, you will lose them with the first layer of paint. In addition, pencil line is hard to erase, and if it remains, it has a surprising capacity for showing through paint in inappropriate places.

Charcoal pencils are also a bad idea. They are made for sketching on paper and don't erase easily. In addition, the intensely black charcoal mixes into and muddies paint that is applied over it. Charcoal is helpful to acrylic artists for

their canvas sketch because their paint dries too quickly to be altered; the proper charcoal for sketching on canvas is vine charcoal. Vine charcoal comes in thin sticks and is made to dust off easily. It will still muddy your color, so it's a good idea to blow and wipe off the excess so that just a minimum remains. I've seen artists use hairspray to set charcoal, but I think retouch varnish is a better idea since that is certain to be compatible with the paint.

Rather than using pencil or charcoal, I prefer to "sketch" my compositions with thinned paint, and I suggest you do the same. After you are satisfied with your arrangement, squeeze out a small amount of Burnt Sienna in its usual place on your palette. Use either medium or paint thinner to thin the paint so that your first lines are very light. (Using paint thinner will help your sketch dry quickly.) Burnt Sienna is a good neutral color for the sketch. (For a cool painting, use French Ultramarine blue.)

*Linda Arthur,* Still Life, *oil on canvas. This painting and the ones by Betsey Domis on page 72 and by Mirjam Borovsky on page 75 were painted for the still life project in the beginning painting course. Notice how Linda has arranged the stems to lead into the composition.*

# DRAWING WHAT YOU SEE

To learn how to draw you must first learn how to see. Everyone has simple images stored somewhere in a mental filing cabinet: a house, a face, a tree, etc. Frequently these symbols were fixed in the mind by the third grade. When faced with the need to draw an apple, many students will ignore the apple sitting in front of them; instead they will rummage through their dusty mental files and make something that looks vaguely heart-shaped on the top—just as they did in third grade. Our first job, then, is to force our minds to actually *look* at what we are drawing rather than using an old symbol.

## Part One: Laying in the Rough Sketch

This two-part guide will help you draw anything from life. Read through this whole section first—and then come back and follow each of the steps to sketch your still life onto the canvas.

### DRAWING WITH YOUR FINGER

First decide where you want the largest element in your composition to be. Using your finger, "draw" the object on the canvas, and imagine the object in that position. Don't skip this step. It may seem foolish, but it serves a purpose.

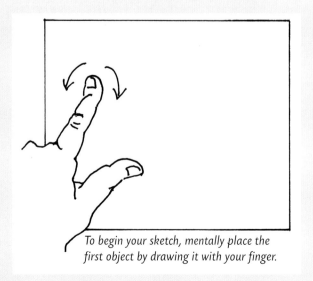

*To begin your sketch, mentally place the first object by drawing it with your finger.*

### RESERVING THE SPACE

When you have mentally placed the first object, make a mark where you think the top edge should be. Then make another mark where the bottom will be, and then one for each side. Make sure you leave room for the second and third objects. Also check to see if you have the right proportion of width to height.

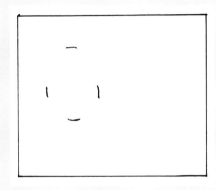

*Now place lines marking the boundaries of your first object.*

### DRAWING THE GENERAL SHAPE

Next draw the general shape. Try to get the main angles and divisions right, but don't do any fancy drawing yet. Never draw a curved line without first mapping the curve—including where it starts, how far out it comes, and where it changes direction. Place a small mark at each point. Another method (which I have used in the illustrations on the facing page) is to draw the object with straight lines; this is called "blocking in."

### CHECKING AND COMPLETING YOUR SKETCH

Before you commit yourself to a detailed drawing, you can change your mind and use a little thinner to erase any or all of this first shape if you decide it needs to be moved a bit. There is nothing worse than doing a beautiful drawing only to decide that it really needs to be an inch higher on the canvas. Once you are happy with the details and position of this first piece of fruit, repeat this process with your other two objects.

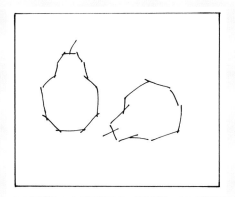

*Then draw the general shapes of all the objects.*

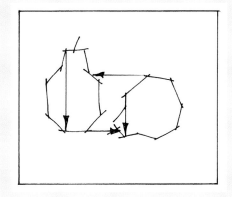

*Use plumb lines to check the spatial relationship of your objects.*

## Part Two: Making an Accurate Finished Sketch

Now that the basic drawing is done it's time to carefully check the relationships among the objects in your drawing. Here are some techniques for getting an accurate drawing.

### COMPARING HEIGHTS

Compare the height of each object to its neighbor(s). If you were to draw a horizontal line from the top of the second object over to the first, where would the line hit the first object? (You'll have to make mental adjustments, of course, if you have altered the size of one of the objects for compositional purposes.)

*Compare heights to insure the accuracy of your drawing.*

### USING PLUMB LINES

If you were to drop a vertical plumb line from a higher object, where would it hit on a lower one? To check the alignment of the objects in your canvas, use plumb lines.

### COMPARING INTERVALS AND PLACEMENT

How much space do you see between the objects? Check your intervals to make sure that you are happy with them. How much lower than the first object is the second one? The third than the second? Check the placement of the objects in your drawing.

*Check intervals (LEFT) and placement in space (RIGHT).*

### USING NEGATIVE SHAPES

Look at the negative shapes between the objects to help you get the correct relationship.

*Check the negative shapes.*

# EVALUATING YOUR WORK

It is important to stand back periodically and examine your work from a distance. Paintings that looked perfectly fine close up will often reveal the need for some adjustment when you get back a little. Evaluate your composition by standing back at least fifteen feet. Make it a practice to do this *frequently* while painting.

The main consideration is not whether you have copied your still life subject accurately, but how it looks on your canvas. If something needs to be moved in your composition, move it, and then change the still life setup to match the adjustment you made. Here are some of the things you should ask yourself:

**IS MY SUBJECT TOO SMALL?** Do my objects satisfactorily fill the space? Whenever you start to worry about what you are going to put in the background to fill up the canvas, a warning bell should sound in your mind that you haven't drawn your subject large enough.

**IS ANYTHING FALLING OFF THE EDGE?** Does any part of my drawing look as though it is about to fall off the bottom or out the edges? Leave enough clearance at the margins.

**SHOULD SOME SIZES BE ADJUSTED?** Would the composition look better if one of the objects was made larger or smaller than it actually is? Each object can be made a little larger or smaller if necessary for greater variety of size.

Check back to the section on composition on pages 74–79 and make sure you haven't made any obvious compositional errors.

# MAKING A CONTOUR DRAWING

It's time to set out the rest of your paint. Our first palette setup was designed for learning color theory, but now we don't need the neutral primaries. Set out all your paint in the usual way without leaving spaces for those mixtures, and you will have a good all-purpose palette setup. You will find it useful to put an extra daub of Cadmium

*To continue the sketch of your still life, do a contour drawing of each form in its basic color.*

Yellow Medium in the orange space, ready to be mixed into orange, and a second daub of Permanent Rose or Alizarin Crimson in the violet space ready to be mixed into violet. (Always mix these secondary colors.) We don't always mix green, but until you learn how to handle Thalo Green, place a daub of Lemon Yellow Hue near Thalo Green to be mixed into green.

Now that you have set up the palette and have the whole composition sketched in and evaluated, let's do a detailed contour drawing of the fruit. Contour drawings are a valuable tool to help you really *see* what you are looking at. Instead of assuming you know what something looks like, you need to closely observe your subject, noting the subtle changes in color and form that make up *this particular object*. Experienced painters don't generally create contour drawings in paint; however, I find them extremely helpful for beginners and you already have each form blocked in to guide you. For this drawing, use your pointed sable brush and dilute the paint with enough medium to make a continuous line.

1. Choose the basic color of each object (red for a red apple, yellow-green for a pear, etc.). Use Yellow Ochre to draw anything yellow.

2. Identify the shape that is farthest back and load your pointed brush with a runny mixture of the basic color of that shape.

3. Focus your attention on a spot at the edge of the object and let your eye follow along the edge, painting that edge on your canvas as you go. Proceed very slowly.

4. Examine each subtle bump or indent along the edge of your object. Even an orange is not perfectly round. Remember, don't draw what you think is there, draw what you see.

5. After you've completed the outline of your first object, add any stems or blossoms (the spot on the fruit that is opposite the stem).

6. Repeat Steps 3–5 with each of the remaining pieces of fruit until you have completed your contour drawing.

## CREATING A SHAPE FOR THE NAPKIN

When you have outlined all of the fruit to your satisfaction, dilute some French Ultramarine blue with medium for drawing the napkin. We will design the shape of the napkin rather than painting it as it is because our goal for this exercise is to make an interesting shape around our objects.

1. Paint two dots, one for each front corner of the napkin. Make one dot higher than the other, and keep both dots out of the corners of your canvas and not too close to the bottom edge.

2. To get the napkin to look as though it is lying flat, make two back dots that are closer together than the front two.

3. You don't want to completely enclose the objects. Instead, the tallest object (and any others you choose) should rise above the back edge of the napkin. Adjust your back dots, if necessary.

4. Now connect the four dots. Make the edges of the napkin curve in and out slightly for more interest. Where there is a bare space in your composition, consider making the edge a little wavier, and try not to make any edge of the napkin parallel to the edge of the canvas.

5. If you have a piece of fruit that comes so close to the edge of the canvas that you feel you are squeezing the napkin into a tight spot, let the napkin go under the fruit and let the fruit stick out over the edge of the napkin. Any napkin edge that goes in back of or under a piece of fruit should intersect the fruit at an angle so that the edge is obviously in back of the fruit. (See image on page 83.)

6. Evaluate your napkin shape and change the outline as desired.

*Draw the napkin through the fruit and then erase that part of the line. This will make it easier to draw the napkin edge.*

*To draw the napkin, place a dot for each corner. Notice the dots in the back are closer together than the dots in the front; this helps to make the napkin look as though it is lying down.*

# SKETCHING IN THE CAST SHADOWS

The cast shadows are next. Look carefully at their direction and shape. Notice that round objects make oval shadows. Take note of where each cast shadow appears to touch the edge of each object. Using the same diluted blue paint that you used to outline your napkin, make a dot at each of those points.

Now map the curve. Make dots to mark how far down each shadow comes, and how far out to the side. (It might extend past the edge of the napkin.) Then lightly draw each cast shadow. If you follow these instructions, you will avoid the mistake of making the cast shadow crawl up the side of the object.

Draw the cast shadows. Look to see where they intersect with the shape that is casting them.

This poorly drawn cast shadow climbs up the side of the pear instead of lying down flat.

*Paint cast shadows with soft edges that become even more blurred as they travel away from the object casting them.*

## GETTING STARTED

### What should I paint first?

Generally speaking, background areas are painted first (or at least roughed in), so that the objects in front can be overlapped. If you decide to paint the background second, or have to repaint the background, be careful not to leave a ridge of paint overlapping what is supposed to be in front. It will confuse the feeling of spatial depth.

# STARTING TO PAINT

We will begin painting the background, and then overlap the napkin. Keep the paint layer in the background fairly flat.

## Making the Background

The background should be painted a solid color, at least to begin with. Choose a color that will look good with the colors in your composition and will contrast with any part of your still life that it touches. My pear would show up best against a dark background, but I have chosen to make it light so that I can illustrate the concept of dark edges against a light background, which we'll talk about later on.

## Adding the Cast Shadows

Mix French Ultramarine blue and Burnt Sienna to make black. Add white and a little more blue to make a blue-gray for the cast shadows on the napkin. Paint the cast shadows light gray, increasing the darkness of the shadows to almost black as they go under the objects. Use a #2 or #6 flat bristle brush and pointed sable for the shadow underneath. Your finishing brush strokes should be horizontal. If a cast shadow goes off the napkin, the shadow color will be related to the background color; don't paint that part of the shadow now.

## Creating the Napkin

Use a #6 flat bristle brush to paint the napkin white. Let your strokes have a slight wave while still keeping them in a horizontal direction to suggest the softness of a napkin. If you have folds, the strokes should follow the folds. Overlap the edges of the cast shadows and blur them slightly. Be sure to paint right up to the edges of your objects.

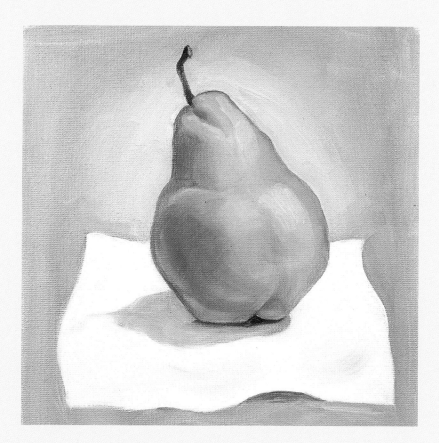

*A plainly colored fruit (pear).*

# PAINTING THE FRUIT

You are now ready to begin painting the fruit. We will concentrate on one piece at a time, starting with the one that is farthest back. The examples shown on these pages deal with a pear and an apple, but the method can be used to match the color of anything.

You must make several color decisions. The first of these deals with the actual colors of the fruit, disregarding lights and shadows. The body color in this case is simply the color of the fruit. Some fruit, such as a pear or a lemon, has a plain color; the color is essentially solid. On the previous page is a painting of a plainly colored pear. Other kinds of fruit, such as Macintosh apples, have blotches of two or more plain colors. And still other kinds of fruit, such as many apples and peaches, have colors layered on top of one another. (Layered color is demonstrated in a step-by-step painting of an apple on pages 92–95.) The second decision is what colors are needed for the body shadows, and the third is how and where you will place the highlights and reflected lights. Let's take these one at a time.

When you are ready to paint, be sure to reserve enough time to finish each piece of fruit at one sitting, because it is easier to blend colors if your paint is still wet. I recommend you read through the directions on body color first, and then look over the application of this procedure in the painting of the pear and the apple in the following demonstrations.

## Determining the Body Color

It can be a challenge to match a color unless you know how to go about it. I always use the following three-step process: find the hue, adjust the value, and adjust the chroma. I've utilized this procedure to match the color of my pear (on page 89). Once you get comfortable with the technique, you will be able to use it to help you match the color of anything.

### FINDING THE HUE

Choose the colors of paint on your palette that come closest to the color that you are trying to match. If you combine two or more colors, consider using less brilliant variations of the primary colors. You may be so used to mixing bright colors that you haven't considered using, for instance, Alizarin Crimson and Yellow Ocher to make orange instead of Cadmium Red and Cadmium Yellow.

Take a look back at the Exploring Subtle Secondary Colors exercise on page 56, and consider which of the reds, yellows, and blues on your palette you should choose for the color you need. A few experiments will let you know if you're on the right track. Or you can start out with the familiar bright combinations and dull them in the following steps. Either way works. There is more than one way to arrive at the color you want.

Remember to start your mixture with the lighter color. Try to judge whether you have the right proportion. Hold the paint up to the fruit to see whether you need more of one color or another. (Does the yellow-green need to be more yellow or more green?) Remember that you are not judging value or chroma at this point, just the proportion of your ingredients.

My pear was yellow-green. I judged the color to be more yellow than green, so I used just a small amount of green. The yellow-green was dull, so I didn't use the Lemon Yellow Hue/Thalo Green combination, which I know is very bright. Instead I used the warmer Cadmium Yellow Medium, adding just a touch of the powerful Thalo Green. I then scooped up some paint on my palette knife and held it up to the pear. The proportion of yellow to green looked right, but I saw that it was too dull, so I added a small amount of Lemon Yellow Hue to make it brighter. Then the color looked almost right.

## ADJUSTING THE VALUE

Assess the value of your color. Is it too dark? If so, add white to lighten the color. (Note that white is added *after* the hue has been determined; often the yellow in mixtures will do whatever lightening is necessary.) If the color is too light, add darker versions of the colors you used to make it.

To check my pear, I held the color up to the pear again to asses the value. The color needed to be a little lighter, so I added white. Then the color matched the pear exactly in hue and value.

*Finding the hue and value of a plainly colored pear. The top color swatches show the hue of the pear and the colors that I used to mix it. In the bottom swatches you see how I adjusted the value by adding white.*

## ADJUSTING THE CHROMA

The most common problem in making color mixtures is that they often end up too bright. If you have used less-bright versions of colors in your mixture and it is still too bright, or if you started out bright and need to lower the chroma, here are three ways to do it:

**ADD WHITE.** Adding white will make a color less bright, but if you have already matched the value, you won't want to add any more.

**ADD AN EARTH COLOR.** A brownish color, such as Yellow Ochre or Burnt Sienna, will make your color duller, but will also make it browner. Ask yourself if you think your color should be browner or grayer. If the answer is grayer, then go on to the next solution.

**ADD THE COMPLEMENT.** Frequently the answer to making a color less bright lies in adding some of its complement. Be sure to match the value of the complement before adding it to your mixture, and then add it a little at a time. If you have a mixture of two or three colors, think of what the complement is of each of the colors. For instance, blue-green could be separated into blue (complement: orange) and green (complement: red); combining the two complements would give you red-orange.

Adding the complement is often the best choice. I recommend starting with this method. For my pear, because I chose a yellow and a green that didn't make a bright hue and then added white while adjusting the value (which also reduced the chroma), further change was unnecessary. I painted the color on the canvas, varying the color more toward green or yellow as I saw the color changes on my pear. I also added a little Burnt Sienna to the Thalo Green on the right edge to more nearly match the brownish green I saw there.

If your fruit has some blotches of plain color, match the colors, paint them, and go directly to adding the shadows. If your fruit has layered color, see the next section on painting in layers.

## Using Layers of Color

Fruit and vegetables frequently have splotches and areas of one color over another. Try to see if there is a color that seems to be *underneath* the others. (Yellow of some kind frequently appears under greens and reds.) Then try to see how far this color extends under the others. Paint the underlying color first, keeping the paint layer thin but solid. Fill in any remaining areas with the body color.

Paint the second layer while the first is still wet. Use a light touch and your #6 flat bristle brush or angled shader to add the second color. If you have trouble painting the second color, you may have to wait until the first layer is dry, but it is preferable to work wet-in-wet. Your hake brush will blend the two wet layers. If you find it necessary to wait until the first layer is dry, then dampen the section slightly with medium, apply the second color, and blend the two layers with your hake brush.

## Adding the Body Shadows

It is time to add the shadows to your fruit. Before you begin, review the Rule for Shadows on pages 58–59.

1. Determine the shape of the shadow. Look carefully for the general shadow shape on the object you have just painted.

2. Create various shadow colors if necessary. If the body color is a mixture of several different colors, make the appropriate shadow colors for each of these colors. Details can be painted over and added again later.

3. Check the shadow color. Hold it up to the actual shadow to check for color and value. If the body color is still wet, you may need to make your shadow color darker to compensate for the fact that you will pick up some of the lighter color underneath.

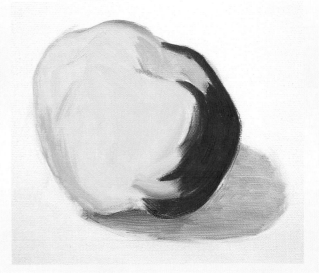

*To paint a layered color in this apple, first I filled in the underlying color (yellow) in the layered area, then I added the rest of the body color (red).*

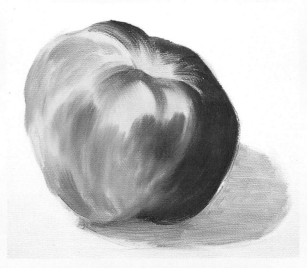

*Next I added the second layer of body color over the yellow section of the apple.*

4. Apply the shadow color to your fruit, blending the edges to create the halftones.

5. Darken the core, if you see one. Paint what you see. If you don't see a core of shadow (you probably won't), don't put it in.

*6.* For the time being, ignore any reflected lights that may be in the shadow.

*7.* Look for dark edges on light areas. When you check the edge of a light area of the fruit, notice the contrast between that edge and the white napkin. The light edge looks dark against a light background. Very often shapes that are turning away from you, when seen against a lighter background, appear to darken. (This wouldn't be noticeable against a darker background.)

Use a little shadow color to darken the edge if necessary, and then blend that darkness gently into the form of the fruit so that it doesn't look like an outline. (Your angled shader will work well for this.) I used this technique to good effect on my pear, which really did look very dark at the edges, even on the lighted side.

*8.* Evaluate your work. Stand back and assess the value of your shadow colors.

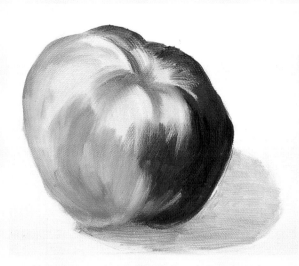

*To add shadows to the apple, I darkened the reds with Alizarin Crimson grayed with green. Then I darkened the yellow-green shadow areas with Yellow Ochre and green grayed with Alizarin Crimson.*

*To add body shadows to my pear, I darkened the yellow-green with Yellow Ochre, Burnt Umber, and Thalo Green. Technically the complement of yellow-green is red-violet, but when you mix these two colors the result will always look too warm because of the earth tones in the yellow-green. So I added French Ultramarine blue to compensate, and the resulting blue-violet worked well.*

## COLOR MATCHING

*Why can't I match the color?*

If you have followed the directions to create a particular mixture and still are having trouble getting the color you want, it is invariably a question of proportion. Is it a lot of red with just a touch of yellow, or a lot of yellow with just a touch of red? Try to evaluate what color you have too much of and then use less. Many times the more powerful pigments on your palette, such as thalos and cadmiums, have to be used in very small quantities or they will dominate a mixture. Start fresh and try again.

*When matching colors, scoop up some of the paint you have mixed on your brush and hold it up to the color you are trying to match.*

## Adding the Lights

Now we add the light areas on the fruit—both the highlights and the areas of reflected light. Use thick paint for the highlights, but keep the reflected lights the same thickness as the rest of your paint layer. Be careful not to get these areas too wet, and use the hake brush to eliminate obvious brush strokes.

### HIGHLIGHTS

Look carefully for the highlight(s) on your fruit. The shinier the fruit is, the lighter the highlights will be. Highlights are slightly gray, so add a very small amount of the complement to white. In no case should the white look like the complement; it should look off-white. Adding this touch of color will help prevent getting a pastel version of the fruit's color.

The dark purple of eggplant presents a particular challenge when painting wet-in-wet because a white highlight will immediately become bright purple as it picks up the under layer of paint, even if gray has been added to the highlight paint. (See pages 52–53 for tips on graying purple.) In cases such as this, it will be easier to let the surface dry and then paint the highlights and reflected lights into a surface dampened with a little medium. (The medium will allow you to blend the edges.)

### REFLECTED LIGHTS

Reflected lights are added in the same way as highlights, but they are not as bright. Look carefully at the shadow areas of your fruit, particularly at the area where the shadow area meets the cast shadow. The white napkin should reflect up into the areas of the fruit that are close to it. To create this effect, either use white plus the complement of the body color, or mix a light gray.

Gently paint the reflected light into the fruit where you see it. If you have trouble with the underlying color mixing in too much with your reflected lights, wait until the fruit dries and then glaze or dampen it with medium according to the instructions on page 96.

## Adding the Final Shadows

Add any cast shadows that extend beyond the napkin. Since these shadows fall on the background color, follow the Rule for Shadows on pages 58–59 to mix that color and paint the shadow on the background. Remember that the shadow is always a darker, grayer version of the color on which it is lying. If there are ripples along the bottom edge of the napkin, paint a touch of shadow in the same color under each ripple where it lifts off the background; don't add shadows to any other edges of the napkin.

## Adding the Finishing Touches

Often fruit and vegetables have speckles and spots. These are best painted into a wet surface. They can be painted on with a brush or you can use the spatter technique—but be sure to mask the rest of the painting. It is sometimes difficult to make spots look like they are part of the surface rather than sitting on top, but if you paint them into wet paint, you can use a dry hake brush to merge them into the color underneath.

If you can't get the spots to stick to the wet paint, let the paint dry and then dampen the surface with a *small* amount of medium or glaze before applying the spots. Use your hake brush to blend them if needed. This method works well and there is less danger of smearing the colors while blending.

Repeat the steps above to complete each of the pieces of fruit or vegetables. When you are done, step back and assess the color, lights, and shadows and make any adjustments necessary.

Pattern (which is formed by the repetition of shapes) can add a lot of interest to a painting. If your objects have lots of spots or splotches, you may already have enough patterns, but if not, you might want to consider adding a pattern to the napkin or the background.

# Glazing Your Work

Glazes can be used to achieve a number of effects. It is a slightly tricky process, though, so refer to page 35 and review the technique before you take out your brush. You might consider using a glaze in your still life painting for the following reasons:

**TO ADD DEPTH AND TRANSPARENCY.** Some very shiny fruit, such as apples, benefits from adding a glaze of the body color when the color is dry. This final layer of color adds depth and transparency to the image.

**TO DEEPEN SHADOWS.** Shadows can be made darker with the addition of gray glazes (glazes made *without* white). The gray is made from diluted French Ultramarine blue and Burnt Sienna or Burnt Umber. If you found, for instance, that the peach you had painted really needed darker shadows, you would mix black, dilute to gray with medium, and brush the glaze over the area you wanted darker.

**TO ADD HIGHLIGHTS.** If you have had difficulty painting a highlight on a dark vegetable (such as on an eggplant, for instance, where a

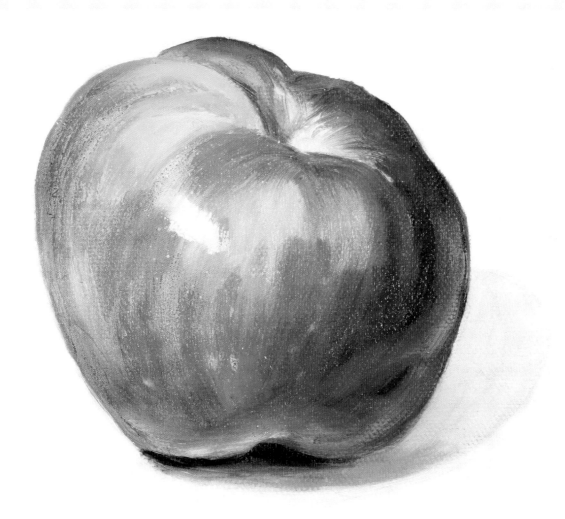

*The finished apple. I made a glaze by adding a little Alizarin Crimson into the medium. This increased the depth and transparency of the color. I then added a highlight and reflected lights.*

white highlight will mix with the eggplant color and turn lavender), try applying the highlight when the painting is dry. Simply dampen the area slightly with either medium or a glaze that is the same color as the body color of the object and then apply your highlight. The slight tinge of color in the glaze will not affect the highlight, and dampening the area will make it easy to blend the edges of the highlight into the surrounding color.

**TO ADD REFLECTED LIGHTS.** Use gray glazes that are made with white to place reflected lights on your object, controlling the value with the addition of more or less medium. If your brushstrokes show, use a hake or other dry blending brush to whisk them smooth.

---

## MORE ABOUT GLAZING

### Why can't I get my glaze to work right?

Glazing presents a number of unique challenges. Here are a few of the common problems—and how to fix them.

**BEADING UP.** Sometimes random areas of a painting will resist a glaze, causing it to bead up. If this happens, gently blot up the beads, spray the area with retouch varnish, and reapply the glaze. The stickiness of the varnish will help to grab the glaze. Another method is to gently dab the resistant surface with a soft, lint-free rag dampened with odorless mineral spirits. This should dissolve whatever is causing the resist. Wait two hours for the residue of the spirits to evaporate and then reglaze your surface.

**VISIBLE BRUSHSTROKES.** Simply whisk brushstrokes lightly with your hake brush and they will go away.

**A SPOTTY EFFECT.** If there are crevices on your canvas, the glaze can sink into them and create undesired effects. Before you glaze, check the surface of your canvas. If you suspect this might happen, use gel medium instead of liquid medium. It will make your paint transparent without thinning it, thus preventing it from sinking into the weave. Be aware that some gel mediums are fast drying and require the under layer to be thoroughly dry.

### What is a white glaze and when would I use one?

A white glaze is a special case. Because it contains white paint and therefore is likely to be *lighter* than the colors underneath, it places a veil over the underlying color. This veil, or haze, can be used to make a section of a landscape look more distant. Use medium to dilute white or mixtures of white with blue or lavender. The less medium you use, the more opaque the veil will be, and the hazier the under layer will look. Excess glaze can be blotted off, and a hake brush will remove obvious brush marks.

*Lisa Wilcox,* Monkey Jar, *oil on canvas. Lisa is not a beginner (she actually did this painting for my studio course) but her painting illustrates many of the skills taught in the basic techniques course. She has a good sense of composition; notice that by coming in very close to the subject, she has made the shapes of the jars form a strong design. She has also handled the shiny surfaces very well.*

# DEMONSTRATION: CREATING A STILL LIFE

I chose some of the items frequently found in still life paintings (flowers, pottery, fruit, and a patterned cloth) for this demonstration to give you an idea of how to approach the painting of these subjects. Notice the importance of lighting. By using a single strong source of light, I was able to create not only dramatic contrasts of light and dark, but a pattern of cast shadows on the wall that fills what would be empty space in the composition and provides a connection between the flowers and the items on the table. The spotlight throws a warm light on the arrangement and makes the tomatoes glow.

*First I sketched the main objects of the still life and added the shadows.*

## Making the Sketch

I started the sketch by making a line for the topmost element, a flower. I made another line indicating where I thought the bottom of the jug should go. Once I was satisfied with the placement of the top and bottom of the largest element in the design, I lightly drew in the jug and the general shape of the flowers in ovals (no petals). I then added the tomatoes and napkin.

After finishing the preliminary sketch, I stood back and evaluated the composition, and then adjusted the drawing by wiping with a rag dipped in thinner. I added shadow shapes and a darker color for the jug and tablecloth. Because I still felt the need for something in the upper left, I added a darker tone. This should focus attention on the center of the design.

## Painting the First Layer

I set out the basic palette and began painting body colors and shadows, starting with the background areas. I added a little warmth to the blue of the table so that it was in harmony with the rest of the warm painting. A mixture of French Ultramarine blue and Raw Sienna in the background wall repeated the color of the tablecloth in the bottom of the painting. The shading of the wall was tricky because it had to be dark enough to balance all of the intense colors at the bottom and provide contrast for the white daisies, and yet be light enough to show the cast shadows, which were such an important part of the composition. The daisies were roughly indicated in their shadow colors. I left the stems for last to allow for final adjustments in the background color.

# Refining the Painting

I adjusted the colors in the tomatoes, adding more yellow and orange, and then finished them so that I could work wet-in-wet all the way through. I refined and deepened the shadows, adding details to the blossom ends as well as highlights and reflected lights. I also nearly completed the napkin, again to take advantage of working into wet paint; this helped me get soft edges on the folds. I added a little Raw Sienna to the white of the napkin to continue the feeling of a warm light.

I repainted the background and shadows with a darker color, darkened and refined the shadow shapes of the daisy petals, and then painted the dark part of the centers.

I checked the jug for symmetry by simply tracing it onto a separate piece of paper and folding the tracing in half. Looking at the folded tracing, I chose which side of the jug I preferred and cut along those lines. I then opened it up, placed it over the painting, and traced around it with white paint. I refined the shape of the jug and added the shadows, reflections, and reflected lights and highlight to the body of the jug. The transparency of Burnt Sienna will require another layer of color after this dries, and I'll add the handle and refine the top at the next step.

*Next I filled in the body color throughout the painting.*

*Then I developed the colors and shapes, added some details, and refined the dark values of the daisies and their shapes.*

## Adding the Finishing Touches

I used the background color to clean up the edges of the daisies and the jug, and then added the lights into the daisies, taking care to paint the petals simply and directly. I added a little Raw Sienna to the white in keeping with concept of a warm light. (Pure white would have looked too cold in this painting.) I added lights to the yellow centers of the flowers and then used an angled shader to paint the stems. I glazed the jug with a combination of Burnt Sienna and Burnt Umber; then I refined the top of the jug and added highlights and a handle. Finally, I refined the cast shadows under the tomatoes and the shadows on the napkin.

After standing back and assessing the painting, I darkened and cooled the background color at the top edges and decided to add a pattern to the napkin. (Actually, the napkin looks just like this. It's part of an old set of linens from my mother, so it has special meaning for me and complements the rest of the composition.) The painting is now finished.

*In the homestretch I made final adjustments throughout the painting and added a pattern to the napkin. I finished the painting by adding lights to the flowers, and finally the stems and leaves. The still life is now finished.*

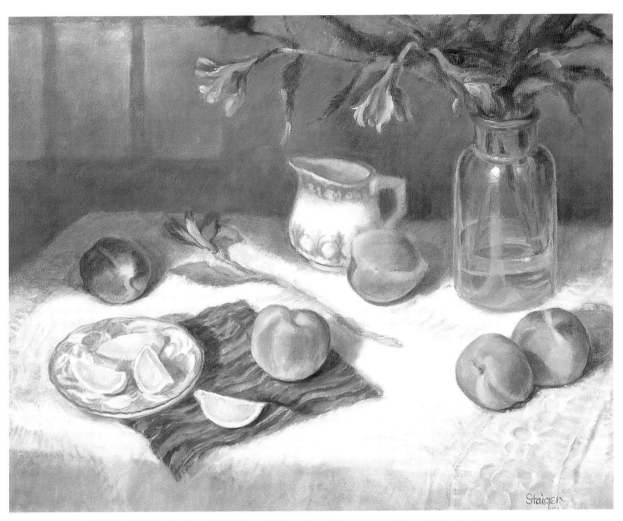

*Kathleen Lochen Staiger,* **Still Life with Peaches,** *oil on canvas. This painting features many different textures, including colored glass, pottery, peaches, flowers, and embroidered material.*

# Creating a Landscape Painting

LANDSCAPES ARE AMONG the most popular subjects for painting—whether they are interpreted abstractly or realistically. This lesson will show you how to make your landscapes both exciting and believable. We will begin with methods for creating the sense of spatial depth that makes it appear as though you could walk right into the painting. You will also learn how to get variety in your greens and how to mix other colors of nature. Next there is a how-to section on painting water, trees, sky, and other important landscape features. In the final section, a landscape paint-along will lead you step-by-step through the painting of a landscape.

OPPOSITE: *Nancy Tuttle,* Ghost Ranch Country, *oil on canvas. Nancy has done a good job here of using color and brushstrokes to suggest the foreground details, and her choices of color throughout the composition make a very appealing painting.*

ABOVE: *Christopher Domis,* Coconut Palm, *oil on canvas. Christopher has used a close-up view of a palm tree to make an intriguing composition of palm fronds and coconuts. The painting creates a wonderful pattern of positive and negative shapes with a nice interplay of light and shadow.*

# MAKING YOUR LANDSCAPES LOOK REAL

A realistic landscape has a sense of distance and a feeling of space. Artists use the rules of perspective to help them create this illusion of three-dimensional space. You have already used some perspective techniques. You know, for instance, that when objects are placed higher on the canvas they appear to be farther away, and that overlapping two objects suggests that one is behind the other. Two other methods are particularly useful in depicting depth in a landscape painting—linear perspective and aerial perspective.

## Linear Perspective

Linear perspective uses the artist's viewpoint to figure out the angles of things that recede into the distance. It can be a little complicated, so don't get discouraged if you don't get it right away. I will present the main principles in the next few pages. For a more in-depth study, I recommend Ernest Norling's book *Perspective Drawing*.

### EYE LEVEL

An artist chooses the viewpoint for his painting. Usually a landscape is painted from the artist's view as he stands on the ground, looking out at the scene he wishes to paint. In the far distance he will see the horizon. The "true horizon" will always be at his eye level, but the artist can only see the true horizon if he is in the desert or looking out to sea. In these cases, the artist will see a level edge (or horizon) where the earth and sky meet, and this edge will always appear straight ahead. The horizon line at the artist's eye level is what is used in linear perspective.

Unless you always paint desert scenes or seascapes, most of the time when you look straight ahead in a landscape you will see a natural horizon that is formed by things such as hills, mountains, and trees. This is not a factor in linear perspective. Since the true horizon is always level with the artist's eyes, the horizon line (H/L) equals the eye level (E/L). When we discuss the horizon line in this section we are always referring to the true horizon, not the natural horizon.

The horizon line is drawn with a straight line across the picture as a guide for figuring out the proper perspective alignment for the rest of the picture. A high eye level creates a high horizon line, meaning your painting will have more land and less sky. A low eye level gives you a painting that has more sky and less land.

### VANISHING POINTS

In linear perspective, all parallel lines that go off into the distance appear to come together and meet at some point on the horizon line. The place where they meet is called the "vanishing point" (V/P). This means that things that go into the distance will appear to get smaller and smaller until they disappear at some point at the artist's eye level. Notice in the image on the lower left on the facing page that the distance *between* evenly spaced objects also gets increasingly smaller as they get closer to the vanishing point.

*High eye level*

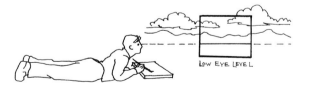

*Low eye level*

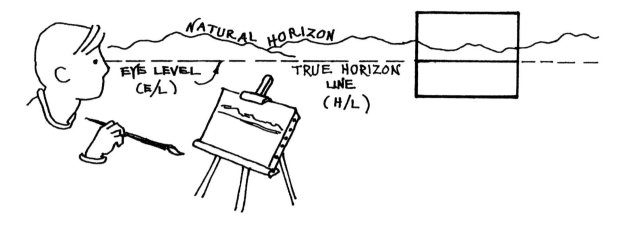

*Eye level and true and natural horizon lines*

Each set of parallel lines has its own vanishing point. If you can see two sides of a box, then one side goes back into the distance on the right and the other goes back to the left. This means that you will need a separate vanishing point for each side. Sometimes, in order to make things look right, you need to position the vanishing points beyond the frame of your canvas.

When painting a cityscape, remember that buildings are boxes. All of the windows, doors, and other architectural elements on the right side of a building will go to a vanishing point on the right, and likewise on the left. Guidelines for a row of windows will go to the corner and then change direction to go to the vanishing point on the other side. Above eye level, lines slant down; below eye level, they slant up; and at eye level, the line is straight. Notice that the higher an angle is above or below eye level, the steeper it is.

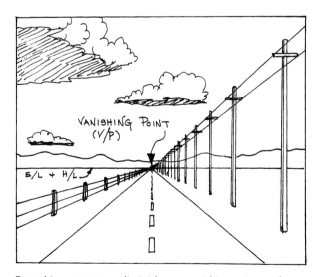

*Everything appears to diminish to a vanishing point at the artist's eye level.*

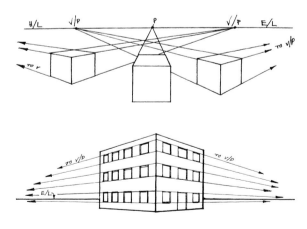

TOP: *Each set of parallel lines has its own vanishing point.*

ABOVE: *Buildings are large boxes; all of the windows and doors on one side of the building share the same vanishing point.*

## CIRCULAR FORMS IN PERSPECTIVE

Circles present unique challenges. At eye level a flat circle such as a coin becomes a straight line. Close to eye level the circle is a narrow ellipse, becoming more circular the farther it goes above or below eye level. When a circular object is directly above or below the viewer's sight, the full circle is seen.

Arms, legs, tree trunks, and flowers are a few of the circular forms that exist in nature; many man-made objects are also circular. Notice in the illustration below how the circles that make up a lighthouse get more and more rounded as they rise above eye level. Many objects commonly used in still lifes are also circles. When you draw an opaque glass or pitcher, remember that the visible part of the bottom of the object is part of a circle and will be more rounded than the top because it is farther below eye level.

Just as circles become ellipses when they rise above or fall below eye level, they also become ellipses as they turn away from you. Flowers are a good example of this phenomenon. Many flowers are basically circular in form, but you only see a perfect circle if the flower is facing you directly. If the circle is turning away, it will appear as an ellipse. The farther away the flower is turned, the thinner the ellipse will be. Always start your depictions of flowers by drawing the right ellipse as a guide.

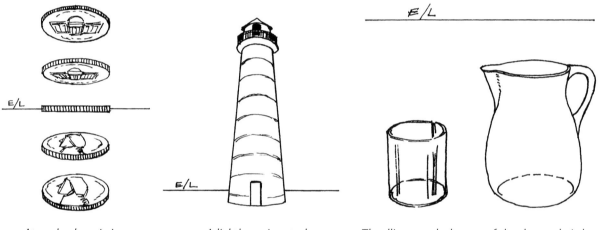

*At eye level a coin is a rectangle; the farther the coin is above or below eye level, the rounder it becomes.*

*A lighthouse is a stack of circles.*

*The ellipses at the bottom of the glass and pitcher are farther from eye level than the ones at the top, so they are more rounded.*

*When sketching flowers in preparation for making a painting, indicate each flower with the appropriate ellipse. Don't render individual petals.*

*Flowers are circular forms, and circles that turn away from you become ellipses. The farther they turn, the skinnier the ellipse becomes.*

# Aerial Perspective

The second perspective method involves changing color tones as objects recede in the distance. This is called "aerial perspective." We think of air as being transparent, but when enough air gets between us and something in the distance, it changes the appearance of that thing. The more moisture, dust, and pollutants there are in the air, the greater the change will be. Three things happen to color in the distance:

THE COLOR'S BRILLIANCE DECREASES. No color is as bright in the distance as the same color would be if it were close to you.

DARKS GET LIGHTER. No dark in the distance is as dark as one up close.

COLORS APPEAR BLUER. When objects recede into the far distance, the yellows lessen and blues increase.

Look at the difference between trees that are close to you and those in the distance. The greens of the trees nearby are bright and warm, but in the distance they look duller, lighter, and cooler. If you looked at a row of pink houses going down a road away from you, the first house would look pink but each successive house would appear a little bit grayer, lighter,

*Kathleen Lochen Staiger,* Colorado Mountains, *oil on canvas. This painting shows the effects of aerial perspective on chroma, value, and hue. Notice how the hills get progressively grayer, lighter, and bluer.*

*When depicting multiple ranges of hills, darken the top and lighten the bottom of each layer.*

and bluer. To paint these houses you would need to add larger amounts of green (the complementary color), white, and then blue as the distance increases. In a hilly landscape each succeeding range of hills also appears progressively grayer, lighter, and bluer. In the far distance, the hills won't have any green or yellow at all, but will be grayed variations of blue or purple.

To show the effect of aerial perspective on the color green (the most common landscape color), add red to gray it, white to lighten it, and blue to make it bluer. If you mix red, white, and blue together, you get lavender. That is why purples are so useful in landscape painting.

### SEPARATION OF PLANES

When making a landscape painting, it isn't enough to render what you see; you must exaggerate the color changes to capture the feeling of space between the objects in your landscape. If you were to set up your easel outdoors and faithfully copy each color that you saw, your painting would look flat. That's because seeing with two eyes enables you to perceive depth. When you transfer a scene to a two-dimensional surface, you don't have that advantage. In order to retain that sense of space between the front plane (foreground), middle plane (middle ground), and distant plane (background), you

need to exaggerate the differences in chroma, value, and hue.

If you have many layers of hills in your painting, you may find it difficult to make enough changes in the chroma, value, and hue to distinguish one range from the other. Try making each layer darker at the top and lighter at the bottom; each of these layers should also get progressively lighter. In this way, the top of each layer will contrast with the bottom of the one farther back.

NOTE: Mountains and hills in your painting do not always have to get progressively lighter in the distance. A cloud may cast a shadow over part of a landscape and make it darker. You can use this technique when you want a darker passage in the middle of your painting.

### AMBIENT LIGHT

When the sun is low in the sky, turning it to beautiful layers of reds, pinks, and yellows, that colored light becomes a part of everything in the scene and should be added to the color of every

*When the sky is filled with ambient, colored light, the glow is reflected down and becomes a part of every color in the scene. The farther back the object is, the more its color will be affected. Kathleen Lochen Staiger,* Evening Glow, *oil on canvas.*

object in the scene. The farther back each object is, the more sky color should be added to it. Sunset sky color is usually some form of peach—a combination of red, yellow, and white. Darker colors in the scene would employ darker variations of this color. Details are lost in this kind of light, turning distant hills into silhouettes. Mist or fog has the same effect but with a different palette; some form of blue-gray should be added to every color.

ABOVE: *To separate the planes and achieve a feeling of deep space, I exaggerated the differences in chroma, value, and hue in this painting.* Kathleen Lochen Staiger, Minnesota Pond, *oil on canvas.*

# MORE ABOUT PERSPECTIVE

*I'm painting a lake scene but my boat in the distance doesn't seem to be properly in the water. How can I figure this out?*

First, using existing elements in your painting, imagine how big the boat would be if it were closer to you on the shore. Using chalk, sketch the boat into your painting. Place a vanishing point on the eye level directly above the boat, and then draw a line from each side of the boat to the vanishing point. This creates a triangular perspective scale. Now, decide where you want to place your boat in the water, and follow horizontally over to the perspective scale to find out how wide your boat will be that far away from the bottom of the canvas.

ABOVE: *By temporarily sketching a boat close to you in the composition, you can quickly determine how large it will be anywhere else in the painting.*

BELOW: *Carole Olsen,* Peggy's Cove II, *oil on canvas. Carole had never painted before taking my basic painting course. Now her paintings sell for four figures.*

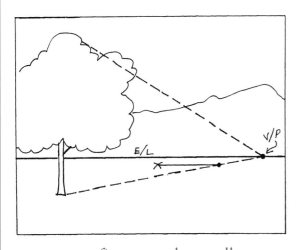

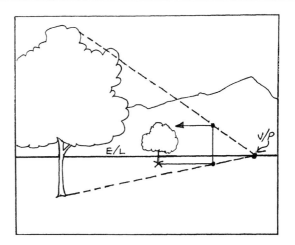

## How can I figure out how tall something should be in the distance?

To find out how tall something should be in the distance, you use essentially the same method as finding out the width of the boat in the previous example. First figure out how tall the object would be if it were closer to you, and then draw perspective lines back to a vanishing point at

*To determine the size of a tree in the distance, make a perspective scale from an existing or imagined tree to a vanishing point at eye level (LEFT) and then find the place on the scale that corresponds to the place where you want the new tree (RIGHT).*

eye level. This will give you a perspective scale that will enable you to place a similar object anywhere in the distance.

## I'm having trouble putting a roof on my building. Do you have any tips?

If you want to draw a peaked roof in perspective, you must find the center of the side of the building over which the roof is peaking. You can't simply measure the center because the area is diminishing as it travels away from you. Instead, you need to find the center in perspective.
To do this, simply use the old trick for finding the center of a rectangle: Draw lines to connect the opposite corners of the shape—where these lines cross is the center.

*To find the center of a square, draw lines to connect opposite corners. If the shape is flat, the intersection will be in the measured center. However, if the shape is receding into the distance, the measured center will be closer than the perspective center*

*The same method can be used to find the center of the side of a house in perspective when you want a roof to peak over that side.*

# SETTING UP A LANDSCAPE PALETTE

A landscape palette is very much the same as your usual palette except that it has a greater range of warm colors. I have mentioned that Thalo Green is a base color. Earth colors, Cadmium Yellow Medium, and the expanded range of oranges that you will mix for this palette are the colors that we add to Thalo Green to bring it into harmony with the greens of nature. (These colors can also be mixed with Thalo Blue for additional natural-looking greens.) Each of these oranges gives a distinctive green, so it is a great help to premix them on the palette.

Set up your landscape palette as you would your standard palette, but leave more room between Cadmium Yellow Medium and Cadmium Red Hue. In this space put out a large second daub of Cadmium Yellow Medium to mix into orange, but instead of mixing one orange, mix three. Start by adding a small amount of Cadmium Red to make yellow-orange. Leave about one third of this alone. To the remaining color add more red to make orange. Leave half of this alone and add more red to the remaining half to make red-orange. You should now have a progression of oranges between the yellow and red. You can omit Permanent Rose on your landscape palette unless you have a specific need for it; a more subdued violet can be mixed using Alizarin Crimson.

I like to add Indian Red (red oxide) and Oxide of Chromium (green oxide) to my landscape palette, as they are very useful in landscape painting. Indian Red is particularly useful in painting rocks when combined with blue. It combines well with Yellow Ochre for sunlit areas, and softens a variety of greens. It also assists Alizarin Crimson; a touch of Indian Red will make the crimson more opaque when needed. Because it comes out the tube as a low-chroma green, Oxide of Chromium can be used to tone down and add opacity to other greens—particularly Thalo Green. It works well in combination with blues for greens in the middle and far distance, and with Indian Red for subtle landscape greens. Indian Red and Oxide of Chromium appear in the image below, next to the violet and Thalo Green respectively. However, they are not mandatory and will not be used for these color-mixing exercises.

*The landscape palette*

# Mastering Greens

You will need the following:

**PAINT:** All of the colors that make up your landscape palette

**OTHER SUPPLIES:** One 12 x 16-inch practice canvas and all basic painting supplies

Most artists who attempt to paint landscapes quickly discover that they are faced with a great deal of green. To some beginners this may not seem to be a problem; just find the right tube of grass-colored paint and fill the canvas. And, come to think of it, aren't trees green too? Might as well paint them all this handy green. Countless tubes of Sap Green and Permanent Green Light have been sold to these artists. The outcome of this kind of approach is a painting that is boring in color, lacks a sense of realism, and is devoid of spatial distance.

The truth is that there is no one color that will work for everything. If you look around, you will see a great variety of greens, many with earth tones in them. Colors that you might expect to be green are often touched heavily with ocher, Burnt Sienna, and other tawny shades. Rarely (outside of a golf course in Ireland perhaps) do you see bright green grass. Even "green" trees will be gray-green or olive green, rather than bright green. Take a brush full of color-wheel green paint and hold it up to a tree or leaf. Notice how much brighter the color is on your brush. This project will help you find many interesting shades of green.

## USING BLUE AND YELLOW TO MAKE GREEN

In Lesson Three you mixed various blues and yellows to make greens. Let's explore this concept a bit more. Starting with whatever greenish blues you have, experiment with mixing them with your assortment of warm and earth colors. The greenish blues will quickly overpower the lighter colors, so make each mixture again—this time starting with the lighter color and adding the darker color to it in small amounts.

Experiment with varying the proportion of one to the other. You will discover a great variety of useful greens. For very dull greens, you might try adding French Ultramarine blue to the warm colors. You may find it useful note the recipe for each mixture on the canvas.

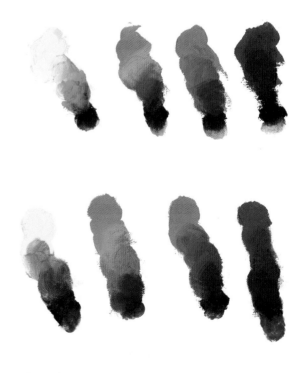

*Greens made by mixing various yellows and yellowish earth tones and blues*

# TAMING THALO GREEN

Why not just mix blues and yellows to make green? Because you can't always get the range of dark greens that you might desire. For instance, you can mix a rich, dark green with Thalo Blue and Raw Sienna. The problem is that to darken a mixture made from blue and yellow you are forced to add more blue, which gives you blue-green rather than dark green. For very dark greens that aren't mostly blue, you need to start with a green that comes out of the tube dark. Not only does Thalo Green come out of the tube very dark, but it is all green—not a mixture. You can lighten it and soften it any way you want, and for those times when you want a sharp brilliant green, it has no equal. I consider Thalo Green to be my one indispensable green.

Thalo Green is a base color; it is made to be added to other colors, and is not a final color by itself. Many artists dislike Thalo Green because they have difficulty controlling it. This project will help you learn how to tame this color and make it a valuable addition to your palette.

## Mixing Light Greens

Mix Thalo Green with Lemon Yellow Hue and paint a swatch on the canvas. It will make a brilliant (and unusable) yellow-green. To tame it, simply add white, red, or an earth tone (or all three), which will give you a wonderful soft yellow-green, perfect for a patch of sunlit grass. You can also use a little red-violet, which is the exact complement of yellow-green. Try mixing some light greens, starting with yellow-green and then adding various warm colors and white.

## Mixing Middle Greens

To make "crayon green," mix Thalo Green with yellow-orange. Then try creating new mixtures by adding oranges and earth tones to this green. Further explore these mixtures by adding white or yellow to some of them.

## Mixing Dark Greens

Olive greens can be created by mixing Burnt Sienna with the Thalo Green. The deeper shadows in greens are easy to make by adding a touch of Cadmium Red Hue to this dark green. Adding red-orange or Raw Sienna to Thalo Green also makes rich dark greens. Make your own mixtures of these combinations. Use a touch of white to find some very soft, muted greens.

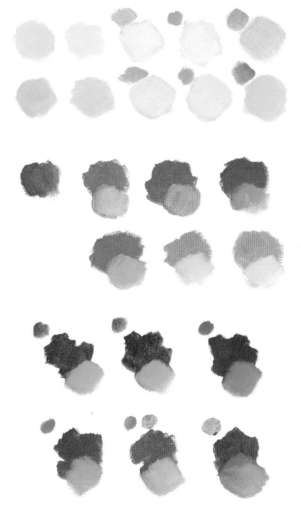

*Light greens based on Thalo Green (TOP), middle greens based on Thalo Green (CENTER), and dark greens based on Thalo Green (BOTTOM).*

# USING GREENS TO CONVEY AERIAL PERSPECTIVE

Earlier we discussed the changes in color that occur as objects recede into the distance. Now let's try making some of these mixtures as they relate to a lush green landscape.

Mix Thalo Green with yellow-orange to get a "true" green. Mix lavender by adding purple to white until the lavender is the same value as your green. Now mix the green and lavender together. Notice how this subdues the green, making it pull back. Since colors get cooler in the distance, try using just Thalo Green lightened with white, and then adding the lavender. Mix Thalo Blue and white and add that to the last mixture to increase the blue for far distance.

In the illustration to the right you see two columns. The first shows greens made from Thalo Green. The second shows greens made using Oxide of Chromium. Because Oxide of Chromium is already low chroma, it doesn't need red to be added to make it less bright; simply adding a lightened French Ultramarine blue will give you similar results to mixing lavender into Thalo Green. Oxide of Chromium offers a shortcut to mixing muted greens. A good combination for very distant hills is French Ultra-marine blue or Thalo Blue and Cadmium Red Hue; remember that very distant hills have no greens, just muted blues.

*The first column shows how lavender can be used with various green and blue combinations to make the green move back in space. The second column uses Oxide of Chromium. Because this color is already muted, only blue is needed to push it back.*

---

## OTHER GREENS

*I see so many kinds of green paint when I go to the store. Would I ever need any of these?*

There are many greens on the market with varying degrees of usefulness.

**PERMANENT GREEN:** This green comes in two variations, Light and Deep. These greens are so easy to mix with Thalo Green and yellow-orange that I see no need to buy them.

**SAP GREEN:** This rich and subtle yellow-green is best used in glazing. It makes wonderful pond reflections in combination with Raw Sienna, but it is very weak and doesn't mix well with other colors in opaque mixtures.

**THALO YELLOW GREEN:** This yellow-green is premixed from Thalo Green and yellow. As such, it is a handy shortcut for lighter greens, but is very much an optional color.

**VIRIDIAN GREEN:** This green has been in use for a very long time. It predates Thalo Green, which it closely resembles, but it is weaker, less brilliant, and extremely transparent.

# Matching Real-life Greens

You will need the following:

**PAINT:** All of the colors that make up your landscape palette

**OTHER SUPPLIES:** One 12 x 16-inch practice canvas, all basic painting supplies, tape, scissors, landscape photographs, and assorted leaves

**TIME:** About 1½–2 hours

This is an excellent exercise and a lot of fun. Gather some leaves from outside and find some photos with landscape greens in them. Tape the leaves onto your canvas. Cut out squares of different greens from the photos (just the colors, not objects) and tape them down on your canvas, too.

## IDENTIFYING COLORS FROM LIFE

Follow the directions on pages 90–92 for matching color. Paint a swatch near the original and make notes as to what you add until you get a good match. Mistakes are valuable, because you can see where the color went wrong and why. Remember that there is more than one way to reach a match.

**NOTE:** Sometimes it's better to *not* exactly match a color. Think about whether you can make your painting more interesting by altering the color in some way. The reference picture below shows a pretty scene, but by changing the lighting and focusing on the waterfall, I was able to add more drama and focus.

*Select a variety of green leaves and color swatches, tape them to a canvas, and then try to match the colors.*

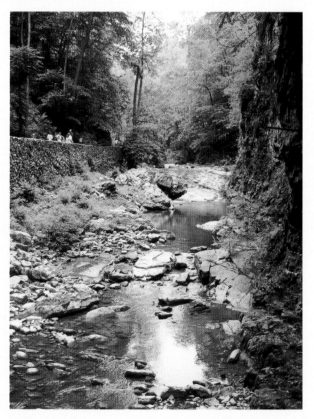

*Photo reference for* Early Morning at Natural Bridge

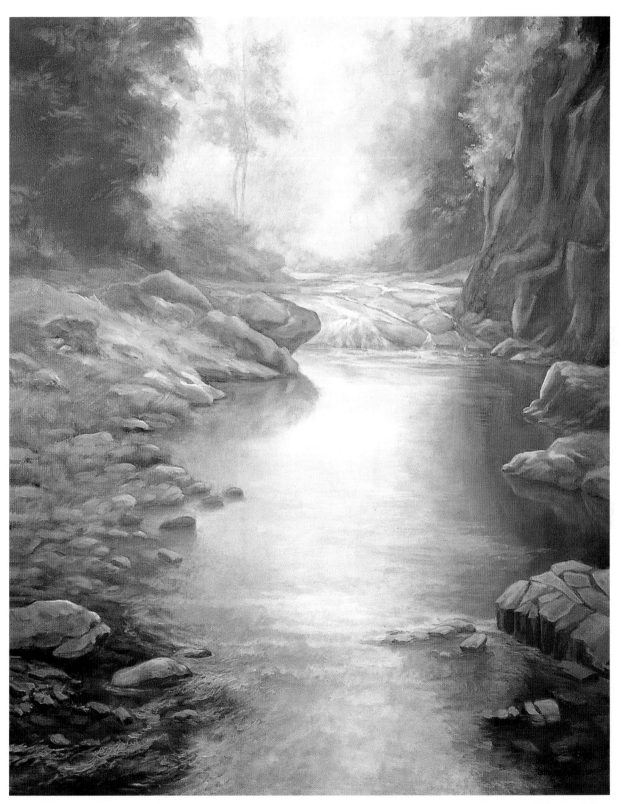

*Kathleen Lochen Staiger,* Early Morning at Natural Bridge, *oil on canvas. This is an example of how altering the lighting and colors of the scene in a reference photograph can enhance the mood of a painting and make it more interesting.*

# USING PHOTOGRAPHS WISELY

Many artists rely heavily on photographs when painting landscapes. Photographs can certainly be useful tools, but—as with any other tool—you need to know when and how to use them. It is important to be aware of the dangers of using photographs and to know what you need to do to make them work for you.

## Being Aware of the Dangers

People have a tendency to accept photographs as reality. The truth is that most photographs distort reality. Photographs that appear in calendars and magazines frequently have very unnatural color, for instance. Professional landscape photographers often use filters to enhance the drama of clouds. This turns the sky a deep royal blue or even purple. No sky is that color. Even if you work from your own photos, you need to be aware of the dangers of copying the colors. Before working from a photograph, always ask yourself, "Does this color look right?"

Shadows present another difficulty for the camera, as it can't capture the details of a shadow area unless it is adjusted to do so. Consequently, shadows in photographs frequently look like solid black areas. We don't see shadows like that, because when we look at them the lens of our eyes opens to let in more light. So when taking photographs as reference shots for a painting, be sure to take additional pictures focussing on the shadow areas.

## Making Photographs Work for You

Photographs should always be regarded as a tool, never as something to copy. They are useful in jogging the memory and supplying details that may have been forgotten. They are invaluable in freezing the action of something in motion so that it can be studied at leisure, and preserving something that may not keep long enough to be painted.

Nature does not arrange itself in perfect compositions. Looking at a photograph can remind you of a scene or object or person, but then you should decide what you want to emphasize and what should be left out because it is too confusing or distracting. You may also want to rearrange some of the shapes, change some of the values and colors, and alter the lighting to give emphasis to your focal point.

### PHOTOGRAPHS AS REFERENCE

When taking photographs in preparation for making a painting, be sure to capture every aspect of the subject. Take pictures to the left and right of your subject, so that you have a wider range of images from which to work. There may be an interesting tree or figure just beyond the frame of the original shot that you could use in your composition, for instance.

It is also helpful to back up the photos with a quick sketch or notation of what strikes you about the scene. The boat that captured your attention as a good subject for a painting may look tiny and insignificant in the printed photograph, and you may forget what inspired you. *Photographs are often disappointing as subjects for a painting.* Remembering the inspiration that prompted you to take the picture will help you find what you need in the photograph itself.

Comparing the photograph on the facing page with the painting *Pond at Natural Bridge,* you can see how many adjustments I made in creating the final work. I changed the value pattern of the rocky hillside. I also reduced the large white area at the top of the hill because it was an empty place that drew the eye. I simplified the striped rocks that plunge into the water so that they are a more even dark value; this created a corresponding dark reflection in the water, which then provided a strong contrast to the light rocks in the foreground.

The rocky hill had a large triangle that pointed out of the left edge of the picture. This strong arrow led the eye out of the photograph, so for the painting I blunted the shape by darkening the land at that edge. I also moved the foreground rocks so that the vine at the top leads into the focal point of the orange slash of color in the rocks. I enhanced the colors overall to make them more interesting—introducing more warm colors into the greens, brightening the orange areas in the rocks, and breaking up the subtle neutral colors of the rocks so that their brighter components were distinguishable.

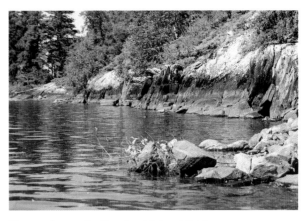

*Photo reference for* Pond at Natural Bridge

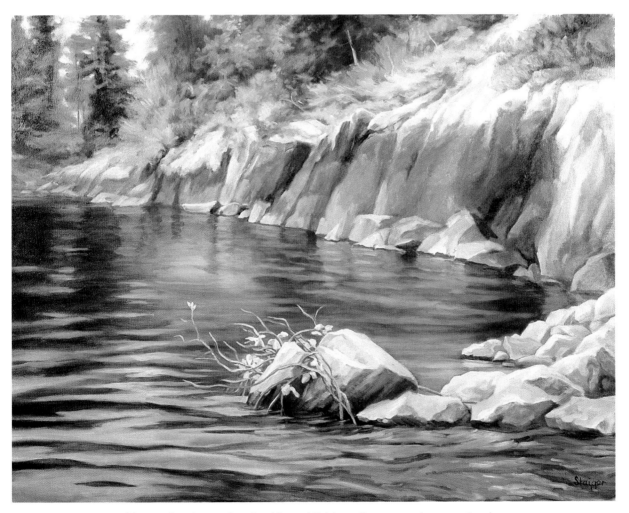

*Kathleen Lochen Staiger,* Pond at Natural Bridge, *oil on canvas. In comparing the photograph and the painting you can see how many changes I made to the final work.*

# EXAMINING THE ELEMENTS OF
# A LANDSCAPE PAINTING

Beginners are often so overwhelmed with all of the details of making a painting that they don't know where to begin. This lesson will show you how to analyze a subject, what to paint first, possible colors to use, and brush techniques that will help suggest details that are too small to paint.

It is not possible or even desirable to provide a color recipe for every possibility in landscape painting. Once you have learned some basic techniques and have a little experience in how to use the paint on your palette to make natural-looking landscape colors, you should just go out and paint from nature. You can paint anything if you know how to analyze it.

## The Sky

Remember that when you paint skies, you are painting *air*. If you mix a batch of light blue and paint it solidly on your canvas, it will look flat and unconvincing. Most "blue" skies have touches of pink and cream (a very pale yellow) in them that becomes more dominant near the horizon line. Study skies under various light and weather conditions. You will be amazed at the variety of colors that you will see.

### SUNNY SKIES

To depict a clear, sunny sky, paint it darker near the top of the canvas (the "zenith"), and lighter and warmer near the horizon. A combination of mostly French Ultramarine blue with a touch of Thalo Blue plus white makes a good approximation of "sky blue." This combination can be used throughout or shaded down to a pale Thalo Blue near the horizon where the sky appears greener.

For a more realistic sky, add touches of cream and pink. For the cream color use Yellow Ochre or Naples Yellow plus white. This mixture must

be *extremely* light, or you will have a muddy-looking sky. The pink (Cadmium Red Hue plus white) can be *slightly* darker. Remember that the sky is not always blue, but may be gray, white, yellow, or other colors.

### CLOUDY SKIES

Wispy clouds are easy to paint. (Simply whisk light cream and pink mixtures on top of the blue.) Let's concentrate on the big dramatic clouds that build up in the air in sculpted mounds.

Clouds follow the laws of perspective. This kind of cloud is comparatively flat on the bottom. So, just like the coin on page 106, if it is close to the horizon and your eye level, you will see just a little of the flat bottom and a lot of fluffy mound. As the cloud gets higher in the sky (and above your eye level), you will see more and more of the dark underside, and less of the top.

Rules of composition apply to clouds. Try to get variety in the size and shape of each cloud as well as in the spaces between the clouds. Clouds should be puffed at the top; the challenge is to make sure the edges are not symmetrical and the mound isn't in the middle. Don't be afraid to have some of the clouds overlap or to let them go right off the canvas.

Clouds are not white. To see this for yourself, simply hold a piece of white paper up to a cloud. Paint "white" clouds with a tiny amount of pink

*Clouds in perspective*

*When painting clouds, allow your brush to pull some of the blue of the sky back into the cloud.*

*See how the blue sky color that was pulled into the cloud gives a feeling of shadows.*

*Add more shadows after your initial cloud is complete.*

and cream. Thin, fluffy or wispy clouds won't have shadows; denser clouds will.

Paint clouds from the inside out. In the illustration above the corner of a #6 flat bristle brush was used in an irregular circular motion, moving from the *inside* of the cloud out into the wet blue paint and then back again. This pulls the blue sky color into the interior of the cloud, giving it dimension and a feeling of shadows. (Clouds can also be added in a dry brush or scumble technique if the sky is dry.) The shadow underneath the cloud was painted with a grayed blue-violet mixture made from French Ultramarine blue with a touch of both Cadmium Red Hue and Yellow Ochre.

## STORMY SKIES

Gray skies are created with the same purple-gray mixtures used for cloud shadows. In the image of an approaching storm below, the back-light at the edge of the clouds was painted first in a muted orange, and the gray-blues that overlap the light edges are mixtures of either French Ultramarine blue or Thalo Blue with Cadmium Red Hue and a touch of Yellow Ochre. The areas of the cloud that face the earth were painted with the warmer Thalo Blue, while the areas facing up have more of the cooler French Ultramarine blue. When painting skies with different layers of clouds, always work from the back and come forward.

*Landscape painting is the art of suggesting the infinite details of nature, not copying every one.*

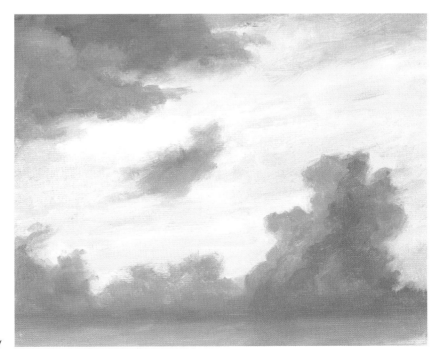

*A stormy sky*

## SKIES DURING SUNSETS

When painting the sky during a sunset, look past the clouds to the sky itself; notice the way the colors blend from horizon to zenith. In the illustration to the right I underpainted the sky with a mixture of Lemon Yellow Hue, white, and a touch of Alizarin Crimson. The sun is just sinking on the horizon, so I used more yellow in my mixture at the horizon and more white at the top. I mixed light versions of Thalo Blue, French Ultramarine blue, orange, pink, and lavender on my palette. Then I brushed the lightened Thalo Blue into the midsection of the sky, blending it into the yellow, and the lightened French Ultramarine blue with a little pink into the top of the sky, overlapping the Thalo mixture.

Next I used pink, golden yellow, orange, red-orange, and an assortment of violets to paint the clouds. Notice that the sunlight is below most of the clouds, making them light underneath and dark above. When clouds are lighted from behind, paint the lights first and then paint the darks in front of them. The farther away the sky and clouds are from the sun, the more they lean toward cooler reds, violets, and blues. Alizarin Crimson and Cadmium Red Hue help with the darker reds and oranges in the sky. Each sunset is different, and may need different colors.

## Grass

As with the other landscape elements, the key to making believable grass is *variety*. Never mix up batches of "grass color." Grass is actually made up of many different colors. Wild grasses in particular have lots of warm colors and earth tones and may contain very little actual green. And don't forget to add weeds, bushes, and flowers to your grassy areas.

### GRASS IN THE DISTANCE

To depict distant land, use horizontal strokes and a variety of colors. Think of the contours of the land as you apply each brushful of color, and avoid straight lines. Your strokes should zigzag

*To paint a sunset, first paint the sky color.*

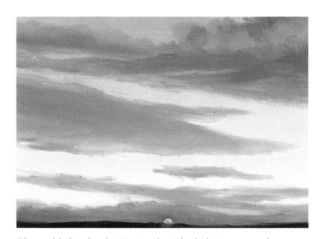

*Then add the clouds. Notice that the lighting comes from underneath.*

each color back and forth, lacing the various colors together in a natural way.

### GRASS IN THE MIDDLE AND FOREGROUND

Lush, deep grasses can be painted with a whisking vertical motion that angles left and right. An old flat sable brush that has gotten bushy at the top is ideal, but you can also use your bristle flats. Start with the darks and then add the lights, varying your colors as you go. Grasses in the distance can be blurred with a hake brush, and close grasses can be defined with a pointed brush.

Use a pointed detail brush to paint longer grasses. Always start at the back and come for-

*Notice the differences between the close and distant grasses. The distant flowers were pounced in with an old, scrubby brush.*

## FLOWERS IN THE GRASS

When you paint flowers in landscapes, resist the urge to paint individual petals and stems. Your brain tells you these things are there, but your eyes don't actually see such details. Nearby flowers can be painted with a just a few strokes, distant flowers with a single touch of the brush. Flowers that are close will be larger, a little more defined, and spaced farther apart than flowers in the distance, which will appear as masses of blooms. Start with the darker color of the flower and then add the sunlit touches. If you use a fan brush, use just the corner so that you don't get repetitious arcs.

## MEADOW GRASSES

A wide flat bristle brush can be used to pounce the paint onto the canvas to create the look of waving tips of grasses. Paint a few inches and then skip to another part of the grass, following the contours of the land. As you come nearer, you can lengthen the stroke downward a little, but remember that you are still seeing just the tips of the grasses.

ward, overlapping each successive layer. Contrast dark areas against light, and warm colors against cool. A splatter of paint thinned with medium will give the look of seeds in the grass. When you have deep shadows between blades of grass in the foreground, try underpainting that area with Burnt Umber and then adding the grasses after it dries.

*This grassland is in the western part of the country, where there is less rain. Notice the predominance of earth colors.*

*Look for ways to introduce colors other than green into your landscape. Berries, flowers, and shrubs will add variety to your grassy areas.*

# Dirt, Sand, and Rocks

Dirt, sand, and rocks are made up of subtle neutral colors that actually contain red, yellow, and blue in varying proportions. If you look at paintings of the rocky coastline of New England by Winslow Homer or Childe Hassam, you will see a rainbow of colors that make up the "neutral" tones of the rocks. How much color you use in your neutrals is entirely a matter of personal style.

I find it helpful to think of neutrals as combinations of complements. In the sunlight these combinations will favor the warm hues, and in the shade they will favor the cool ones. If you look at a concrete sidewalk, you will see how warmer tones prevail in the sunlit portions, while the shadows look bluer.

Rather than dismissing these colors as drab, think of them as an opportunity to add sparkle to your painting. Instead of thoroughly mixing the neutral color, let some of the bright colors that you use in the mixture show as you apply the paint. This technique is called "broken color." Another approach is to paint a neutral color first and then add touches of warm or cool colors into it. You can also start with an underpainting of a bright color and then lay more subtle colors on top. Be careful to keep the values of each of these layers similar and to apply each color with a single, confident stroke and not go back over it.

*Always paint a dirt road with horizontal strokes. Notice the amount of color used instead of just brown or gray.*

The sunlit portions of a path could have combinations of Raw Sienna and purple (which are complements) with additions of pale orange, pink, and yellow. The shadowed areas could begin with the same complementary combination, but emphasize the cool color in the mixture. Other cool colors in the same value could be brushed in. If the color gets too bright at any time, simply stroke warm color into the cool or cool color into the warm to gray it up a bit.

When painting rocks, try to capture the patterns of the shadows first. Pay close attention to the outline and shape of the rock and to the shadow shape. After you have articulated these features, go back and add your "neutral" colors.

*To create rocks, paint the darks first (LEFT); then add the lights (RIGHT). Again, notice the wide range of colors used to paint this "drab" subject.*

## The Beach

Beaches vary according to the color of the sand, but most are either essentially grayish or golden. In the illustration to the right, I used a combination of Yellow Ochre, orange, Burnt Umber, and white to create the sand. Shadows on the sand will be bluer because they are outdoors under the warm light of the sun; here I used French Ultramarine blue and purple with some Burnt Umber. For wet sand, I generally use more Burnt Umber and a touch of blue because sand that is covered by a thin layer of water will reflect the color of the sky.

*The beach*

*Kathleen Lochen Staiger,* **Seacoast Maine,** *oil on canvas*

# Trees

Each type of tree has a characteristic shape. (A fir tree looks very different from a palm tree, for example.) Study the distinctive shapes of the trees in your landscape before you start to paint. Examine the colors as well. You may be surprised to discover that tree trunks are rarely brown; oftentimes they are some variety of gray. Many of the techniques you have learned for other subjects apply to trees as well. For instance, trees in the foreground can be painted in detail, showing bark texture and individual leaves, but trees that are farther away are painted more simply. Likewise, shadows for trees are painted first, thinly and with no detail.

## LEAVES ON A BRANCH

Our innate desire to have things even, and evenly spaced, works against us when we attempt to paint leaves or other shapes in nature. Our tendency is to paint each leaf an equal distance from the others. You must overcome this urge.

Leaves grow from tiny branches that are too small to be painted. Think of the direction in which the leaves are growing. They radiate from the imagined branch—some massed together and overlapping, some separate, and each at a slightly different angle. Paint the leaves with this in mind and the viewer's eye will accept that the branch is there.

Keep in mind that you will be seeing most leaves from the side, not from above. Leaves that are close should be painted with a quick stroke of the brush. First press on the brush to widen the stroke and then let up as the stroke narrows. This will create a natural-looking leaf shape.

> *It is easier to get a natural effect if you paint quickly.*

*Leaves on a branch are best painted quickly. The stems of the leaves will always radiate outward from the tree.*

## TREES IN THE FOREGROUND

Whenever you are painting something that has thousands of details, simplify the subject into masses of light and shadow. To paint a tree in the foreground, start with the sky, extending it into the edges of the tree and adding patches of sky (called "sky holes") within the leafy masses. Then position the trunk and add some of the lower branches.

In dealing with the leafy mass, paint the shadow areas first, keeping the edges leaf-like and airy. In the example on the facing page, the top part of the tree has fewer leaves and is catching the light of an overhead sun, so there are not many shadow areas high in the tree. Paint the middle tones next. Make sure there is enough contrast between the light color and the shadow color. For this painting I used a mixture of Thalo Green, Cadmium Yellow Medium, and white. Premix the general color if you like, but then add touches of pure color for sparkle and variety. Your paint can be a little thicker for this layer, and you can use a small brush to suggest individual leaves.

While there will be light leaves on top of the shadow shapes, remember that they are inde-

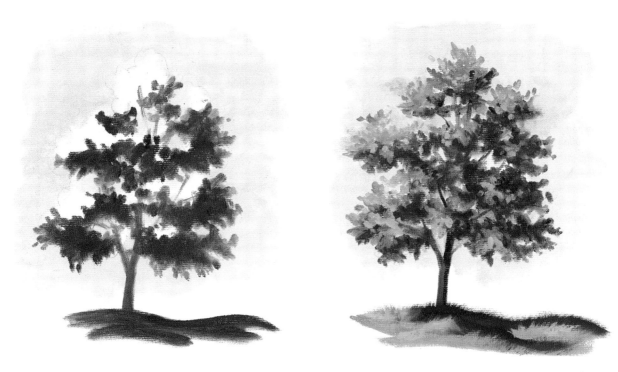

*To paint a tree in the foreground, first position the darks (LEFT) and then add the lights and highlight color (RIGHT).*

pendent of the leaves in the shadows. Don't follow the shadow shape exactly. Instead, make the light leaves stick out farther and bring some of them down over the shadow shape. There may also be light leaves in places that have no shadow shapes.

In this example I added a few thick touches of a lighter color for those leaves that are catching the most direct light. To finish the tree, I made sure any bare canvas was filled with sky and added additional sky holes in a slightly darker blue. And finally, I threaded tree branches through the leaves.

## TREES IN THE MIDDLE AND FAR DISTANCE

Trees that are in the middle distance should be simplified even more than trees in the foreground. Reduce the masses of light and dark to a minimum number of shapes. Apply the paint in longer strokes, rather than with strokes that suggest individual leaves. Trees in the far distance will have just a few key light and dark

masses, and will have simplified colors. As we learned in the section on aerial perspective, the yellow tones that are clearly distinguished in trees in the foreground will diminish gradually and can be replaced with cooler greens for middle-ground trees and then blue-greens for trees in the distance. Keep in mind that in the distance darks look lighter; lights, on the other hand, look slightly darker.

*Compare the tree in the middle distance with the one in the far distance. Notice how details lessen and colors change.*

# Water

Everything has an effect on the color of water—including the time of day, the color of the sky, and the depth of the water. The surface of the water facing the sky will reflect a grayer version of that color. Even if the sky is bright blue, in the water the blue will be grayer and darker.

## STILL WATER WITH REFLECTIONS

Before painting very still water with mirror reflections, first cover the water area with a thin layer of light blue that has been diluted with medium. This will help your colors blend, and the slight tint will subdue the color of the reflection in the water.

Be sure that the objects in the water are mirror images of those on land; a plumb line will help ensure that the reflection lines up. Colors in reflections are duller and darker than those in the objects they are reflecting, and shapes and details are greatly simplified. The length of each reflection is dependent on the angle of the sun and the distance the reflection is from the actual object. When you have finished, use a blending brush and light vertical strokes to melt the reflections together, then brush horizontally to give the feeling of a glassy surface.

## ROUGH WATER

Rough water has two distinct colors: the top of the ripples will reflect the sky, the underside will be darker and warmer. If the water is near

*Kathleen Lochen Staiger,* Autumn Reflections, *oil on canvas. Notice the reflections in the still and shimmering water.*

land, some of your land colors should appear on the undersides of the ripples in the form of brownish-green areas of color. If the water is not near land, the underside will be some form of a warm blue-gray.

Choppy water can be approximated with a series of shallow U-shaped strokes made with a flat bristle brush with a good edge. Hold the brush so that the wide edge is in a horizontal position and rock it back and forth on the flat edge. Adjust your strokes so they become flatter as they recede and become dashes in the far distance. Paint the light parts first, making them lighter and warmer as they approach the sun.

Then add the darker color, starting in the darkest spot. Traveling across your canvas toward the sun, the brush will pick up the light color, making the darks increasingly lighter.

## FLOWING WATER

A stream with vegetation close to the banks will reflect the surrounding land. In the middle image to the right the yellows and mossy browns of the riverbed show through the shallow water, further affecting its color. When painting streams, watch for where the moving water reflects the sky. If vegetation partially or completely blocks the sky, however, there may be no blue in the stream at all.

Bits of foam in a stream will look off-white in the sun and bluish in shadow. In this illustration, notice how the streambed rocks show through the shallow water near the waterfalls. I painted the submerged rocks, allowed them to dry for a few days, and then added the water in thin glazes. After this dried, I added the waterfalls and foam, working from dark to light. I introduced the lacy details in the foam at the very end.

## OCEAN WITH WAVES

The ocean is one of the most difficult things to paint because of its changeable nature. Nothing can substitute for firsthand observation coupled with good reference photos. Essentially, waves rise up, curve over, and ebb. The center of the wave is its highest point and it tapers to nothing at each side.

When painting an ocean, keep the edges of the distant horizon soft and pale so the horizon line doesn't distract from more important areas in the painting. Deep waters in northern climates will generally be a colder, grayer blue, while shallow waters appear greener. (By contrast, water in southern climates often has a brilliant blue-green color.) When the water is very shallow, it will be colorless: what you will see is the color of wet sand with some reflection of the sky.

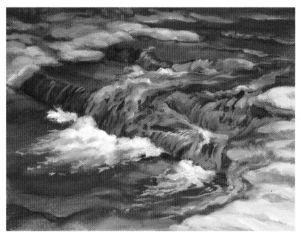

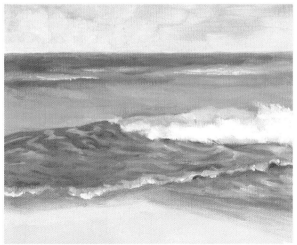

TOP: *Choppy water on an overcast day. Note the brushstroke technique highlighted below.* MIDDLE: *Moving water: a stream. The rocks showing through the water were painted first and allowed to dry.* BOTTOM: *Ocean with surf*

# Doing a Landscape Paint-along

You will need the following:

**PAINT:** All of the colors that make up your landscape palette

**OTHER SUPPLIES:** One 12 x 16-inch canvas panel and all basic painting supplies

**TIME:** About 16 hours total (seven sessions, ranging from 1½–3 hours each)

This project is quite lengthy and is divided into seven painting sessions. Each session may require slightly different paint. Check to see what is needed before you begin. Take a clean sheet of palette paper before each session, transfer usable paint to the new palette, and discard the old palette. This is the best way to insure the success of your color.

This project will give you a chance to practice some of the landscape features we discussed in the last section. Copy the divisions of land, sky, and water as they appear in the drawing on the facing page, because these have been carefully planned to give you enough room to practice each element; later you can be creative and make your own clouds, mountains, trees, and other details.

This is a "paint-along." In order to learn how each element is painted, we will depart from the standard method of working all over the painting; instead we will paint one thing at a time and bring it to completion before going on to the next area. When you make paintings on your own, you should follow standard painting procedures.

## DRAWING THE SCENE

You'll probably want to give yourself about three hours for this first session; we will be sketching the landscape and adding the sky and distant mountains. Place your canvas horizontally on the easel. Set out French Ultramarine blue and Burnt Sienna in the proper places on your palette. Put a small puddle of paint thinner on your palette. Use thinned Burnt Sienna to mark the halfway point; place a small line along each edge and a cross in the center of the canvas.

To prevent confusing the halfway division of the canvas with the drawing, use French Ultramarine blue for the actual drawing. (This color was chosen because this particular painting will have a lot of cool colors; any color can be used for the sketching stage.) Remember to make the drawing very light so that you can easily wipe away any mistakes.

*1.* Make a mark about one-third of the way up from the bottom of the canvas and draw it

straight across. This is the waterline. Below it will be the lake, above it will be land.

*2.* A half inch or so above the waterline, make another line parallel to the first, but not as rigid. The area between these two lines represents the meadow.

*3.* Draw the hills behind the meadow. The hill line should be higher at each side and lower in the middle. You can decide how high you want your hills to be; just avoid the halfway mark and be sure that they are not the same height.

*4.* Behind the two hills are distant mountains. You can make them high or low, but leave room for the sky. Draw the mountains in one continuous line, trying to get an uneven contour. Make one part higher than the rest, perhaps on the right side so it is not hidden behind the tree that will be on the left. The mountains can be softly rolling or more rugged.

*Draw the major components of your landscape.*

To separate the mountain into different layers, take any diagonal line on the mountain and continue it down a short distance, giving it mountain-like bumps. Make some diagonal lines go to the left, some to the right. Just do two or three; don't get too complicated.

5. To draw the island, paint a straight line approximately three-quarters of an inch below the waterline. Start the line at the right edge of the canvas and bring it in as far as you wish, but stop short of the center of the canvas. Draw the top of the island with a bumpy line that tapers down to the left. I recommend making the island approximately one inch high.

6. Start the foreground at the left edge, about half way between the waterline and the bottom of the canvas. Taper it down past the center of the canvas.

7. With your diluted paint, sketch the reflections in the water. Do not reflect the meadow. (Landscape elements that are very low won't cause a reflection.) Instead, start with the hills, then add the mountains. (The island reflection will be added later.) Keep the reflections very simple. Gently wipe the reflection marks with a rag so that they are soft and blurred and erase the Burnt Sienna guide marks using a rag or brush dampened with medium.

# MAKING THE PAINTING

As mentioned earlier, we will create this landscape painting in several stages, allowing the painting to dry in between each stage. To set up your palette for this first session, put out white, Yellow Ochre, Cadmium Red Hue, French Ultramarine blue, and Thalo Blue in their proper places. You only need the primaries for the time being because the colors in this first stage are really just variations of blue.

## Starting with the Sky

Review the section on painting sunny skies and clouds earlier in this chapter. Premix the sky colors (pale cream, soft pink, and light neutral blue) and paint the sky. Mix cloud "white" and French Ultramarine blue, Cadmium Red Hue, and white for cloud shadow. Mix plenty of this color, as you will also use it to lay in the distant mountains.

### CLOUDS

Paint the top of the clouds with either definite or soft edges, but keep the bottom of the clouds blurred and indistinct. Keep the left side on your canvas fairly simple, as most of it will be covered by leaves.

### CLOUD SHADOWS

In this painting the sun is above and to the left, so the shadows will be on the bottom and right sides of the clouds, with additional shadows in the middle of the larger clouds where any puffs stick out. Be careful not to overdo the shadows. There is a subtle difference between the cloud shadow and the blue sky. Finish the clouds by blurring them with the hake brush, or leave them alone for a more vigorous painting style.

*When making clouds, never paint an outline and then fill it in. Clouds should be formed by moving the brush from the inside out and back.*

## Adding the Distant Mountains

The distant mountains are mixtures of purple-grays and soft greenish blues. We will use two variations of blue to paint the first layer of color in the mountains. Before beginning, darken the remaining mixture that you created for your cloud shadows by adding a touch more French Ultramarine blue. Then make a second blue by adding touches of Thalo Blue to white until you achieve a mixture that is similar in value to the first mixture. When painting the distant mountains, use both of these colors, adding touches of the cream and pink you have left over from the clouds for variety.

### MOUNTAINS

Because they are farther away, the mountains will be lighter than the hills in front of them. Each succeeding mountain range will become progressively lighter as it goes back into the distance, so keep the mountain range relatively simple.

Use straight applications of both of your blue mixtures along the top edges. Then bring these colors down into the body of the mountains, adding cream and pink to lighten them. You simply want to establish a basic form and color for the mountains and distinguish one layer from the next one. You will add shadows and lights after this paint has had a chance to dry.

Your brushstrokes should follow the form of the subject. Use short strokes on the diagonal, going both to the left and to the right. You are using a variety of colors, and the less you go over your strokes, the more you will keep that variety. These strokes will give the mountains a three-dimensional quality that we will enhance later. Stop here and let the painting dry.

## MOUNTAIN LIGHTS AND SHADOWS

This is the beginning of your second painting session. We will be adding light areas to the mountains and introducing the hills and meadows. Allow two to three hours. Because a few days have passed since you have worked on your canvas, you'll need to start a fresh palette; this time set up the full landscape palette.

For the shadow colors of the mountains, make a fresh purple-gray mixture using French Ultramarine blue, Cadmium Red Hue, and white. Then add white to each of your two blues (French Ultramarine Blue and Thalo Blue) to create lighter values of each color. In value, they should be just a little darker than the color already on the mountain.

For the light areas, mix Cadmium Red Hue and Yellow Ochre to make orange. Then add a touch of this orange into white to make a very light orange. Use the same method to make a very light pink using Alizarin Crimson and white. These will be your sunshine colors.

Using a flat bristle brush and short diagonal strokes, put shadows on the right sides of the mountains. Remember to save the layering effects you created when you initially painted the mountains; don't bring the dark down too far. Start with the purple-gray color, then add touches of both blue mixtures for variety.

Paint in the sunlit areas on the upper parts of the mountains. Use the same short diagonal strokes, but slant them to parallel the left face of the mountains. Start with the pale orange and vary with pale pink. Check to make sure your mountains are light enough to convey the impression that they are in the distance.

*Lay in the distant mountains and sky.*

# Introducing the Hills, Trees, and Meadow

In preparation for painting the hills and meadow, mix lavender in a progression from light to dark on your palette. In addition, mix light values of both blues.

## RIGHT HILL

The right hill is catching the light coming from the left. Paint the hill in light yellows (anything from Yellow Ochre to yellow-orange on your palette, plus white) and greens that have been muted with lavender. I recommend using a #6 flat bristle brush. Load your brush with a mixture of yellows. Add a touch of Thalo Green and some white. Test the color on your palette. You can decide whether you want the color to be more green or more yellow. Freely paint the sunlit slope, allowing your brush to form its contours and give the impression of grassland. Most of this will be covered by the island trees, so don't worry about adding details. Bring down the brightness where necessary by brushing in some lavender. Don't paint too thickly in this area.

Check to make sure your hill isn't too bright or too dark. It should stay back in the distance. Further touches of lavender (the complement of yellow) can be added into all the colors to lighten and mute them if necessary. Remember to match the value of the lavender to the value of the colors on the hill. Keep it simple.

## LEFT HILL

The hill on the left is in shadow and will require two mixtures. For the first mixture combine green, Cadmium Red Hue, and lavender. The second should consist of Raw Sienna and green. Both of these mixtures should be fairly bright and dark; as we paint we will be working in touches of duller, lighter colors, which will tone down and lighten the overall effect.

Paint the left hill and up the right hill slightly. (The shadow on the right hill is cast by the left hill due to the low angle of the setting sun.) Use short vertical strokes to convey the feeling of trees or bushes. Alternate between the two mixtures. Using the same strokes, add touches of light reddish and bluish lavenders into the two colors. (This will lower the chroma and lighten the value at the same time.) You can also add touches of both of your light blue mixtures to increase the feeling of distance. Keep doing this until the hill recedes into the distance.

When creating the hills, follow the layering technique, using dark colors at the top and lighter ones at the bottom; keep in mind that soon we will be adding a layer of dark green trees at the base of the hills. Remember that these background areas must be kept comparatively light and dull so that they adequately contrast with the foreground areas that we will paint later; properly toning down your background at this stage will enhance the sense of space and distance in your final painting.

*Ordinary white chalk is excellent for trying out additions to a dry-to-the-touch painting. The marks are easily wiped off with a slightly damp rag.*

*Enhance the distant mountains and add the hills and meadow.*

## TREES AND MEADOW

At the base of both hills, along the top of the meadow, create an irregular row of trees no more than ¾ inch high. Using the corner of a #6 brush and a vertical stroke, apply a mixture of Thalo Green and Cadmium Red Hue that has been muted and lightened with lighter lavender. If the trees do not contrast sufficiently with the hill, you may have to lighten the hill with some light blue or lavender. This is best done while everything is still wet so that the colors blend together. Remember not to use heavy brushstrokes on the right side of the painting, as this area will be painted over with trees on the island.

The ½-inch strip of land between the trees and the water will be a meadow. Paint it a muted light green with a mixture of Thalo Green, yellow, orange, and white. Vary the color between warm and cool green, changing from one to the other. Overlap the bottom of the trees so that they look as if they're behind the rise of the meadow, and be sure to include a few gentle ups and downs. Add lavender to mute this area. Stop here and allow everything to dry.

## Beginning the Island

This marks the beginning of your third painting session. You will be working on the island and the water. Allow yourself two to three hours. Because a few days have passed, you'll need to create a full fresh landscape palette.

We will paint the elements of the island in two parts. First we will add the dark areas and let them dry. Later we will add the sunlit parts.

### FIR TREES

The trick to painting a conifer, as with any tree, is to let your brush *suggest* the details, rather than attempting to depict them all.

*1.* Plan the spacing of the fir trees on the island with a piece of ordinary chalk. Make a light line for every trunk. (The chalk can be easily wiped off.) Keep in mind the importance of uneven intervals and leave some open spaces so that you don't cover up the entire sunlit hill in the background.

*2.* When you are satisfied with the placement of the trees, wipe most of the chalk off, load a pointed brush with Burnt Sienna thinned with medium, and lightly paint in the trunks. This is not the final painting, just a reference point for where to place the branches.

*3.* Use the corner of an angled shader to make the branches. Your pointed brush can be used for the small top branches.

*4.* Now paint the shadow color of the trees. Don't cover the entire trunk; let it show here and there, especially near the top. Paint the whole tree; when the shadow color is dry we will add the lights right on top. Dip your brush in a mixture of Thalo Green and Cadmium Red Hue lightened and muted with slightly lighter lavender. Do not mix a big batch of this color but get a slightly different mixture every time you reload your brush. Leave a lot of open spaces so the background can show through.

*5.* Add touches of a slightly lighter violet, red-violet, and Thalo Blue into the shadow color of the trees to push it back into the distance.

### GROUND AND ROCKS

The shadows of the grass will be a little lighter than the fir trees. Both will be lightened later.

*1.* Mix Thalo Green with orange and paint the island. There will be rocks at the base of the island, so don't paint the green all the way to the water line. Lighten this area with lavender.

*2.* The rocks along the waterline can be painted in with a mixture of Burnt Umber, Thalo Blue, and a little white. Use a rounded brushstroke and do not attempt to paint individual rocks. Remember that all of these colors are the first layer of darks to be followed with the light colors.

## Beginning the Water

Reflected colors are duller and darker and reflected shapes are more simplified than the objects they are reflecting. You may want to review the section on still water reflections on page 128 before you paint.

*1.* With thinned-down French Ultramarine blue, draw the reflected shape of the island and fir trees. Now your canvas has outlines of all of the reflected objects you will be painting.

*2.* Dilute a lightened French Ultramarine blue with medium and slightly dampen the water area with the light blue paint, being careful to avoid your fresh outlines.

*3.* Paint the reflections right into the wet surface, starting from the water line at the far side of the lake and matching the colors in a general way. Don't get into details, and keep the paint layer thin. When you get to the sky reflections, don't forget to add touches of white for any clouds you have. The reflections of the fir trees can be painted as simple shapes; don't try to get

the light spots between the branches. The rock reflections should look almost black.

4. When you have completely covered the water, take out a dry hake brush and gently sweep downward in straight vertical strokes. Start with the light colors; then do the darker ones. Wipe the brush frequently to remove the paint it will pick up but do not rinse your brush or add medium. This action should feather the reflections in the water. Follow this with horizontal strokes.

5. If you wish, use your angled shader to cut different colors of paint together to give the effect of ripples. A good place to try this would be at the edges of the fir tree reflections. Place the edge of the brush where two colors come together and cut the brush back and forth in a zigzag. You may want to practice this on your palette or on a spare piece of canvas before doing it on your painting. More ripples will be added when the first layer is dry.

Stop here and let the island and the water dry.

*Position the shadow colors on the island and introduce the reflections.*

# Completing the Island

This is the beginning of your fourth painting session. We will be finishing up the island and water areas. Allow two to three hours and set up a fresh palette. Now that the shadow areas on the island have dried it is time to add the highlights.

### FIR TREES

Using mixtures of oranges plus just a touch of Thalo Green and a little white, add lights to the left sides of the trees. The tops should receive touches of light. However, don't make the lights continuous all the way down; there will be shadows under each branch and in the interior of the tree. Some trees may also be in the cast shadow of other trees. Use bright red-orange to pick out bits of trunks and touches of Cadmium Red Hue in the branches for added sparkle and to depict the warm late-afternoon sun.

### GROUND AND ROCKS

Use a mixture of Raw Sienna and yellow-orange, plus a little Thalo Green and white, for the sunlit grass. Use Raw Sienna, Thalo Green, and some Cadmium Red Hue for the shadowed grass. For sunlit portions of the rocks, use mixtures of Burnt Sienna, orange, and white. Add a little bit of French Ultramarine blue to make the mixture less bright, if desired, and add cooler reflected lights to the tops of the rocks on the right.

*Complete the details on the island. (Note: Ignore the fir trees in the meadow for the time being; we will be adding these at a later point.)*

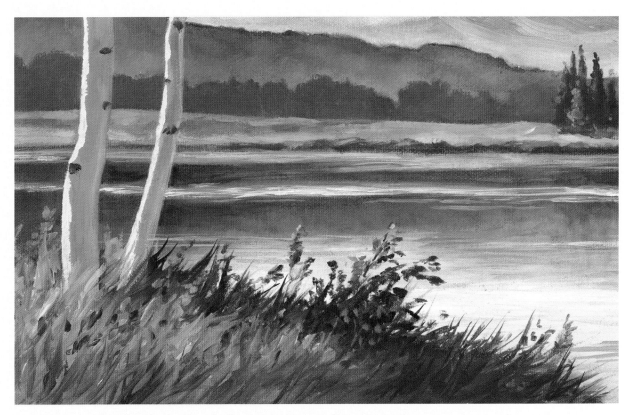

*Complete the details and reflections in the water. (Note: Ignore the two aspen trees and details in the foreground for the time being; we will add these in the next painting session.)*

## Completing the Water

Use medium to *lightly* dampen the areas where you want to add color, and then brush the highlights into the reflection. The reflections of the sunlit rocks can be relatively distinct because they are close to the water and have a contrasting color. In general, however, the reflections should be simple. Next, using a dry hake brush and short downward strokes, brush the reflections to blur them.

Putting a few ripples in the water will enhance the contrast between the horizontal surface of the water and the vertical reflections of the trees and bring the water to life. Use your angled shader to apply a light mixture of Thalo Blue and white for the ripples, keeping them darker in the shadows, lighter in the sunlight. The ripples are horizontal in the distance, but angle slightly in the foreground. I broke up the dark reflection of the hill on the left with a lot of light ripples in the water to provide a contrast to the foreground shadows.

When you are satisfied with your reflections, stand back and evaluate the colors and values throughout the entire painting. You should have an impression of space between mountains and hills, meadow and island. Make whatever adjustments you feel are necessary. At this point, I darkened the color of the meadow to provide more contrast with the island and the lights on the water. Allow the painting to dry.

## Beginning the Aspen Trees

This is the beginning of your fifth painting session. We will be adding the aspen trees and other details in the foreground. Allow about two hours and set up a fresh palette. Interval is one of the keys to creating a successful composition—particularly when depicting groups of trees.

1. Use white chalk to plan where you want your aspen trees. For areas where the chalk won't show up, use thinned-down French Ultramarine blue. Draw one or two trunks and the main branches. Avoid making the trees parallel to the edge of the canvas or each other, and lean them into the picture slightly. Erase any mistakes with a rag or clean brush dampened with medium.

2. Paint the trunks with a mixture of Thalo Blue and Burnt Umber lightened with white. Use a slightly darker mixture for the core of the shadow. Where the trunk is against a lighter background, bring the core right to the edge; where it is against a darker background, bring the core slightly inside the edge to show reflected light. You may need two applications of paint to cover the background. The light comes from the left so keep shadows to the right.

3. Use an even darker mixture of the blue and umber to place the distinctive spots on the aspen bark. Be careful not to space them evenly on the trunk, and vary their position (right, left, and center).

*Add some aspen trees to the foreground, including leafy branches at the top.*

## Leaves

Review Leaves on a Branch on page 126. You have two options in painting the leaves. If you like to see every leaf, you may want to paint them on a dry sky. Because I prefer softer, more blurred leaves, I paint into a wet background, so I put a fresh layer of sky color where I wanted leaves. This is easier than you might think, because you don't need to go into detail. Just vary your paint from white (where clouds are) to light blue. Apply a solid but *thin* layer of paint with very little medium.

The main mass of the tree's canopy is out of sight. We are just painting a few scattered leaves at the top and on a low branch. These directions relate to the wet-in-wet technique.

1. Start with the shadows. Mix combinations of Thalo Green plus Raw Sienna and/or various oranges for the leaves on the shadowed side of the tree.

2. Push the first layer of leaves into the wet sky color, and then come back with more definite color. If your leaves need to be softened, blur your strokes with a small dry brush.

3. Leave plenty of sky holes. If you lose too much of your sky, use a small, stiff brush dampened with medium to erase any unwanted leaves. Wipe your erasing brush frequently.

4. Paint over the branches where necessary; they can be added back in. Remember that you do not need branches for every group of leaves.

5. Leaves on the left will catch more light, but so will branches on the right that are hanging down far enough to catch the rays of the sinking sun. For these light leaves use mixtures of Lemon Yellow Hue, Cadmium Yellow Medium, Thalo Green, and white.

Because we are looking at the branches from underneath, we will need to repaint any branches we covered with leaves, using a mixture of Burnt Umber and Thalo Blue. If you want crisp, sharp lines for the branches, wait for the leaves to dry. If you want softer lines, paint them into the wet leaves as I have done. Interrupt your branches here and there with leaves. Dead branches can be added, but don't overdo it. They should come out of the dark spots on the trunk. Mix light blue and add sky holes as necessary. Allow the tree to dry before the next step.

*Never attach leaves to main branches. Paint them as though they are radiating from unseen small branches.*

## Completing the Aspen Trees

This is the beginning of your sixth painting session. We will be completing the aspen trees and adding grasses in the foreground. Allow about one and a half to two hours and set up a fresh palette.

Mix together yellow-orange, orange, a small touch of Burnt Umber, and white, and put in an edge of sunlight on the left side of the tree trunks. I prefer using an angled shader rather than a pointed brush for this kind of mark. Lay the edge of the brush against the edge of the tree and drag the paint into the tree slightly. Paint the sunlight right to the edge of the trunk wherever the background is dark, but where the trunk reaches into the light sky, bring the sunlight slightly inside the base color of the trunk. This will leave a little bit of the umber-blue to contrast with the light sky. Also add touches of light orange here and there in the tree branches on the left and top for a bit of sparkle.

## Grasses under the Tree

Now it's time to paint the grass. Remember that the sun is coming from the left, so the left side of the grass will be lighter and the right side will be in the shadow of the trees. Paint the top edge of the grassy mound first.

1. Start with the sunlit top left edge of the grass, using yellow-oranges, oranges, and maybe some earth tones with a touch of Thalo Green and a little white. Use a pointed brush and enough medium to insure an unbroken line, and start each stroke from the bottom up. In general, use plenty of oranges and earth tones to keep the grasses looking like wild vegetation; avoid sharp greens that will look unnatural.

2. As soon as you pass to the right of your trees, switch to a shadow color made from Thalo Green with Cadmium Red Hue and Raw Sienna. Pay particular attention to the way the grass overlaps the water. This is the place for some interesting detail.

3. Paint the remainder of the grass, using lights on the left and across the top of the grassy mound, and then switching to shadow colors as the mound bends away from the light. The light on the left can be brought all the way down to the bottom, and dark patches can be worked in here and there. By starting at the top and working down, you can pull each layer of color up and contrast it with the layer above. Let the painting dry before adding the final details.

## Adding the Final Details

This is the beginning of your seventh and last painting session. We will be finishing the grasses in the foreground and making our final adjustments. Allow about one and a half to two hours and set up a fresh palette.

Use a pointed brush to put in as much detail in the grasses as you want. The corner of the angled shader loaded with oranges and siennas works well for adding fronds of seed grasses when pushed in a right-to-left stroke.

Stand back and take a look at your painting. Check to see if any part needs to be lightened or darkened. At this point I felt that the distant meadow needed more interest and variety. Although I had previously darkened the whole meadow to provide contrast with the island and the water, I decided to add a streak of sunlight to contrast with the aspen trees and to break up the dark in the left side of the painting. I also added more rocks with a few dark and light strokes at the water's edge.

To create more variety of color and provide a distant focal point, I added a slight rise of land in the meadow with a few strokes of light orange. This leads up to a small stand of firs, which I painted just off-center and in a value lighter than what I used for the trees on the island. The rest of the meadow was made more exciting with touches of a variety of light colors. I repeated the light colors in the island grass and introduced

reflections of the new fir trees with thin paint. Finally, I added a few more ripples to the water.

After your painting has dried to the touch, be sure to give it a light spray of retouch varnish spray to bring out the gloss. (See page 174 for more about varnishing your work.)

*Add the water details, lights on the island, foreground images, and a few finishing touches.*

# LESSON SEVEN
# Creating a Portrait Painting

THERE IS NO GREAT MYSTERY to painting people. Everything you have learned in painting a still life or landscape holds true for painting a portrait. You can use what you have learned about shading forms to give depth to facial structures, use the methods we have discussed about mixing colors and their shadows to make convincing skin tones, and use the techniques you have employed to draw what you see to get a convincing likeness of an individual.

This lesson provides detailed advice about analyzing the individual facial features—eyes, nose, mouth, ears, and hair—and shows how they are positioned on the head. There is a special project on mixing a variety of skin tones and their shadows, and directions on how to approach a portrait. A portrait paint-along will help you put all these pieces together with step-by-step guidance in painting a face. A traceable drawing of a face is included so that you can concentrate on your painting skills. Finally, there is a portrait demonstration.

Don't get discouraged if your first portraits leave something to be desired. Painting people well takes practice. Little mistakes in drawing are more obvious in the depiction of people than in other subjects because we are so familiar with how people look that we notice immediately if something isn't quite right. To get a likeness, you need to sharpen your skills at drawing what you see, and study the construction of the various facial features so that you understand how they are formed. You *will* improve as you practice.

LEFT: *Jeany Sawyer,* Hope, *oil on canvas. In this unusual portrait the subject is looking down. It is beautifully composed and the Asian skin tones are painted realistically.*

OPPOSITE: *Millie Gilluly,* Portrait of My Grandson, *oil on canvas. Millie has done many fine portraits in class and this is one of her best. Notice the touches of blue in the skin tones.*

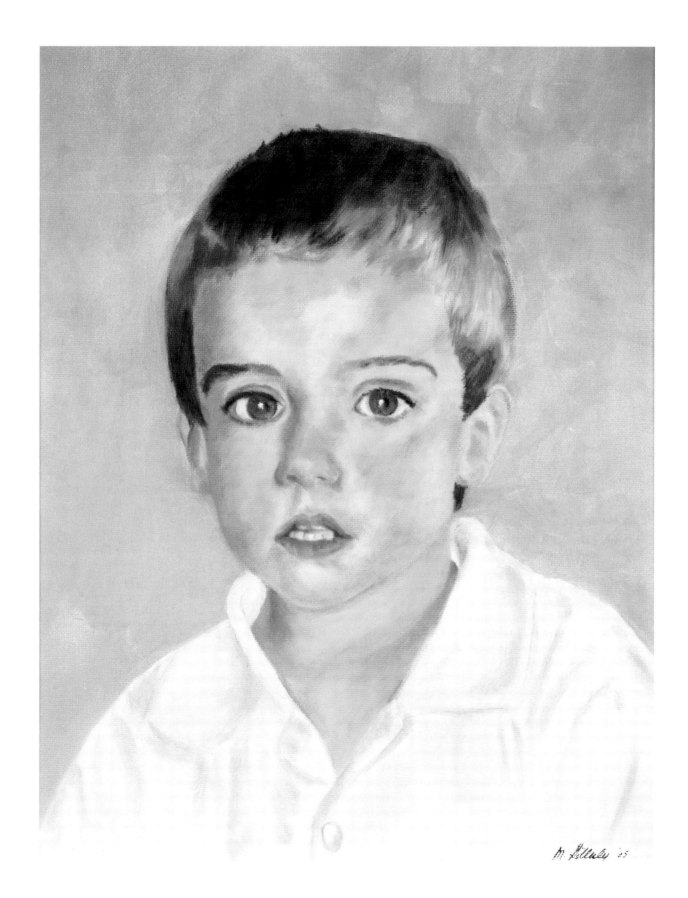

# DRAWING THE HEAD AND FACIAL FEATURES

To draw portraits well you must be acquainted with the structure of the head and its features. Let's look first at a simplified skull from the side, front, and back. Notice in the profile view that the jaw is lower than the base of the skull where the neck is attached. The neck is not erect, but swings forward from the shoulders. Notice in the frontal view that the neck doesn't join into the shoulder line but instead passes *in front of* the shoulders. In the dorsal (back) view, you may see the jaw on either side of the base of the neck.

*Simplified skull: profile view (LEFT), frontal view (MIDDLE), and dorsal view (RIGHT)*

## Using a Center Axis

Begin your portrait by drawing a line (called the "center axis") that indicates the division between the right and left sides of the face. The center axis does not always fall in the measured center of the face. If the person is facing you directly, the center axis will indeed be in the middle, but if the person is turning partly away from you (called a "three-quarter view"), the center axis will be off center.

Once the center axis is drawn, you can add positioning guidelines for each of the major features as shown in the illustrations on the facing page. These guidelines are always at right angles to the center axis and follow the curvature of the skull. In an adult, the eyes generally fall near the halfway point from the top of the head to the bottom of the chin. In a child, the features are much lower on the head.

When you are working on getting a likeness, look for ways in which your subject's features differ from the average. These differences will help you capture the likeness.

*Center axis of the features: frontal view (LEFT) and three-quarter view (RIGHT)*

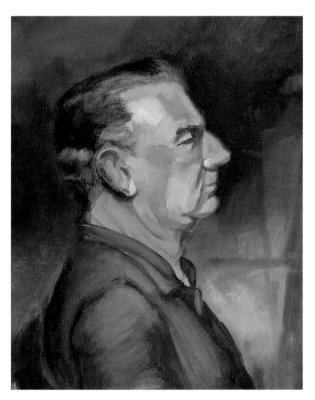

*Kathleen Lochen Staiger,* Study of Harry, *oil on canvas. The proportions on this model's head differ from the "ideal" or "average." Finding these differences will help you get a good likeness.*

HAIRLINE

EYEBROWS

EYES $\frac{1}{2}$

NOSE (BOTTOM)

MOUTH

TOP OF CHIN

$\frac{1}{2}$ EYES

TOP OF HEAD

$\frac{1}{2}$?

EYEBROWS

EYES

NOSE

LOWER LIP

CHIN

TOP: *Feature guidelines are always at right angles to the center axis and follow the shape of the skull.*
BOTTOM: *A child's features are lower on the skull than an adult's.*

As a child grows, the eyes become
higher in the head; therefore, if the
child you're drawing looks too young,
try raising the eyes.

## Drawing the Features in Different Positions

As the face turns away from you, the center axis also turns. When the head tilts up or down, the feature lines curve up or down as well. As the head turns, the *shapes* of the features also change. In a three-quarter view, for instance, the eye farthest from you is not the same shape as the eye closest to you. The farther halves of the mouth and the nose are also different from the closer halves.

Similarly, when the head tilts up or down, your view of the features changes. In the illustrations below, notice that when the head tilts up you see more of the *bottom* of each feature. The ears are very low and you can see under the nose and the chin; the bottom of the nose is triangular in shape and the top is foreshortened. Likewise,

*When the head tilts up or down, the feature guidelines also curve up (LEFT) and down (RIGHT).*

when the head tilts down, you see more of the forehead and less of the chin; none of the underside of the nose is visible, the shape of the eyes has changed dramatically, and the ear is positioned much higher.

*Notice how the features change as the head tilts up (LEFT) and down (RIGHT).*

## EYES

Earlier we discussed the importance of really *looking* at what you're drawing or painting—and seeing these objects with fresh eyes. Simplified facial features (such as a curved line for the mouth or two dots for the nose) still lurk in our subconscious files along with the lollipop tree. These are two-dimensional simplications of three-dimensional structures. Before you begin to draw and paint portraits, you have to consciously set aside these symbols and take a fresh look. Otherwise they will continue to crop up in your more sophisticated art.

The eye that we see is actually part of a round ball. The lids of the eye open to show only a part of the eyeball, and usually only a portion of the iris (the colored part) of the eye. Beginners frequently ignore the crease above the eye and the shadows below and around the eye that indicate the eye's three-dimensional structure.

*The eye is a ball. We only see a small portion of this ball in the frontal view (LEFT) and even less in the profile view (RIGHT).*

Another common mistake is drawing an almond-shaped outline for the eye with a round ball in the middle for the iris. The eye is not symmetrical. Usually the highest part of the arch of the top lid is near the nose rather than in the center. Always look to see where the highest part of the arch occurs in your subject. The lower lid is a much shallower curve. Both lids wrap around

LEFT: *Notice how the upper and lower curves of the eye differ.*
RIGHT: *Drawing the negative shapes on either side of the iris can help you identify its position.*

the ball of the eye and the corner may disappear as the face turns away to a three-quarter view.

The full iris of the eye is rarely seen except when a person is crazed or surprised. The upper lid usually covers approximately the top third of the iris; the bottom of the iris appears to rest on the lower lid. When a person smiles, the corners of the mouth extend into the cheek, which pushes up the lower lids. The lids rise and cover the bottom of the iris.

When eyes are looking away from you, the irises are ellipses rather than perfect circles. Notice, however, in the tonal study of the three-quarter view below that the iris is a full circle because it is *facing* the viewer.

When eyes are focused on something close, the irises are closer together; when the focus is off in the distance, the irises are farther apart. To help you focus the eyes, it is often helpful to draw the whites that are showing on either side of the iris, rather than drawing the iris. If you draw the whites as a negative shape, you will have isolated the iris as a positive shape.

When painting the eyes, details such as eyelashes should be indicated as a blurred line or tone, not as a fringe of individual hairs. In tonal studies of the structure of the eye I have included the eyelashes so you can see how they are positioned around the eye.

*Tonal studies of the eye:*
*frontal view (LEFT),*
*three-quarter view (MIDDLE),*
*and profile view (RIGHT)*

## NOSE

Put your finger on the bridge of your nose and follow it to the tip. The bone ends partway down, and you can feel the cartilage that forms the ridge down to the tip of the nose. The tip stands out from the face, while the bottom angles back toward the face.

Look at the illustrations below for help in shading the form of the nose. In most lighting situations the tip of the nose should have a highlight, and the triangular form of the underside of the nose should *be* in shadow and also *cast* a shadow on the upper lip. The nostrils, as normally viewed, are shallow arches with some shading underneath (not round black holes); they should be understated so that the eye is not drawn to the dark forms.

When strong lighting hits one side of the face, the nose is easier to paint because shadows define the structure. Full-face "glamour" light-

ing that erases all wrinkles also erases the shadows that give form to the face. In this situation, add a little complement to the sides of the nose to make them recede. See the portrait paint-along on pages 158–169 and the demonstration portrait on pages 170–173 for examples of using this technique.

## MOUTH

To draw or paint a realistic mouth you need to know about the five muscles that make up the lips. These muscles are identified in the illustration below. They create the unique and subtle shapes that form the mouth. Look closely at the way the mouth is formed. (A mirror is a handy tool for the artist.) Notice how the top lip slants in and is usually in shadow, while the lower lip juts out and catches more light. There is usually a shadow under the middle of the lower lip but not on either side due to the muscles under the sides of the lip. Sometimes the edges of lip and muscle under the lip run together and you have a "lost" edge.

*The muscles of the mouth*     *Tonal study of the mouth*

The three-quarter view of the mouth shows it turning away. Depending on how far the mouth is turned, you may not see its far corner any more than you could see the far corner of the three-quarter view of the eye on page 149. In the profile view of the mouth, look for the "mustache" area above the upper lip to curve out, and the face under the lower lip to curve in down to the chin.

Mouths can form a countless number of expressions. Each presents unique formations of the five muscles. Smiling and open mouths are probably the most common.

*The nose: frontal view (*TOP LEFT*); three-quarter view (*TOP RIGHT*); and profile view (*RIGHT*)*

The mouth: three-quarter view. Notice that you don't see the far corner of the mouth.

The mouth: profile

**SMILING MOUTH:** Smiles stretch the lips, which makes them thinner and also makes the line between them straighter. Smiling lips generally curve up slightly and push back into the cheeks, creating a soft shadow.

**OPEN SMILE:** When the lips part in a smile, you can see that the structure of the upper lip at the corners partially overhangs the corners of the lower lip. To draw an open smile, first draw the bottom edge of the upper lip, looking carefully at how it is shaped. Then judge how much of a space there is between the lips and how much space you will need for teeth and gums, and mark the opening. Next, make marks for the width of the upper and lower lips and connect the lines marking the opening to the corners of the mouth.

Now that you've studied the lips, let's focus on the other components of the mouth—specifically the teeth, gums, and tongue. Teeth do not march in a flat row from corner to corner of the open mouth. Put your finger on one corner of your lips and run it across your upper lip to the other corner. Feel the arch that makes up your teeth. When you see the teeth in an opened

*To create natural-looking lips, try to depict the structure and paint the edges with a blurred line. Never outline the lips and then fill them in.*

mouth, remember that the teeth in the center may catch some light, but the rest curve back into the shadows inside the mouth. There is usually a dark triangle at the corners of the mouth where a space shows between the teeth and the side of the mouth.

When drawing or painting teeth, downplay or leave out entirely the lines that separate each tooth. Instead, indicate the overall shape of the teeth, both at the gum lines (if they show) and at the edge of the teeth. Teeth can be depicted in paint by using a light warm gray mixture. (Burnt Umber plus French Ultramarine blue and white works well.) This color can be lighter at the center, but never paint the teeth white or they will look false. The gray mixture should get darker as the teeth go back into the mouth.

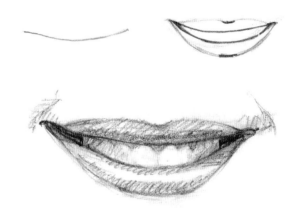

To draw an open mouth, first define the area between the lips (TOP LEFT); next decide on the size of the opening and draw the lips, starting with the top of the bottom lip (TOP RIGHT); finally, add the shading details (BOTTOM).

Keep the colors of the tongue and gums muted and shadowed. The gums will be in the shadow of the upper lip and the tongue is well into the shadow of the mouth. Gums, tongue, and other parts of the inside of the mouth can be painted with mixtures of Alizarin Crimson, Burnt Umber, and white. Be sure the tongue is not much lighter than the shadows inside the mouth and that it goes back into the dark areas. If needed, gray the mixture with a little Oxide of Chromium.

## EARS

Beware of all that detail in the ear; a complex pattern on the side of the head will draw attention away from more important features of your portrait. Instead, suggest the light and dark areas of the ear with as few strokes as possible. Since ears are particularly tricky, before you start to paint them, you might find it helpful to study how they are depicted in other paintings, including the examples in this lesson.

*The ears: frontal (LEFT) and profile view (RIGHT)*

## HAIR

Paint the hair as a group of masses rather than trying to depict individual hairs. In the painting on the facing page look at how the light hits the hair and places highlights *across* the mass of hair. Your brushstroke will control the texture of the hair—whether it is straight or curly. Hair should look soft, so make sure to paint the edges of the hair into wet background color; this will help blur the colors and underplay the complexity of the hair so it doesn't distract from the features.

## Planes of the Head

If your subject is illuminated from above and facing you, parts of his or her head will naturally face up toward the light and therefore receive more light, and others will cut in and therefore be in shadow; planes that turn away from the light toward the shadow will be in halftone. Under these lighting conditions, look for lights on the top of the forehead and cheeks, the top of the eyelids and nose, above the upper lip, and on the upper chin. Look for shadows around the eye socket where the eyeball goes back into the head and under the eyes, nose, and chin. Halftones may appear under the cheeks if the light is directly overhead, and in various areas of the face according to how the light is falling. Lights and shadows on the head will change if the location of the light source or the position of the head is altered.

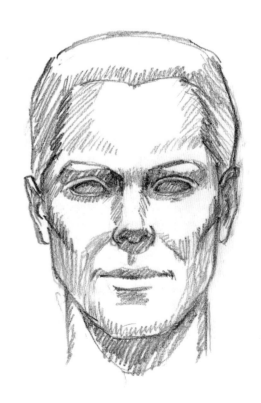

*Planes of the head*

# PAINTING A PORTRAIT

While many of the skills used to paint other subjects apply to portraiture, painting people poses unique challenges. Some artists like to make a detailed pencil sketch of their subject. If you want to do this, make the sketch the same size as the portrait will be and then transfer it to your canvas. (See Transferring the Sketch on pages 158–159.) You may wish to use a watery *acrylic* paint (Burnt Sienna) to set your sketch lines. Personally, I prefer "sketching" directly on the canvas with *oil* paint that has been diluted with paint thinner; Burnt or Raw Umber works best. Either way, once lines have dried, they will be difficult to change, so keep them light.

Start by placing one line for the top of the head and another for the bottom of the chin. Decide on the tilt (if any) of the center axis and paint in a guideline for it. Then judge the width of the face and head and paint those guidelines, noting how much of the width falls on each side of the center axis. Add the neck and shoulders and sketch in the features in a very general way to establish their size and position.

The features should guide the contours of the face. Ask, "How close is the edge of the face to this eye, or from the corner of the mouth?" Look for places where bones jut out slightly. Use plumb lines and negative shapes to help you position everything. Add ears, neck, hair, and anything else that will appear in the portrait. Block in the shadow shapes, including those in the hair, clothing, and background, using Burnt Sienna with or without French Ultramarine blue. Before applying any color to the face itself, establish what colors will surround it, as these will influence the color and value of your face. Paint in those areas, keeping all edges soft, and then begin your face.

*Kathleen Lochen Staiger,*
The Irish Cousin, *oil on canvas*

# Mixing Skin Colors

You will need the following:

**PAINT:** All thirteen colors that make up your standard palette, except Lemon Yellow Hue and Permanent Rose

**OTHER SUPPLIES:** One 12 x 16-inch practice canvas and all basic painting supplies

**TIME:** About 1½–2 hours

Mixing skin color is the same as mixing any other color. In general:

**FOR LIGHTER SKIN TONES:** Mix the red of your choice with Yellow Ochre and white.

**FOR DARKER SKIN TONES:** Mix combinations of Burnt Sienna, Raw Sienna, and Burnt Umber with white.

## PAINTING LIGHTER SKIN TONES

What many people refer to as "white" skin is basically a pale, low-chroma orange made up of red, yellow, and white. Personally, I like using Cadmium Red Light (which is not part of your standard palette), Yellow Ochre, and white. However, you can use other reds, including Cad- mium Red Hue, Alizarin Crimson, or even a red oxide such as Indian Red. If you want to follow the color in this exercise exactly, add a little Cadmium Yellow Medium to Cadmium Red Hue; this will help make it equivalent to Cad- mium Red Light.

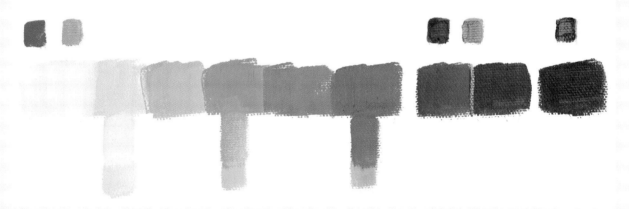

*Value progression bar of light-colored skin with blue (the complement) added to some swatches to create shadow colors*

### Mixing a Base Color

The first step in mixing skin color is to combine your chosen red with Yellow Ochre. Once you decide on the proportion of red to yellow this becomes your *base color,* needing only the addition of varying amounts of white to lighten it to the desired value, and/or of the complement to gray it to the desired chroma. Having this base mixture allows you to keep your skin color constant throughout your painting.

When preparing to paint a portrait, it is a good idea to mix enough base color to last through its completion. It can be kept in a covered container so you will always be able to mix more of your exact skin color at any point simply by adding white. When you become more experienced, you will see and paint a greater variety of color in the face and you won't need to mix a base color. For this exercise we will only mix a little of the base color. Refer to the image above to see the general layout of the exercise.

1. If you wish your color to exactly match the illustration, add a small amount of Cadmium Yellow Medium to Cadmium Red Hue and mix it well. This becomes your "red." Alternatively you can just use Cadmium Red Hue as your "red." Both methods work well.

2. Mix your red and Yellow Ochre together to make the base color.

3. Add some white to check the proportions. If the color looks too pink, add Yellow Ochre to your base. If the color looks too yellow, add red. You'll want something in the middle.

4. On your canvas, make a value progression of your skin color from white to base.

5. Mix a darker base color with Alizarin Crimson and Raw Sienna. Add on to the value bar by mixing the darker base with the first base color, and then add the darker base by itself. The last section of the scale is a mixture of the dark base with Burnt Sienna.

## Mixing a Shadow Color

Review the Rule for Shadows on page 58. To make a shadow on skin in a portrait, you first have to darken the skin to the desired value of the shadow. The value progression bar of skin color gives you many options for how dark you may want a shadow.

After selecting the value of the shadow, you need to find its complement. Since red and yellow make orange, you would look to blue. But which blue? To find out, mix Thalo Blue and white to the same value as a light value of skin color in the value progression bar. Add just a touch of the lightened Thalo Blue to a little of the skin color. If the mixture looks greenish, your skin color mixture has more yellow than red and you should try French Ultramarine blue (which is closer to purple) instead.

1. Take a #2 flat bristle brush and pull down some of the wet paint on your value bar at three different points, making sure that one of the values that you select is *very* light. Pull the paint down about half an inch.

2. Using the blue you have decided best complements your skin color mixture, match the values in the three places you have chosen.

3. Use a clean #2 flat bristle brush to place a small amount of the value-matched blue under each place you've pulled down color on the value bar.

4. Wipe your brush so that it has just a small amount of the complement, then mix the two colors together. Remember that your goal is to make the color grayer.

Now that you are familiar with the process, experiment with other mixtures for skin color. Try Burnt Sienna, Cadmium Red Hue, Alizarin Crimson, Raw Sienna, Yellow Ochre, Cadmium Yellow, and orange with white in various combinations. Make a note of what you used.

*Alternate combinations for skin color*

## Making Olive and Pink Skin

To make olive or pink skin, use the same three colors that you used for the previous exercise—red, Yellow Ochre, and white—but simply adjust your "recipe" slightly by adding more or less Yellow Ochre. The resulting skin colors, rather than being basically "orange," will become basically yellow or red and the complement should change accordingly.

1. Mix a light to middle value of your original skin color and add a small amount of Yellow Ochre to create a more olive skin color. Paint a swatch of this color near the color bar that you made in the previous exercise.

2. Mix purple (the complement of yellow) with Alizarin Crimson and French Ultramarine blue. Add enough white to this mixture so that it matches the value of your paint swatch.

3. Pull down a patch of the olive skin color and then add a small amount of the lavender mixture into the patch to gray it. The purple may require

a touch more crimson or blue for balance. Repeat this process until you are happy with the shadow tone.

To make pink skin, use the same three basic colors used to make lighter skin tones, but favor the red just slightly. You may even want to add a touch of Alizarin Crimson. Skin that is very fair and reddish may require a greener complement. Make a swatch on your canvas and try a lightened Thalo Green as the complement.

*Olive skin with a shadow tone using violet, the color's complement (LEFT) and pink skin with a shadow using green (RIGHT)*

# PAINTING DARKER SKIN TONES

Darker skins of all varieties can be created from earth tones such as Burnt Sienna, Burnt Umber, and Raw Sienna. They can be turned warmer with the addition of reds and oranges, and cooler with either French Ultramarine blue or Thalo Blue—depending on the proportion of red to yellow in the skin tone. Highlights are more visible on darker skin and should be grayed with a touch of blue.

In order to show a broad diversity of darker skin colors we are creating not a value bar, but a color bar. This will show the varying colors that are the base hues for a variety of darker skins. White will be added at the upper edge and complements at the lower edge.

1. Make a color progression bar of darker skin color. Start with Raw Sienna and continue through Burnt Sienna; a mixture of Burnt Sienna and Burnt Umber; Burnt Umber; and a mixture of Burnt Umber darkened with French Ultramarine blue. Mix the colors together with the ones on either side.

2. Pull up a sample of each of the variations and mix white with each to show lighter values.

3. Pull down samples of each color, add some white, and then add light blues below each color to find highlight colors.

4. More variations can be obtained by adding yellows and reds to the earth tones.

*Darker skin tones made from the earth tones with highlight variations that feature the complementary color, blue*

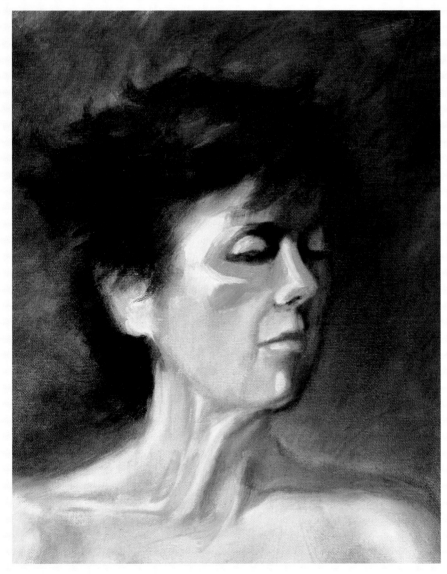

*Kathleen Lochen Staiger,* Study of a Female Model, *oil on canvas. In this study I used a broken-color technique in which the colors are not blended, but are broken into distinct strokes. Thus, instead of mixing blue with skin color for the cool light at the top of the cheekbone, I laid a stroke of blue into the wet skin color. For the warm glow of the cheek turning from the light I added a stroke of warm red. I also controlled the edges of the forms by varying them from soft to sharp.*

# Doing a Portrait Paint-along

You will need the following:

**PAINT:** All the colors that make up your standard palette, except Permanent Rose

**OTHER SUPPLIES:** One 12 x 16-inch canvas panel, all basic painting supplies, #2 pencil, kneaded eraser, masking tape, graphite paper* (optional), and Burnt Sienna acrylic paint (optional)

**TIME:** About 9 hours total (three sessions, each roughly 3 hours)

*Graphite paper is similar to carbon paper, but with graphite (pencil) rather than ink.

The landscape painting in the previous lesson was done during a number of sessions because we needed to let areas dry. Not so with this painting. Since you will be building layers of shadow and light on a single area of the canvas (the face), it is preferable to work wet-in-wet. This painting can be made during three sessions. First you transfer your sketch to the canvas and lay in the background areas; next you set up the full portrait palette and begin the face; and finally you finish the features and the hair.

## TRANSFERRING THE SKETCH

*Copy and enlarge this head and transfer the image to your canvas.*

Before you begin to transfer the sketch onto your canvas, I would like to explain the curved line under the tip of the nose. This little line marks a subtle turning place in the structure of the nose and not an edge. Therefore it should be sketched in very lightly. The transparent nature of oil paint may cause pencil marks to show through your paint.

1. Enlarge the image on the left on a photocopy machine to fit the canvas.

2. If you are not using graphite paper, turn the photocopy over and rub your pencil on the back of the image where you can see the lines of the face and hair.

3. Tape your photocopy (with the right side facing you) to the canvas. Use two pieces of masking tape at the top, one on each side, to create hinges. (This way the paper can be lifted to check how the tracing is coming along.)

4. If you are using graphite paper, slide it between your photocopy and your canvas.

5. Using your pencil, trace the face. Lift the paper as you go along to make sure that your tracing is coming through clearly.

6. Remove the photocopy and compare your transferred sketch with the drawing in the book. The roughness of the canvas may have affected the accuracy of your lines, so correct the drawing and make sure all the lines are dark enough to see clearly.

7. Lighten the pencil lines with an eraser until just visible.

8. When you are satisfied with the accuracy of your drawing, you may want to use watered-down Burnt Sienna acrylic paint to go over the lines. This will make them permanent. Remember, the acrylic is optional.

*Position the head high on your canvas to give importance to your subject.*

## PAINTING THE BACKGROUND AREAS

Before painting the face, it's a good idea to establish the colors that will surround it, as they will influence its color and value. Always put in the background tone and then a splash of hair color so that your relative colors and values end up as you intended them.

1. Combine French Ultramarine blue and Thalo Blue and add white. This will make a good background color for this portrait.

2. Paint in the background with a flip-flop stroke. The paint layer should be solid, but the color can vary from light to dark. Extend your paint *slightly* into the edges of the hair.

3. Paint the hair any earth color you wish, but don't make it so dark that you won't be able to see shadows. Use Yellow Ochre or Raw Sienna for blonde, Burnt Sienna for auburn hair. I used a medium brown mixture that I made from Yellow Ochre, Burnt Sienna, Burnt Umber, and a little white. Stay away from the face for the time being, but overlap into the background color to create a soft edge. The image to the right is only a guide. At a later stage I decided to reduce the hair mass.

4. When you have finished painting the general mass of the hair, take a clean brush dampened with medium to soften all the edges surrounding the face.

This marks the end of your first painting session.

*Loosely paint the colors that surround the face.*

# SETTING UP THE PORTRAIT PALETTE

For this second painting session we will set up the portrait palette and begin the face. As you learned in the project on mixing colors, there are many reds you can use. In this paint-along I use a slightly warmer version of Cadmium Red Hue called Cadmium Red Light, which is not part of your standard palette. If you want your color to match mine *precisely,* substitute this color. Or just use Cadmium Red Hue, which is part of the standard palette and is very close.

*1.* In the center top of your palette place a daub of Cadmium Red Hue and another daub of Yellow Ochre.

*2.* Put a small daub of Cadmium Yellow Medium to the left of these two colors.

*3.* Mix a small amount of the Cadmium Yellow Medium into the Cadmium Red Hue to make a slightly warmer red.

*4.* Directly beneath the Yellow Ochre and warm red mixture, thoroughly mix equal amounts of both colors. (Don't use all of the paint; leave a little of each.). This is your base color, and you should have a substantial amount of it.

*5.* At the bottom of the palette, under the base color, place a daub of white paint.

*6.* Mix some white into the base color to confirm that the proportion of red to yellow looks right. Amend if necessary.

*7.* Make a vertical value progression bar of skin color by drawing down a small portion of the base color with a palette knife and adding increasing amounts of white.

*8.* To the right of the first two colors place daubs of Alizarin Crimson and Raw Sienna.

*9.* Mix a small portion of these two colors together on the palette underneath the crimson and Raw Sienna. This is your dark base color.

*10.* Mix a little of the base color and a little of the dark base color together and make a daub between the two base colors.

*11.* Place small daubs of French Ultramarine blue and Thalo Blue on the left edge of the canvas.

*12.* Lighten a small amount of Thalo Blue and add it into a similar value of skin color. If the mixture looks greenish, try the French Ultramarine blue.

*13.* When you have found the best complement to your base color, make a value progression bar of the complement alongside the skin color value progression bar.

*14.* Place the remaining colors in small amounts around the edges of the palette.

To preserve your color mixtures when you are done painting, follow the directions on page 39. It is particularly useful to save your base color.

*Mixing skin color. After mixing skin color as shown, add small amounts of the rest of the standard palette colors around the edge.*

# PAINTING THE FACE

As we will be working on the face for two sessions, it would be helpful to keep the paint moist—both on the painting and on your palette. It's not a big problem if the paint dries before you complete the face; it just makes a little more work.

## Painting the Shadows

With the colors all mixed, let's get right to painting the face. In oil painting the dark areas are painted first—and portraits are no exception. Mix enough shadow color to finish all the shadow areas on the face and neck. Make this color just a little bit darker than you think it should be; it will naturally be lightened as you paint when you add the lighter colors. To gray this color, choose a slightly *lighter* value of the complement and add it to your shadow mixture.

1. Load your #6 flat bristle brush with a scant amount of paint and brush the color into the halftone areas of the temples, around the eye sockets, along the area from the outer corner of the eye to the eyebrow, and on the side and under the nose (from the tip to the base, using the small mark you made when sketching as your starting point).

*Diagram of the placement of facial shadows*

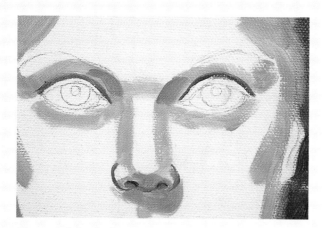

*Close-up of the shadow areas*

2. Then continue along the cheekbones, in the little indentation above the upper lip, and along the edges of the chin and neck. Don't forget to make a cast shadow under the nose in the "mustache area."

3. Clean your brush thoroughly and then sweep the paint that you applied along the cheekbones so that it forms a light haze of shadow on the lower half of the face.

4. Now let's add the darker shadows. Load your brush with a bit more color than you used in the previous step, and go back over the areas that need to be darkened—the triangular shape at the bottom of the nose as well as the shadows cast by the nose onto the upper lip, by the face onto the neck, and by the wave of hair along the right side of the face (if you included it).

5. Using your pointed brush, apply the darker shadow color to bring out the creases of the eyelids and the outer form of the nostrils as well as the nostril holes.

6. Use your pointed brush to finish the nostrils by sweeping some of the lighter shadow color partway into the nose holes.

At this stage your face will resemble a zombie, but have faith.

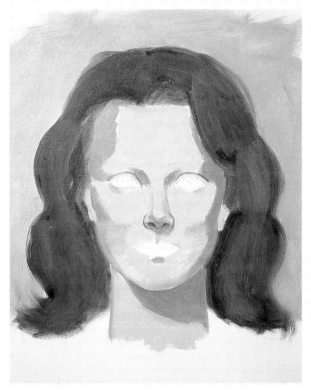

*Paint the general light tone of the skin.*

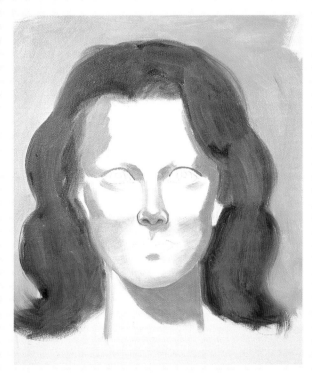

*Paint the face shadows.*

*Paint shadows thinly and lights thickly.*

## Adding the Middle Tones of the Face

1. Pick a value on your palette for the general color of the face.

2. Test a small amount of this color on your painting. You want to make sure that this mixture isn't too light. Even "white" skin is darker than you may imagine. Adjust as needed.

3. When you are satisfied with the color, mix enough paint to cover the face.

4. Paint the face, being careful to go right up to but not into all of the shadow areas and leaving the eyeballs and mouth white for now.

5. Paint right over the eyebrows. (A trace of the sketch should still be visible.)

## Blending the Shadows and Face Color

Now comes the blending. The basic idea is to brush the face color into the shadow areas—not the other way around. I find it helpful to work on the portrait from top to bottom.

1. Starting at the top of the face and using a #6 flat bristle brush, blend the skin color *over* the lightly shadowed temples, creating a halftone.

2. Proceed in this manner down the face. Take extra care around the eye socket, making sure to blend the light color that appears at the bone under the eyebrows into the shadow areas near the nose, along the creases of the eyelids, and from the corner of the eye to the eyebrow.

3. When you get to the area under the eyes, gently sweep your middle-tone areas into your shadow areas.

4. Around the nose, you'll want to blend the skin tone into the shadows and nostril creases to soften these areas.

5. Add a little bit of reflected light at the base of the nose to separate it from the cast shadow on the upper lip.

6. When working on the cheek areas, blend the color out to the edges of the face and also down to the chin.

7. At the lower portions of the face, sweep the face color into the shadow under the lower lip.

## Adjusting the Shadows

At this point in the process it is important to stand back and evaluate your shadows and the general skin color. Stand back at least fifteen feet. It is very common to find that your shadows are not dark enough. (Throughout this paint-along I continually reassessed my shadows and altered them as I thought necessary—darkening, lighten-

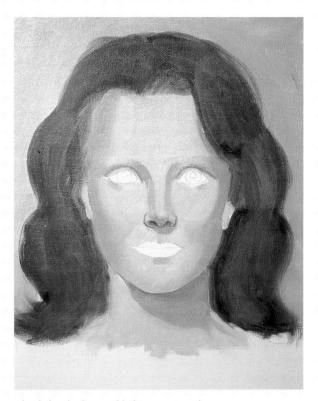

*Blend the shadow and light areas together.*

ing, or adding warmer or cooler colors.) If your shadow areas need to be adjusted, note the following directions. If you like the way they look, proceed to the next section.

1. Darken any shadows that need it by stroking a brush loaded with a fresh application of your shadow color into the necessary area.

2. If some shadow areas appear too dark, load your brush with a fresh application of face color and gently blend it into the shadow area.

3. Shadows that face up, toward the sky, are frequently cooler (have more blue) than shadows that face down. Touches of value-matched blue can be added in areas that are facing up, such as the cast shadow on the upper lip, or to the side such as the temples, the sides of the cheeks, and the sides of the nose. Shadows that face down (such as the underside of the nose) are frequently warmer.

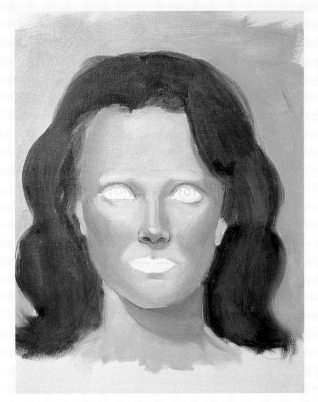

*Add a light blush of a redder skin tone to the face.*

## Adding Warm Tones and Highlights

For your warmer skin tones, mix a little bit of the warm red on your palette with medium-value skin color. Using a #6 flat bristle brush, add this blush tone to the cheekbones and down the bridge of the nose right to the tip. Blend this color into the wet skin color so that the effect is subtle.

Use a very light value of skin color to add highlights at the top of the forehead, along the brow bone, at the top of the cheeks, on the bridge and tip of the nose, on the upper lip, on the top center of the chin, and along the side of the neck. To enhance the realism, all of these highlights should be worked into the wet skin color.

This marks the end of your second session for this project. In the next session we will paint the features and finish the portrait. Take steps to preserve your base colors.

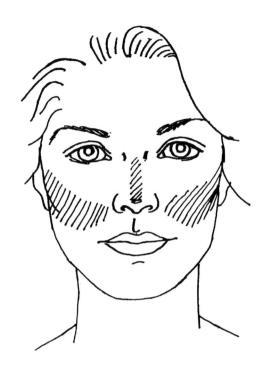

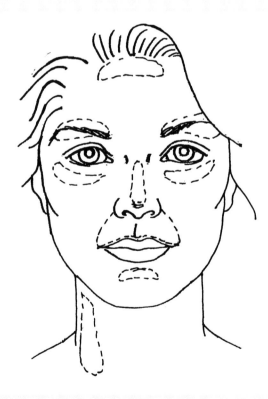

*Diagrams for adding warm tones (ABOVE) and highlights (BELOW) to the face*

## Developing the Eyes

For this third and final painting session, we will concentrate on the features, starting with the eyes. The eyes in a portrait are what compel the attention of the viewer, and it is important to paint them well. In preparation for this session, be sure all of your paint is usable. Replace any that is not, and mix more skin color, shadow color, and complementary color as needed. Also mix some true green (Thalo Green plus Cadmium Yellow Medium) on your palette. As you follow the instructions below and develop the eyes, refer to the two demonstrations portraits to the right.

1. Paint the inside "white" of the eye with dark and light grays and a touch of light skin color.

2. Use these same grays for the shadows on the eye—both where it turns away from the light and under the top eyelashes. Make these shadows darker than you think they should be.

3. Use your pointed brush and a combination of white, Alizarin Crimson, and Burnt Umber for the pink in the inner corner of the eyes. Start with a darker pink to draw the edges of the triangle and then paint a lighter pink inside it. The darker pink can also be used to outline the bottom of the white of the eye to separate it from the skin below. Follow the illustration below.

4. Use Burnt Umber to draw an outer edge for each iris.

*Paint the pink areas, "whites" of the eyes, and the shading and highlights surrounding the eyes.*

*Then add the irises and pupils.*

5. Fill both irises with your chosen eye color, painting into the Burnt Umber line. For blue eyes, mix a little Cadmium Red Hue or Burnt Umber with whatever blue you choose so that it isn't unnaturally bright; for brown eyes, use an earth tone such as Burnt Sienna mixed with Burnt Umber; hazel eyes might have Raw Sienna with a little green. Make the eye color darker in the area that falls in the shadow of the eyelid.

6. Mix Burnt Umber with French Ultramarine blue for the black pupil of the eye.

7. For a highlight on the eye, load a little white on the tip of your brush and place a small light daub slightly to the left of center, facing the source of light.

8. The eye is translucent, so the light from the highlight will pass through the eye and hit the opposite inside of the iris, making it lighter and brighter. Apply a lighter and brighter shade of your eye color to this area to really make the eyes come alive.

*Diagram of the pink areas surrounding the eyeball*

## Adding Eyebrows and Eyelashes

Hair should always be painted into wet skin color so that it looks soft and natural. Remember that painting hair of any kind is not a matter of painting individual hairs but of painting a blurred tone that suggests the softness of the hair. A pointed brush dragged slightly on its side works well for this.

1. If the eyebrow and eyelid areas are dry, rewet them with a little more skin color.

2. To create eyebrows for a brunette, use Burnt Umber; add a little Raw Sienna to the umber if your subject is blonde. Use short strokes that follow the direction that the hairs grow. The eyebrows should be darker near the nose where they grow more heavily, lighter past the arch.

3. For the top eyelashes, use Burnt Umber to paint a thin, soft line from the inner corner of each eye, widening and darkening the stroke toward the outer corner and slightly beyond.

4. Paint the bottom eyelashes, again with Burnt Umber, from the outer corner of the eye just under the ledge. Since the eyelashes are very thin past the center of the eye, you can stop the line near that point.

*Add the eyelashes and eyebrows.*

## Finishing the Nose

The nose is fairly well developed, but it needs a few finishing touches. Add a core of shadow just above the reflected light. Darken that area with shadow color and blend it in. Since the light is coming slightly from the left, the left side of the nose should be only slightly darker than the adjacent cheek. The shadow on the right side of the nose should be darker. Refine the nose and nostrils as needed so that they look finished.

*Finish the details on the nose.*

## Adding the Mouth

Now let's address that gaping hole in the middle of your canvas and paint the mouth. You will use a combination of your pointed brush and your #2 flat bristle brush.

1. Rewet the skin color around the mouth if you think it is necessary.

2. Mix Alizarin Crimson with a little of the true green you mixed on your palette. Paint the line between the lips and add a little of this shadow color into the upper lip and at the bottom center of the lower lip.

*To make the mouth, first paint the center line and the darker color in the upper lip (ABOVE). Then add your lip tone, blending it into the shadow areas (BELOW).*

3. Mix Cadmium Red Hue or Alizarin Crimson into your skin color to achieve the redness you desire for the mouth. Paint the upper lip, brushing the paint into the thin line between the lips. Pull some of this shadow color into the upper lip as needed.

4. Use the colors of the upper lip to paint the lower lip. It should be dark under the center line where it is in the shadow of the upper lip and at the bottom center. In the middle, the lower lip should be lighter than the upper lip.

5. The area above the upper lip protrudes slightly. Add an edge of very light skin color just above the lips and blend. Soften the edges of the lips with a dry brush.

6. Extend the center lip line slightly with skin shadow color at the corners of the mouth. Blur these areas for a slight smile.

# Finishing the Hair

Evaluate the general shape of the hair and adjust as necessary. When creating my painting, at this stage I decided that the hair had become too large, so I removed as much as I could with Turpenoid Natural and then repainted the background into it around the edges.

1. Mix a batch of your chosen hair color and also some of your background color. Repaint the background around the edge of the hair.

2. Repaint the skin color around the forehead, painting into the hairline a short way, and then repaint the hair with your chosen color so that you will be working into wet paint. Keep away from the skin color for now.

3. Overlap the hair color into the background color so that the edge of the hair looks soft.

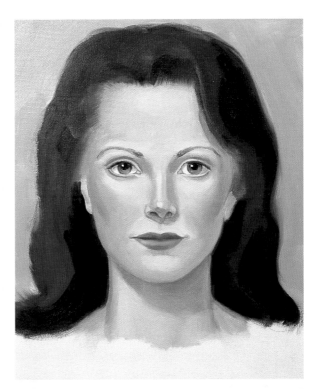

*Sweep hair color into wet skin color to create the hairline and then add the shadows.*

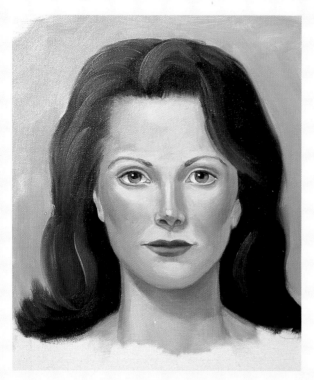

*Add lighter tones to the hair for variety of color.*

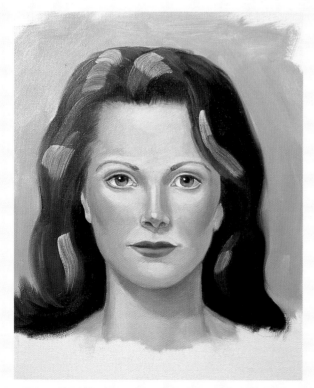

*Block in the highlights; these will then be feathered into the rest of the hair color.*

4. To create the hairline, use a #10 flat bristle brush and sweep your hair color *from the hair* into the wet skin along the edges. Know where to stop. You will get skin color into the hair, but that can easily be covered. If the hairline gets too far into the face, fix it by removing as much of the paint as possible with a dry brush and then loading your brush with fresh skin color and sweeping it into the hair, making sure you wipe your brush after every stroke.

5. Paint the shadows in the hair. They should fall in the areas under both earlobes near the neck and shoulders.

6. Continue to add the dark areas, following the example in the image on the previous page, and then create a soft edge where the face and neck come together with the hair.

7. To add the light areas, mix lighter varieties of your hair color. For my painting I used Raw Sienna, Cadmium Yellow Medium, and a little white. Add these lights where you imagine the light from the upper left would hit, but be careful not to cover all of your original color.

8. For the highlights, add white tinged with a little of the complement (which in my case was French Ultramarine blue). Place the highlights across each shape of hair that catches the light.

9. Use a bushy brush (such as your utility brush) and feather the highlights into the hair.

## Evaluating Your Work

Take a look from a distance and see if anything needs adjusting. If not, then you are finished. At this point, I brought the hairline further into the forehead and adjusted the shadows here and there. If you are unhappy with the results, try again. Just remember to be patient with yourself. If you practice, you will improve. I guarantee it.

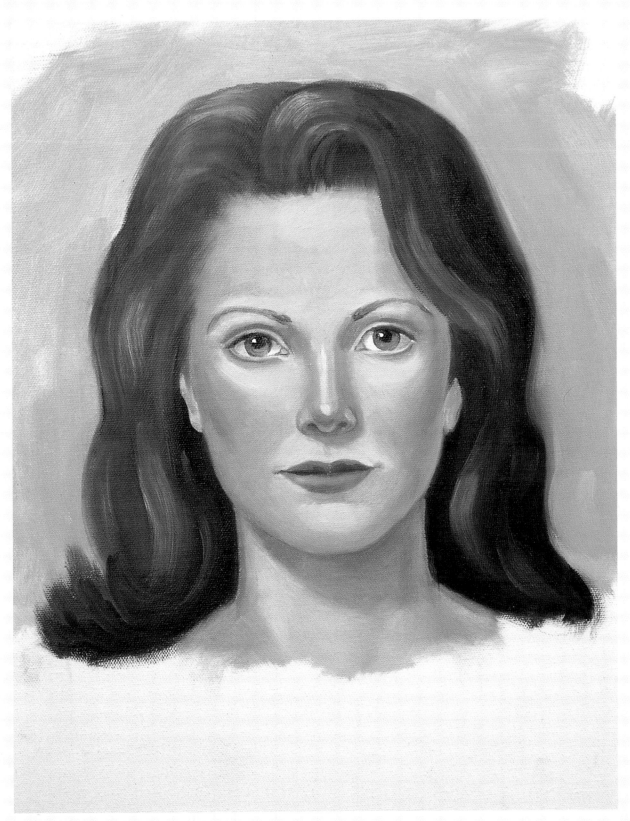

*The finished portrait*

# DEMONSTRATION: CREATING A PORTRAIT

My neighbor posed for this portrait. I wanted to capture the colors of her blonde hair and unusual hazel eyes and chose the colors of the background and her shirt to harmonize with them. The portrait was painted from photographs I took of her, but photographs can only take you so far. If this had been a commissioned portrait, I would have followed up with several sittings to make sure I had captured her likeness and personality.

## Making the Sketch

Using thinned Burnt Umber, I made lines for the top and bottom of the head. I checked the angle of the features in my model and placed the center axis on my canvas. I then divided the head in half vertically and found that the eyebrows are in the middle, so I placed a feature guideline at a right angle to the center axis at that point and added the hairline.

I divided the space between the eyebrows and chin in half and found that the nose is just a little longer. I put in another guideline for that. Then I divided the space between the nose and the chin in half and found that the lips are higher. I tentatively placed another guideline for the mouth, and one for the top of the chin. Then I placed two curved lines representing the nose between the eyes; with those placed, I could position the eyes. I noted that my model's eyes tilt up at the corners. I also noted the distance from the nose line to each eye, and sketched in the general position of the eyes.

To sketch the nose, I looked for the distance from the center axis to the tip of the nose. A plumb line dropped from the eye helped get the tip of the nose out far enough. Then I sketched

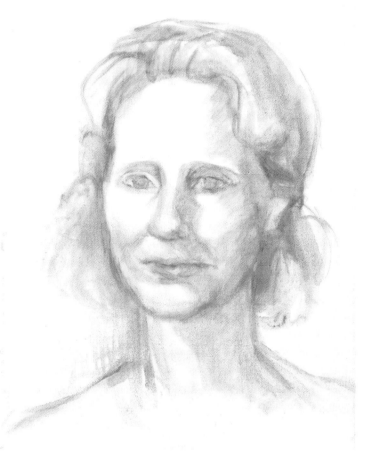

*I used thinned-down Burnt Sienna to indicate my initial guidelines and then sketch in the basic features.*

the mouth, lining it up with the nose and eyes, and noting that one side of the mouth is higher than the other.

Once I had placed the features, I started to find the edges of the face and put in the hair, neck, and ears. To insure a good likeness, I stood back and considered what unique characteristics my model has. I evaluated the sketch to see whether I had come close to capturing these features and made just a few minor adjustments. Finally, I lightly washed in a tone for the general shadow shapes and wiped out the center axis and remaining feature guidelines.

# Laying in Color

A word about my color palette. You will notice the use of a few colors not on your basic list. Since this is a demonstration of how *I* would paint a portrait, I am showing you the colors I use. Some of these go beyond the basic palette. Cadmium Red Light is a slightly warmer version of Cadmium Red Hue and Oxide of Chromium is a shortcut green.

To set up my palette, I placed daubs of Lemon Yellow Hue, Cadmium Yellow Medium, Cadmium Red Light (*not* Hue), Yellow Ochre, Raw Sienna, Alizarin Crimson, Burnt Umber, French Ultramarine blue, Thalo Blue, Oxide of Chromium, and white in their respective positions. (Lemon Yellow Hue and Burnt Umber were not specifically mentioned in the palette setup on page 160; however, as discussed, each portrait palette has slightly different needs and I decided that I needed these two colors for this portrait.)

I mixed a base color of Cadmium Red Light and Yellow Ochre, and a darker base color of Alizarin Crimson and Raw Sienna. I added white to the first base color, compared the color to the model's skin tones, and then added some Alizarin Crimson to the mixture to match the model's pink skin tone.

I experimented with lots of different blues and green to find just the right complement, and finally decided on a combination of Oxide of Chromium with a touch of Thalo Blue. I made a value bar of this color on the palette next to the skin colors. Then I mixed Oxide of Chromium with Yellow Ochre and white and lightly painted in a general background tone, extending it well into the hair.

To create the general color of the blonde hair, I mixed Burnt Umber, Raw Sienna, French Ultramarine blue, Yellow Ochre, Lemon Yellow Hue, and white. Then I painted the hair, extending over the background green for soft edges.

To create the facial shadow areas, I applied mixtures of the two base colors plus the complement. For areas of halftone that looked very cool, I used a light green. I also added Cadmium Yellow Medium for warmth to light areas of the skin here and there, overlapping some of the lighter color into the halftones.

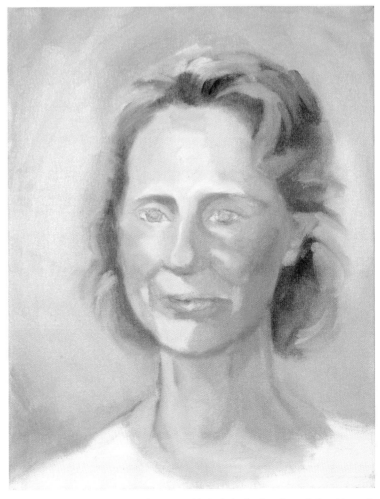

To capture the basic likeness, first I established the basic colors of the skin and hair, then I added general shadows and lights, keeping all of the edges soft.

## Adjusting the Final Features

Now I needed to make sure that I captured all of the features. I started with the eyes, reexamining their relationship to the nose and working my way out from there. This is the time for close evaluation and standing back; another trick is to hold a mirror up to the painting. I checked the width between the eyes and used plumb lines to make sure that the rest of the features lined up.

I used Burnt Umber to paint the eyelash line and to position the irises and pupils. I paid particular attention to the shape of the iris as it intersected with the upper lid to get the right amount of the iris circle. I stood back to see if the eyes were in focus. I also worked on the shading around the eyes.

The nose was fairly complete, but I looked for the exact placement of each nostril. Once I had the right drawing of the eyes and nose, it was easier to get the mouth in the accurate position. Then I worked on some of the muscles around the face and the shadows on the neck.

## Finishing the Painting

The paint was dry on the face, so I lightly dampened it with medium applied with a soft brush. I then concentrated on perfecting all of the skin tones. I looked for warm and cool shadows, and refined the structural shapes of the face and neck. I left out a lot of reflected light on the right side of the face to create a stronger shadow shape and also made the shadow cooler.

I then finished the eyes, adding the "whites," the colors of the iris, and the highlights. The nose needed very little, but I altered the highlight somewhat and paid closer attention to how the light fell across the bridge. I softened edges on the lips and worked on the turn of the upper lip as it met the cheek. I refined the ears, trying to do so in as few strokes as possible.

I dampened the hair area with medium and repainted the darks in the model's blonde hair, refining the shape of the face as I did so. For the darks I used a combination of Raw Sienna, Burnt Umber, and French Ultramarine blue. I added some medium tones with the same combination but with more Raw Sienna and less Burnt Umber. I used a mixture of Yellow Ochre, Lemon Yellow Hue, and white to place the lights.

*Then I concentrated on getting the features right, starting with the eyes and then using them to judge the rest of the features. I also worked on the muscles around the mouth and in the neck.*

I repeated the hair color in the shirt, painting it a soft yellow. At this stage I was doing a lot of stepping back and evaluating. I decided to darken the background to bring the face out more, and the portrait was finished.

This concludes your final lesson in the course. Hopefully you have learned not only how to paint, but how to look at the world with an artist's eyes. Don't get discouraged if you run into a problem with a painting. I've been painting for a very long time and I think only once has a painting gone smoothly from start to finish. Expect that at some point you'll want to throw the painting against the wall. If you work through that point enough times, eventually you will realize that you can do it. Learning to paint is an ongoing process; give yourself permission to make mistakes. Bon voyage!

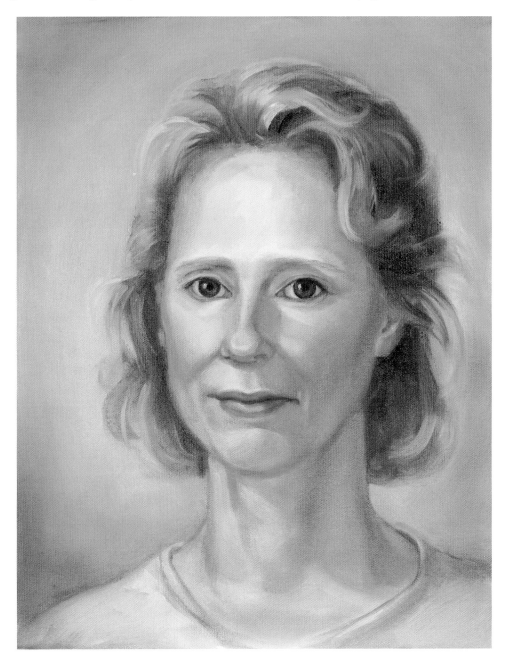

*I fine-tuned the skin color, refined the features, and painted the blouse a soft yellow to repeat the color of the hair. After stepping back to evaluate the painting I decided to darken the background color. Now the portrait is finished.*

# VARNISHING YOUR WORK

## Why should I varnish my painting?

Varnish protects the paint layer by putting a barrier between it and the oil, dust, and other pollutants in the air. It also brings out the depth and luster of the color. The difference varnish can make in the look of a painting is truly astonishing.

Most paintings have a variety of thicknesses of paint. These variations will cause the varnish to look shinier in some places than in others. Where the paint is applied so thickly as to completely cover the weave of the canvas, the varnish layer will be very shiny, and where the paint is applied very thinly, the varnish will not appear as shiny. Don't go crazy trying to get every area equally shiny; unless your painting is extraordinarily uniform, it just won't be possible.

## Which varnish should I use?

There are two different kinds of varnish—retouch varnish and picture varnish.

### RETOUCH VARNISH

This protective varnish is often put on a painting before it has fully dried so that it can be framed or sold. It is applied when the painting is dry to the touch but before it is dry all the way through.

Retouch varnish allows air to penetrate, which lets the work continue drying, while simultaneously providing some of the cosmetic benefits of varnish—such as improving color, helping to match new color to old by making the old color look wet again, and providing gloss to make the painting look "finished."

Retouch varnish has other uses as well. It can seal off a dry section of an unfinished painting so that if you want to add something that you are not sure will work, you will be able to remove it with less chance of damaging the underlying layer. It can also be sprayed on an uncompleted painting that hasn't been worked on for a while to insure the bonding of the new layer of paint to the old.

### PICTURE VARNISH

Picture varnish is the final layer on a painting. It provides an airtight coating and is applied when the painting is *thoroughly* dry. I recommend a spray form of picture varnish that dries quickly. Using a fast-drying varnish is a real advantage compared to the slow-drying damar varnish, which is prone to attracting hair, dust, and insects while it is drying.

## When should I varnish?

Many experts say an oil painting should dry a minimum of six months to a year before applying varnish, depending on the thickness of the paint layer and the time used to paint it. This estimate includes paintings done with fast-drying mediums. Other experts say some thinly painted works can be varnished in as little as three months.

Remember that paint dries from the top down, so when the surface seems dry, the painting may still be wet underneath. If you apply varnish too soon, it may sink in, giving you a spotty finish. The unevenness of the varnish layer caused by the paint being thick or thin is acceptable; spottiness is not.

Try not to varnish in humid weather, as it can cause mold to grow on your painting. After you have varnished the painting, protect it from dust, insects, and animal fur until it dries by leaning it face down against a wall.

## What are the differences between the various finishes?

Picture varnish comes in gloss, satin, and matte finishes. Usually oil paintings are expected to display the luster for which oil paint is noted. However, if you want less shine, spray a layer of matte varnish over a layer of gloss or use a straight satin varnish. Matte varnish has wax in it, and will dull the finish.

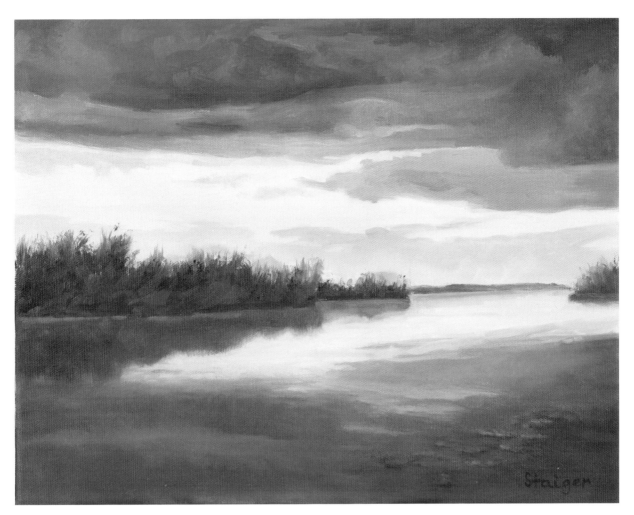

*Kathleen Lochen Staiger,* Barrier Islands, *oil on canvas*

# INDEX